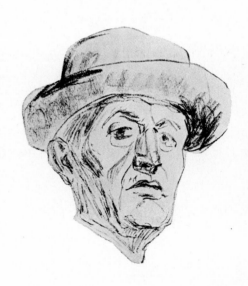

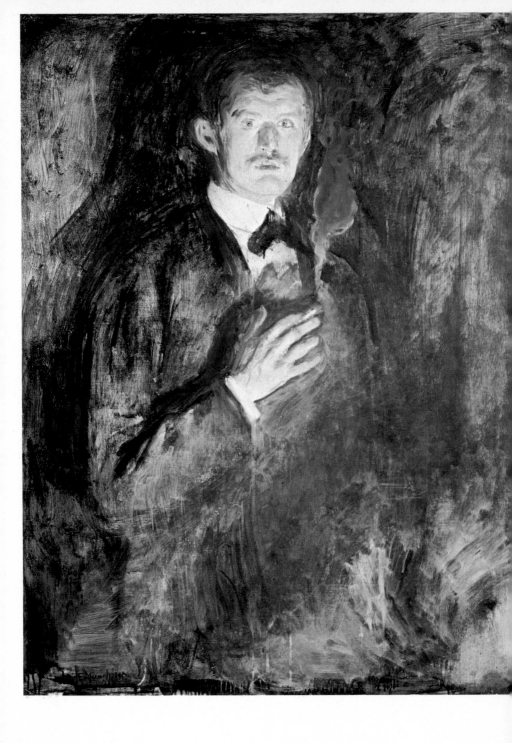

Nic. Stang

Edvard Munch

Illustrations edited by:
Ragna Stang

Translated by:
Carol J. Knudsen

JOHAN GRUNDT TANUM FORLAG OSLO

© JOHAN GRUNDT TANUM FORLAG 1972

Black and white and colur plates, printing and binding:
Dreyer Aksjeselskap, Stavanger, Norway.

ISBN 518 0010 2.

On the dusk jacket: Detail from Dance of Life (p. 122)
Page 1: Self-Portrait lith. 1930 OKK 456
Page 2: Self-Portrait with Cigarette 1895 NG

Table of Contents

To the Reader

The methods of the art historian are many, still you will find those who swear to a "one and only" approach to the subject. However, the subject matter of art history is so manifold and varying, that the methods of treatment must vary with it. You cannot approach the art of Munch and Cézanne in the same way.

Edvard Munch developed as an artist during a literary period – perhaps the most literary period in the history of modern art – or it might be more correct to say the period most dominated by literature. He himself was in the midst of the creative milieu of those times, the milieu of literature and pictorial art. In his youth he was connected with Norwegian bohemianism, an intellectual anarchistic movement, as well as with the more or less naturalistic painters in the small provincial Norwegian capital. Both in France and Germany he looked for, and found, related environments, where he encountered the literary lights – of differing brilliance – of the age; among them were authors like Strindberg and Mallarmé and people from the theatre world like Lugné-Poë and Max Reinhardt.

This environment shaped his attitudes to life and art, above all to the art he himself wanted to create. His personal letters and notes are many; they even include a strongly autobiographical draft of a novel. "You shall write your life!" was one of the famous nine commandments of bohemianism. More than anyone else, Munch became the painter who painted his life, his innermost feelings as well as outer experiences.

Though Edvard Munch, even as an older man, kept himself well informed as to what was happening in the world of art, we can probably say that symbolism was the last trend that really exerted a strong influence on his deeply personal art. But he differs from the other artists of the time in that he doesn't search for his symbols outside himself. No, it is his own life experience he builds upon and he manages to

7

universalize it so that his works concern all of us. It is impossible to go deeply into the art of Munch without knowing his biography.

I regard this book as an introduction to an understanding of Edvard Munch and his art. Therefore I have found it important – indeed vital – to emphasize the biographical, the milieu, and particularly, the words of Edvard Munch himself from his letters and notes. Some of this material is presented here for the first time. (Munch's own words are set in italics throughout the book.)

Originally it was the intention that I should again write a book together with my wife, Ragna Stang. But an unkind fate – at least with regard to our co-authorship – has placed so much work upon her as the director of the Munch Museum that our co-authorship was limited on her part to giving advice and providing some of the material. For that I wish to thank her, as well as for undertaking the editing of the illustrations.

Oslo in June, 1971 Nic. Stang

Abbreviations Used:

OKK – Oslo Municipal Art Collections
NG – National Gallery, Oslo
RMS – Rasmus Meyer's Collection, Bergen
PC – Private Collection
ptg. – painting, lith. – lithograph, etch. – etching
drg. – drawing, wdct. – woodcut

Scandal in Berlin - 1892

There was a rich Norwegian art milieu in Kaiser Wilhelm's Germany. The great Norwegian painter of the romantic period, J. C. Dahl, had been an influential professor in Dresden, and Hans Gude was a professor at the Berlin Academy in 1892. Norwegian literature – particularly Ibsen's drama – was gaining great success in Germany and the rest of Europe. The interest in things Norwegian was so strong in fact, that to interest German readers, two well-known German authors used a Norwegian pen-name, 'Bjarne P. Holm", for one of their books! Swedish and Danish literature too, especially Strindberg, increased the general interest and curiosity in what was going on in the Nordic art world.

In 1891 the Berlin Artists' Association planned to celebrate their fiftieth anniversary with a large international exhibition, prepared particularly to compete with art-loving royal Munich. At that time Munich was the only city with the exception of Paris where such exhibitions were held. Everything was to take place in Berlin with imperial pomp and circumstance, brass bands, and Prussian thoroughness. In spite of urgent pressure the French didn't come because they had not forgotten – indeed, didn't wish to forget – their defeat at Sedan twenty years earlier. In addition there was still another minor scandal: all of twenty-nine Norwegian artists were invited but their pictures wound up in the rivaling Munich's Glass Palace.

What really happened?

A mediocre Norwegian artist had somehow managed to convince the powerful, conservative, court-and-battle-scene painter, Anton von Werner, ("boots and uniform" painter as the younger artists called him) that these Norwegians were a group of "anarchistic impressionists" – a clique that was terrorizing the Norwegian art world. The words "anarchist" and "impressionist" were about equally insulting in the Prussia of that time. The result was that the court painter caused the invita-

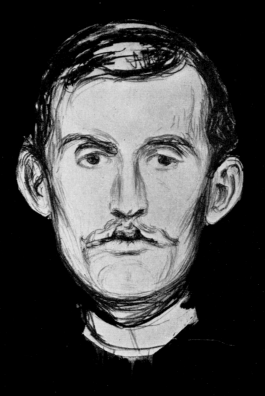

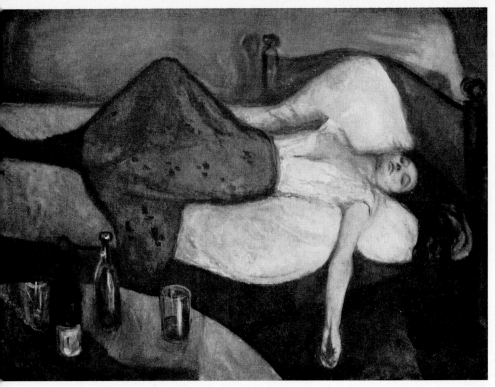

p. 10: Self-Portrait with Skeleton Arm, lith. 1895 OKK 192.
Above: The Morning After, oil 1894 NG.

tion to be withdrawn. To make up for that, personal invitations were
sent to twenty-two artists, Norwegian and of Norwegian descent, living
in Berlin and Düsseldorf. This is more evidence of the breadth of the
German-Norwegian art milieu.

The Norwegian comittee refused, naturally, to take any respon-
siblity for these paintings and, as mentioned before, sent their paintings
to competing Munich. One of the Norwegian participants was Edvard
Munch. He submitted four paintings, and one of them, "Night in St.
Cloud", belonged to those that earlier that year had aroused Norwe-
gian critics. The conservative newspaper *Morgenbladet* wrote: "The
painting called 'Night' places such demands upon people's ability to
guess that only a few would bother taking the trouble to give it a
closer look. We can inform you that it's supposed to depict a room or

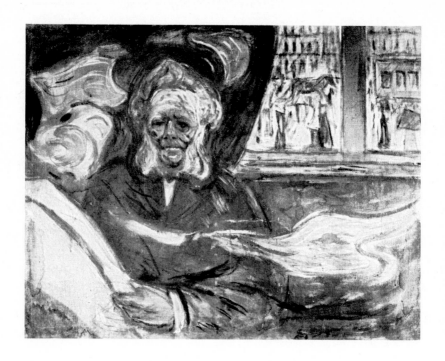

a hall, in which a man sits looking out over the water at a steamboat
passing by with lanterns lit. The atmosphere is, however, so vaguely
expressed that it slips away before you can catch it." About the artist
himself, the critic says: "He wanders along his own paths in a shape-
less misty dream world." Even though this important little work in
Munch's development as an artist was among the four that went to
Munich, it aroused as little interest as the other three. The critics
didn't even bother to mention the artist's name. Concerning the Scan-
dinavian section, however, a critic says: "It won't be long before Ger-
many is talking about Scandinavian art instead of French." A French-
man writes: "after us: the Scandinavians," and about the Norwegians:
"even though they are still in the toddling stage, they will soon be
taking giant strides."

The next year however, an extraordinary thing was to happen. The
young outsider, Munch, was formally asked to exhibit at that same
Artists' Association with that same conservative leadership. It is pos-

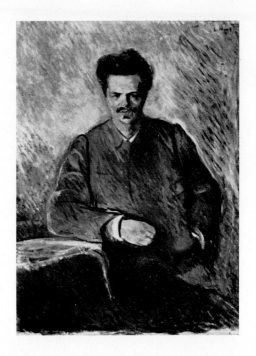

p. 12: Henrik Ibsen in the
Grand Café, oil 1906—10
OKK 717.

This page: August Strindberg,
oil 1892 Nationalmuseum,
Stockholm.

sible that this strange invitation was the result of a recommendation
by the highly respected German painter, Fritz von Uhde. He had seen
Munch's paintings both in Oslo and in Munich. But it is doubly strange
that von Uhde should recommend Edvard Munch, as his own natu-
ralistic portrayals of Christ among the peasants of the nighteen-nine-
ties were as far removed from Munch's art as possible.

On invitation from a conventional, but sincere Norwegian landscape
painter who had himself seen Munch's paintings and who was a mem-
ber of the board of the Berlin Artists' Association, and with the unani-
mous dicision of the board, Munch opened his exhibition of 55 paint-
ings on the 5th of November, 1892. One week later the paintings
were taken down again after one of the biggest scandals in Germany's
modern art history.

A thing like this had never before been heard of in the fifty year
history of the Artists' Association, but neither had such pictures as these
ever been exhibited. The radical German art of that time was prima-

13

rily represented by Max Liebermann and von Uhde's naturalism. Down in the south, in Munich, you could perhaps find one or two who had learned something from the impressionists; but in Kaiser Wilhelm's and von Werner's Berlin, "impressionist" was still a term of abuse. And apart from a few artists, hardly any Germans ever went to Paris – so anti-German was the atmosphere in the French capital.

The debate started right away. Everyone was shocked, and sharp criticism came from all sides. The conservative *National Zeitung* which, by the way, called the Norwegian artist *"E. Blunch"* said that he has sold himself – "body and soul to the French impressionist school, and like all (!) his countrymen he was trying to break all the established rules of art and if possible outdo the Parisians he seems to follow. All traditions and ideals in art have been forgotten by E. Blunch and his colleagues."

Another critic demanded that the exhibition be closed immediately. But the sharpest attack came from the editor of *Kunstchronik,* the highly respected art historian, Adolf Rosenberg: "Excesses of naturalism like this have never before been exhibited in Berlin. What this

Mr. and Mrs. Walter Leistikow, lith. 1902 OKK 243

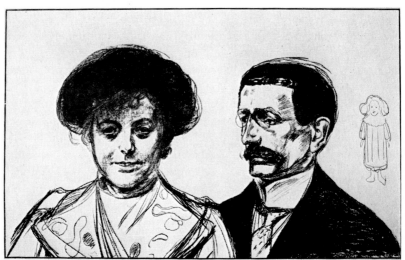

14

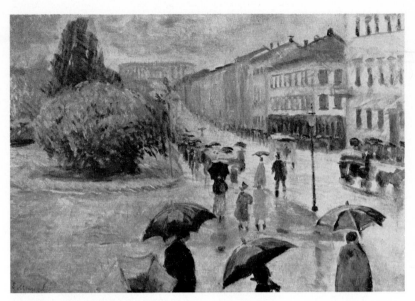

Rain in Christiania, (on Karl Johan's St.) oil 1891 PC.

Norwegian allows himself with regard to lack of form, and brutality in his painting, crudity and baseness of expression, overshadows all the sins of the French and Scottish impressionists, and the naturalists of Munich as well. There are portraits, interiors with figures, street scenes, beach landscapes, and grotesque products of the imagination daubed on in the most depraved way so that at times it's difficult to recognize the human figure – or indeed any objects at all.

Concerning these Munch paintings let us say no more, for they really have no connection with art."

More than ten years were to pass before Munch's art was mentioned in the *Kunstchronik* again. There is no point in immortalizing reviews of this type. They were almost all equally derrogatory, even in the liberal *Berliner Tageblatt*. There, however, Theodor Wolff, who was later to gain fame as editor-in-chief, found it necessary all the same to defend Edvard Munch from his colleague. He went to the exhibition to laugh, he admits, but ... "by all the saints I must confess that I didn't

15

laugh ... for among the strange fancies and real horrors, I found a very fine and delicate atmosphere." And then follows a favourable description of the motifs. Another defender of Munch in this stormy period was the two years younger artist, Walter Leistikow, who wrote favourably in the periodical *Freie Bühne*, though under a pseudonym. Later they were to become good friends.

"Art is Endangered" was the headline in the *Frankfurter Zeitung*. And in the days that followed, the debate was to widen and Munch's "reputation scandaleuse" was to spread all over Germany and even to the French periodicals. This debate was to continue for many years. Naturally, the Norwegian newspaper, *Aftenposten* joined in – and laid it on thick. Under the headline: "Munch's Fiasco in Berlin," they quoted from the above mentioned reviews, particularly: " ... what a depth of poor taste and brutality naturalism brings with it ..." and went on to tell how people laughed at the paintings because they didn't understand what they meant. The quote is probably from Rosenberg,

16

p. 16: A Dance, oil
1885 PC Oslo.

This page: Walter
Rathenau, oil 1907
RMS Bergen.

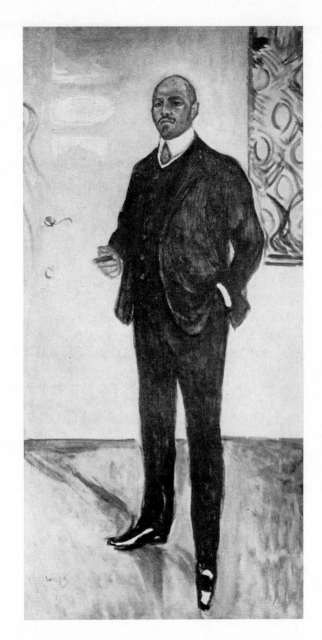

and his strange use of the word "naturalism" tells us something about the attitude towards modern art in Prussian Berlin.

There had to be a scandal.

The intriguers belonging to the art world began to collect signatures, and when there were enough, a general meeting of the Artists' Association was called. The storm broke loose November 11th. By 120 to 105 votes it was decided to close the exhibition and the next day this was done. During the uproar, the 105 marched out and went to another meeting place, where they founded a new sort of association, though without breaking off from the old one.

One of them, the sculptor Max Kruse, tells us dramatically what happened: "This exhibition," he says, "showed us that a painter can have as his vocation the expression of all the feelings that move people's hearts. The 'rules of art' as we have heretofore understood them are completely turned upside down when form and colour become subordinate, become only the means to reach a goal, rather than an end in themselves as in previous tradition." He points out that the exhibition was the beginning of the secession movement and that it was held during a dispute between von Werner and the academy, a dispute in which the young artists played a major role – it was their representatives that were on the commission. The powerful von Werner had only contributed his signature to the invitation; "but he couldn't have known anything about a certain painter, Munch ... All the same we didn't suspect that this exhibition was to be a turning point in the life of the association. I must confess, by the way, that when we saw the paintings hung, we ourselves began to be almost afraid – of our own courage! But the outburst of dismay, of anger, that came from the older gentlemen was something far beyond anything we had expected.

They had barely seen the paintings when they fled back to the lecture room and Anton von Werner declared that the exhibition was a mockery of art, was filthy and vile – and he declared it closed. We maintained that one couldn't throw out a guest who had been invited.

Werner said: 'That is a matter of absolutely no consequence to me, the exhibition is closed.' and then there was an awful row with shouting and whistling and, in the end, actual fist fights. We younger artists wanted to leave the room and the older ones barred our way. In the

18

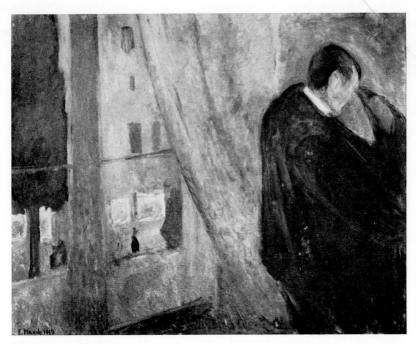

The Kiss, oil 1892 NG.

end we formed a wedge and broke through the barrier formed by our opponents. Intoxicated with victory we left Wilhelmstrasse . . ."

The group was larger than the rebels themselves had expected, and there were faces they could only shake their heads at. It was inconceivable to build a secession on this foundation. "Unfortunately it is always easier to break something down than to build something up," concludes Max Kruse.

This was, in short, "the fall" or: "the Munch affair." The *Berliner Tageblatt* was completely correct in saying: "The result cannot be interpreted as though those who voted against closing the Munch exhibition were in favour of this trend in art." This was emphasised in a manifest that the 105 put out. They stuck to the only argument that Munch's supporters used: that he was an invited guest and that the rules of hospitality were being broken. This was inexcusable, but

19

it did not mean that we " . . . therefore take any stand whatever concerning the art trend expressed in Munch's paintings." In reality, it was a fight for freedom of expression, for the right to be heard.*

The defeat was almost complete, but Munch had at any rate become a famous, or perhaps more correctly: an "infamous" artist in that Germany that was the Scandinavian artist's path to the world. More than anyone else he had become the "man of the day" in a large cultural area. Immediately after the scandal he was invited to exhibit in Düsseldorf and Cologne, the first of a long line of German exhibitions he was to hold in the coming years.

This side of the case, the infamous fame, Munch understood very well. He writes: *All this uproar has really been a pleasure. Better advertisement would be hard to attain. It's amazing that something as innocent as painting can cause such excitement.*

But when he writes home that: *. . .all the young people, nevertheless, like my paintings,* it's probably mostly to reassure his family.

Already in March, 1893, something rather surprising happened: Edvard Munch applied for membership in the Berlin Artists' Association and submitted a painting: "Man Lying on a Sofa." The application was refused by 77 to 39 votes.

Even if the new association didn't get any further than holding their own exhibition the next year, there had developed a real schism and deep personal antagonism. (Munch participated in it with two paintings.) Three professors withdrew from the Berlin academy because they couldn't manage to co-operate with the authoritarian von Werner. And in 1898 the revolutionists rallied together in The Berlin Secession; but Munch wasn't even invited to participate in their first exhibition the next year. There were too many of the old group, and they considered him a "crank" and an "unwished for intruder," says his good friend Jens Thiis. They were too absorbed in their own success and in Manet. It was only when The Secession broke up with a number of the older ones withdrawing, and Munch's friend Leistikow becoming one of the directors, that Munch was invited to exhibit the "Life Frieze" in 1902.

* The new material in this chapter is taken from the recently published article by the American, Reinhold A. Heller.

Why did Munch try to become a member of the Berlin Artists' Association just after "the Munch affair?" We think he was fighting a bitter – and ambitious – fight to be recognized, and especially to win a success abroad that would refute the hateful Norwegian critics. But most important was to win over the public. Munch's untiring champion, Jens Thiis, says with regard to the critics: ". . . the general public is often against anything new; but there is a small select group that in the long run will not be cowed by criticism that is arrogant, ignorant, and in addition anonymous. This group will eventually take the leadership and be decisive."

This small select group was to develop in Germany as it had already developed with regard to the naturalists of the eighteen-eighties in Norway.

Already in July 1893, Walther Rathenau bought his first Munch painting: "Rain in Christiania."

Jens Thiis, lith. 1913 OKK 371.

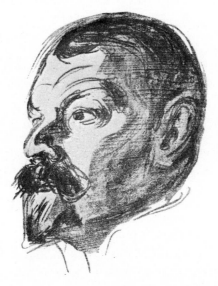

Qualifications - the background

What then was behind the fact that this twenty-nine year old painter (born 1863) from provincial Norway could so shock Berlin both by the form and the subject matter of his paintings? The greater portion of the fifty-five paintings were impressionistic. He used varying techniques in a very personal way and to a certain extent it was correct of the critics to say that he sometimes "tried to outdo the French."

Even in the naturalistic period of the eighties impressionism and its theories were relatively well-known in Oslo. Some Norwegian artists had returned from Paris, where, by the way, Munch himself spent a few weeks in 1885. That same year Gauguin had three paintings in the State Autumn Exhibition in Oslo.

When Munch came home from Paris after his first state scholarship and exhibited all of ten paintings in the Autumn Exhibition of 1890, they were hung in the company of works by Monet, Degas, and Pissarro. The participation of these artists shows how active a Norwegian interest there was in impressionism.

In spite of the fact that the art centre itself, Paris, was well on its way into new trends, trends that were to be decisive for Munch and in a strange way confirm his own experience and views, impressionism was still the last word in Germany and the naturalists represented a hated radicalism. The word "impressionist" meant to the general public, as we have said before, almost the same thing as "anarchist", whether it was in connection with art traditions or with the values and norms of society.

As for subject matter, Munch's art has two main sources: The home the artist came from and to which he was closely tied all his life – and the intellectual milieu he encountered as a young man in the Christiania (Oslo) of the eighties – the bohemian milieu as it was called. Impressions from this milieu were later to be re-inforced in the Berlin and Paris of the 1890s where Munch found a Scandinavian-German-French milieu. It called itself decadent, and "fin de siècle" and expres-

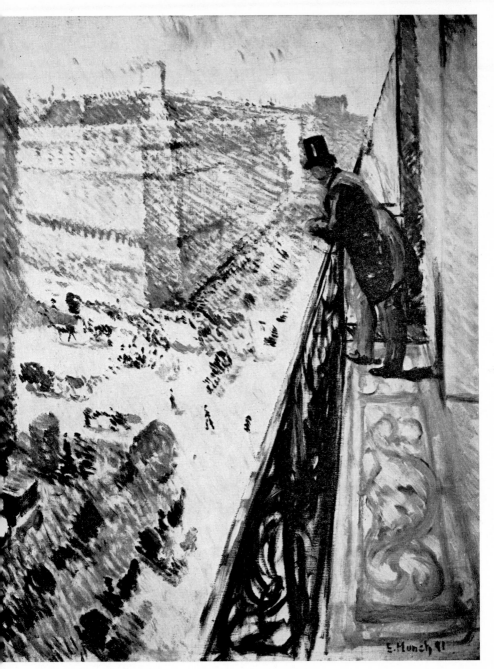

Rue Lafayette, oil 1891 NG.

sed itself artistically in "l'art nouveau" with the symbolism of its many different movements – the one shading imperceptibly into the other. In Norway they talked about the "new romantics" both in literature and the fine arts, a trend that eagerly challenged the materialism of the naturalists and to some extent their atheism. But these subjective individualistic, and "soulful" artists kept to the bohemian way of life and were a continual thorn in the side for "the good citizens".

In the Berlin exhibition, Munch exhibited for the first time pictures from the soul epic he dreamed of creating with the motifs of Love and Death: the "Life Frieze" he was to struggle with for three or four decades. He makes no attempt to hide the fact that the ideas are not his own, and in a letter to Thiis as late as the beginning of the

In the Digs (Tête à Tête) oil 1885 OKK 310.

24

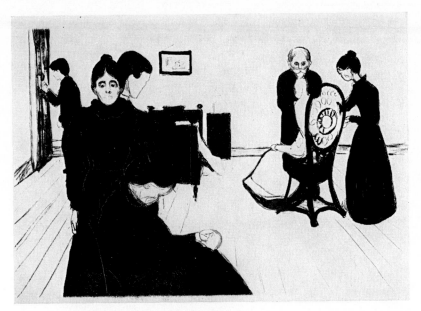

Death in the Sick-Room, lith. 1896 OKK 215.

1930s he says: *You don't have to look too far to explain the emergence of the 'Life Frieze'. It has its explanation in the bohemian era itself. The important thing was to paint real life – from one's own experience.*

Faithful as he is to his own life experience and to his art, he even as late as that, is still confessing his belief in the ideas of the bohemian era. His statement reminds us of the merciless demand placed upon writers by one of the famous nine commandments of bohemianism: "You shall write your life!" It was this milieu that determined his basic attitude towards the central questions man asks himself.

While the symbolists, in Germany as well as in France, were looking for literary motifs and working, so to speak, with borrowed material, Edvard Munch's life was such that his own experience gave him his subject matter. Death in all its gruesome incomprehensiveness was close to him when he was still only a sensitive child and youth. Love in all its phases he experienced both personally and through his friends in the "fin de siècle" milieu. He was one of the handsomest men in Scandinavia and his shy charm attracted various types of women.

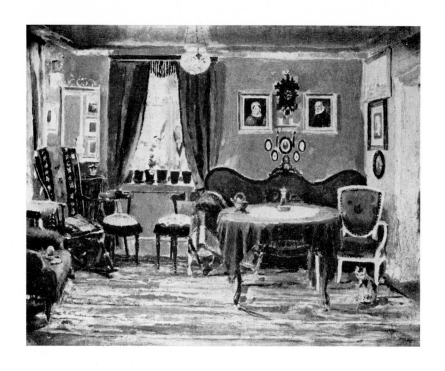

THE MUNCH HOME

Edvard Munch comes from one of the old families that have made important contributions to literature, science, and art in Norway. The Munchs were mostly officers and clergymen. One Engineer Corps officer became a painter and, among other things, studied under David in Paris and became Norway's most typical portrait artist of the empire period (Jacob Munch). Another Munch, a clergyman, combined being a bishop with writing poetry. His son, Andreas Munch, (d. 1884), a lyricist and dramatist of the late romantic period, played an important role in his time and was awarded the title of professor. But the most important man in the family was another professor, Edvard's uncle, P. A. Munch (1810–1863), whose work as a historian was so brilliant that we dare to use that perilous word, *"genius."* P. A. Munch's brother was the Army Medical Corps doctor, Christian Munch (1817–1889), Edvard's father.

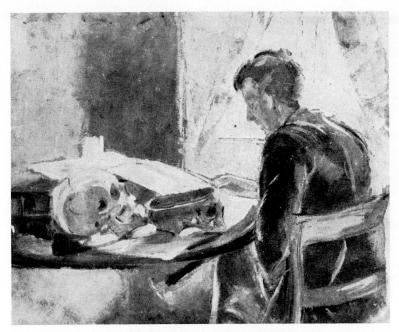

p. 26: The Great Aunts' Sitting Room, oil 1881 OKK 1047.
Above: Brother Andreas Studying Anatomy, oil 1883 OKK 202.

Dr. Munch's home bore the imprint of culture, of old family tradi-
tions, as well as active intellectual interests. The five children were
raised in the tradition of P. A. Munch's contribution to the nation,
spending many evenings reading aloud under the oil lamp the works
of Walter Scott and other literature as well as their uncle's *The Le-
gends of the Norse Gods and Heroes* and his monumental *History of
the Norwegian People.* And the father was a fine story teller, espe-
cially of the old sagas, though he wouldn't hesitate to tell a good ghost
story either.

Unfortunately the doctor had financial difficulties. His practice was
on the east side – where the poorer classes lived – and this was
before the days of socialized medicine. Misfortunes came to the family
of seven. Edvard was only five when he lost his mother from tuber-
culosis. That affliction, so common in those times, was also to take his

27

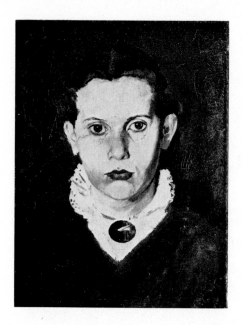

Sister Laura, 14 Years Old, oil
1881–82 OKK 1046.

Opposite: Siesta, oil 1883 OKK
1055.

favourite sister, Sophie, when she was only fifteen years old. In 1895, when Edvard Munch was at the peak of his powers, his brother Peter Andreas was to die at the age of thirty.

His father's sudden death in 1889 recalled to mind these sad memories from childhood and he re-lived the last Christmas his mother was with them:

The air was full of the waxy smell of candles and singed evergreen, the dark corners were gone and there was light everywhere. In the middle of the sofa sat Mother, quiet and pale in her black silk dress – the silk looking even darker in all the light. The five of us sat or stood around her.

Father paced nervously back and forth, then sat close to her on the sofa and they whispered together, his head bent over her. She smiled and the tears ran down her cheeks. Everything was so quiet and so bright . . .

She sat there in the sofa looking first at one, then the other, touching our cheeks gently with her hand.

28

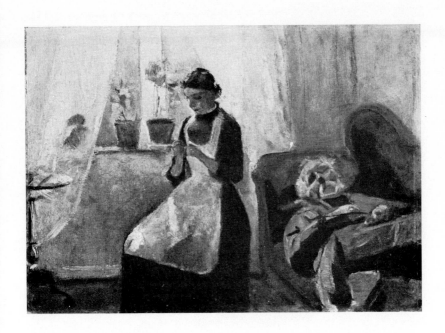

We were to leave home.
A black-robed stranger prayed at the foot of her bed...
It was dark in the room and the air was heavy and grey.
We were in our coats and boots, and the maid who was taking us
away stood at the door waiting.
We went one at a time to the bedside and she looked at us so stran-
gely and kissed us.
Then we left the house and the maid took us to strangers. They were
all very kind to us and we could have all the cakes and toys we
wanted.

There was both vigour and artistic talent also on his mother's side
of the family. His maternal grandfather was a powerful fellow, a ship
captain and timber dealer who fathered a score of children by his two
wives. Characteristically – according to what Munch tells us – when
the doctor was trying to prepare the old skipper for death, he broke
out with: "Ha! Imagine that a thing like this should happen to me!"

To the relief of the stricken family Mrs. Munch's sister, Karen Bjoel-

Gamle Aker Church in Oslo, oil 1881 OKK 1043.

stad, took over their care. She encouraged the artistic talent of the children who were all keen on drawing. And when they needed money badly, she could even help out a bit herself by selling decorative works of art: landscapes with moss, fern leaves and twigs in the foreground. That sort of thing was popular in those days.

From the very beginning she had faith in Edvard's talent; she helped him to leave the Technical College where his father had sent him, so that he could begin to paint. And so in the autumn of 1881 Munch began his studies under Julius Middelthun at the State School of Art and Crafts. Soon he was to sell his first two paintings at an auction for the fantastic amount of 26.50 Norwegian crowns (some 30 shillings).

The death of his wife was a great blow for Munch's father. He lost a lot of his cheerfulness and his deep religious beliefs became more intense – and gloomier. Many years later Munch was to write:

My father tried to be both a father and a mother for us, but he had a difficult nature, an inherited nervous disposition with periods of

30

The Artist's Aunt, oil 1888
OKK 1057.

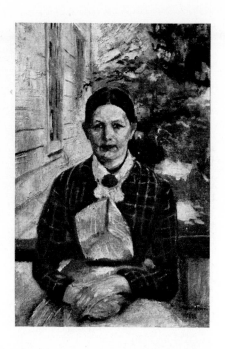

*religious obsession that came close to insanity. There were times when
he spent days pacing his room in prayer to God. At an early age he
taught me about the misery of life on earth and its dangers, about life
after death and the eternal suffering in hell that awaited the children
of sin.*

After one of the far-from-rare family clashes, Edvard returned home
late at night and found his father in prayer. The artistic result was the
woodcut "Old Man Praying" done as late as 1902.

Munch carried his father and his family with him in his heart, and
when he sat alone in the cold winter of Paris after his father's death,
he noted down in his "spiritual diary":

*And so I live with the dead – my mother, my sister, my grand-
father, and my father – most of all my father. All the memories, the
little things come back. I see him as I saw him for the last time when
he said goodbye to me four months ago on the pier. We were a little
shy with each other – didn't want to show how much it hurt to part*

31

– how fond we were of each other in spite of everything – how he suffered in the night for my sake, for my life – because I couldn't share his beliefs. Yesterday I looked through some old letters ...»

And his sister, Inger, can tell us that Edvard always had a suitcase full of old letters with him on his travels.

Karen Bjoelstad brought security back to the stricken home; but it wasn't long before tragedy came again. Fifteen-year-old Sophie's illness and death in 1877 was an appalling experience for a shy and sensitive fourteen-year-old, an appalling human experience from which he never

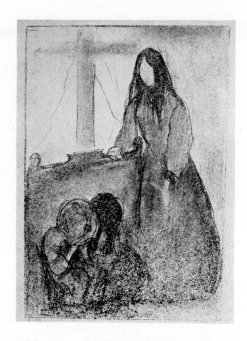

Opposite: The Sick Child,
chalk 1896 (?) PC.

This page: Childhood
Recollection, drg. 1894
OKK 2358.

escaped. That his principal works, "The Sick Child" and "Spring"
were to appear already in the last half of the next decade may be
connected with these early experiences. But all the same, many worked
with these motifs in the "pillow period" as Munch himself called it.
Actually it was his father's death that evoked all these thoughts again.
We see them in his notes and letters, and they find their memorial in
his works of the '90s, both in painting and graphic art. One principal
motif is "Death in the Sick-Room" that almost minutely re-creates his
recollection of what happened.

Just at the time when he was seriously beginning to work with the
death motif he writes, as though it were a section of a novel:

*Her eyes were reddened — the fact that it was certain now — that
death was coming — it was incomprehensible ...*

The vicar came — in his black robe and white collar —

*Was she then really going to die? During the last half hour she had
begun to feel better, the pain was gone ... She tried to lift herself*

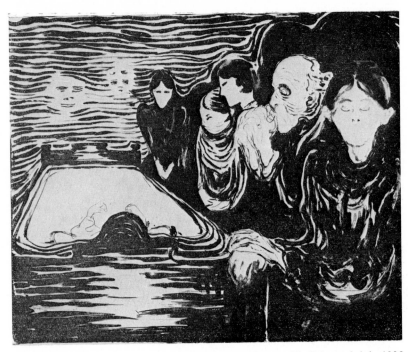

At the Death Bed, (also called "Fever" and "The Son") lith. and ink 1896
OKK 214.

*up – pointed to the easy chair beside the bed – "I should so like to
sit up a bit," she whispered. How strange she felt – the room was
different, she saw it dimly as through a veil – her limbs were heavy –
how tired . . .*

"The Dying" – in another version "The Dead" – sits in an easy
chair in Munch's paintings, this artist who painted not *what I see,*
but *what I saw!*

Edvard Munch recognized clearly the principal sources of his art,
especially what his home and his experiences there meant to him. When
he reached maturity and was a recognised artist he explains it very
simply, sincerely – and pathetically: *Illness, insanity, and death were
the black angels that kept watch over my cradle and accompanied me
all my life.*

Sickly as he was while growing up, often absent from school because of rheumatic fever and other illnesses, he always had in the back of his mind a fear of tuberculosis and insanity – and the thought of death accompanied him throughout adolescence and manhood. He even thought of illness as a pre-requisite for his work: *these weaknesses I shall keep, they are a part of myself. I would not cast off my illness, for there is much in my art that I owe to it.* Dependence during his youth and deep human experiences bound him closely to his home and family. His letters tell of his concern and of his will to help whenever he was able to do so.

It was a patriarchal home ruled by "good old fashioned" order and discipline, and Karen Bjoelstad managed the household with a firm though loving hand. But their financial straits, the loss of the mother, and the many moves from one small flat to another kept the family rather isolated from the "better society" of Christiania (Oslo). Already as a very young man, Edvard Munch was, in a way, an outsider from the "upper circles" and his aversion to their conventions and moral concepts was strengthened when he became more or less closely tied to the bohemian set.

Of the members of this set, Munch was probably the one who has come closest to fulfilling the moral demands set by its leader, Hans Jaeger. Few of the others so mercilessly revealed the secrets of their inner lives or exploited their own experiences to such an extent – with the possible exception of Jaeger himself in his books.

Munch's art still speaks to all of us directly and the reason is because he plumbed the depths of his own being and touched something that is common to all. His individualism is universal.

Artistically he was to completely break away from Hans Jaeger and the ideas of naturalism. He wanted to depart from outer reality and search out the secrets of the soul – to paint "from the Modern Psyche". It was this title he gave the "Life Frieze" when he exhibited 22 paintings at the Secession Exhibition in Berlin in 1902. It was this Secession that was partly a result of Munch's exhibition in the Berlin Artists' Association ten years earlier.

THE BOHEMIANS

Until the last decade of the eighteen hundreds, Norway was a very provincial country, in a way something apart from the rest of Europe. We Norwegians didn't even have the connections with the European centres that a court and a king would have provided. For almost five hundred years, the king of Norway lived in Copenhagen, and after 1814, in Stockholm. This was reflected in the fact that we used the word "European" to mean sophisticated, worldly, up-to-date and impressive – as though we ourselves were not a part of Europe – something in the same way that Englishmen use the word "continental" – for better or worse.

Our artists and writers had to look abroad. We had no opera, no ballet, and no academy of art. Ibsen left his country and didn't return permanently until 1891. However, by that time Christiania was on its way towards becoming a small European capital.

Like the storms of autumn, the winds of change swept over the

The Quarrel in the Studio, oil 1885 OKK 628.

At the Military
Hospital, oil- 1881–82
OKK 185.

country. The Dane, Georg Brandes, was to bring new impulses from European intellectual life and to serve as a midwife at the birth of modern Norwegian literature. He was in direct personal contact with our writers as almost all of them published their books in Copenhagen. His atheism, however, disquieted minds in Norway as well as in other countries.

Early in the eighteen-eighties, the best and most concerned Norwegian artists were to move from Munich to Paris – and to return home! When they return, they are full of new ideas, of impressionism and anarchism; they have adopted continental habits, spending time in cafés; they are familiar with the brothels of Paris and pay homage to free love. The writers too, have found the road to Paris, and soon there is a small clique of artists and writers that completely breaks away from the habits and attitudes of life of the sleepy citizens of that little capital with its 135,000 inhabitants in 1885.

Relationships in the secure upper class milieu, among the people who

37

At the Cottage, drg. 1889 OKK 2389.

counted, were both petty and narrow. You get a glimpse of it when you hear that there was a public scandal concerning the daughters of the attorney general. In full daylight during the daily promenade on the main street they had dared to ascend the "stairs of sin" – the steps of the Grand Cafe – and go in! One of them, by the way, was later to become an artist and to marry that painter who in the early years meant the most for Munch: Christian Krohg.

Most of the bohemian set were writers of greater or lesser importance, and these naturalists idolized, naturally enough, Émile Zola. Literature was to be evaluated according to its usefulness to society, and the central figure of Christiania bohemianism, Hans Jaeger, found it necessary to write a foreword to his novel, *fra Kristiania-Bohêmen.* "Though lacking in genuine literary talent" he had felt compelled to tackle the task he had expected others to do – i.e.: "to initiate a contemporary Norwegian fiction." And he realizes that his novel "both in its form and content will violently offend against what is considered good social manners."

And conflict with the mores of the times, it did. This revealing auto-

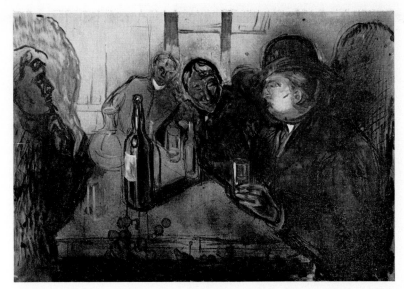

The First Highball, oil OKK 15.

biographical novel was considered "raw" and pornographic by the standards of those times. It was immediately confiscated and its author sentenced to two months in prison.

On the wall of his cell Hans Jaeger hung the first (later lost) edition of Munch's "Madonna."

Hans Jaeger was deeply honest, an intellectual rebel and convinced anarchist who, in addition to his literary works, wrote a study of Kant and ended his writing career by publishing "The Bible of Anarchy."

People thought of this whole circle of young people as revolutionists who refuted everything that was sacred both on earth and in heaven.

New proof of this was seen again the year after Jaeger's book was confiscated. In the novel, *Albertine*, Christian Krohg attacked a well-established and accepted bourgeois institution: public prostitution. This was accepted as necessary because, people said, it protected the virtue of the daughters of good society. *Albertine* was seized; but Krohg, who in addition to having a law degree was a member of one of the best families, got no more than a fine. He continued the struggle with the exceptionally large painting "Albertine in the Police Doctor's Waiting

Self-Portrait,
oil 1881–82 OKK 1049.

Room" based on a chapter of the novel. Krohg was in every way one of the central figures among the bohemians, and edited their newspaper. It was not without reason that this newspaper was called: *The Impressionist*.

The debate waxed strong over the wine glasses. It could be concerned with the determinism that these naturalists believed in – or in spite of this belief, it could concern a free man's right to live his own life – and to take it if he wished! It could concern liberation from the church and religion, and when the talk turned to the freest of free love the words poured forth. It is at this time that the debate concerning morals started in earnest, a debate that still troubles Norway today.

But we mustn't forget the discussions about society itself and the place of man within it, the deep social conscience that demanded a new society after the defeat of the old one: in word and picture it was essential to show the seamy side of life in contemporary society, the painter was to present a "picture of the times".

The Painter, Andreas Singdahlsen, oil 1883 OKK 1054. (According to tradition, painted in co-operation with Christian Krohg.)

Personal tragedies, syphilis and suicide, alcohol problems and difficult relationships with women was the price the bohemians had to pay to translate their theories into practice – as part of the price too, they were completely isolated and outlawed from good society. But all the same, a sharp eye was kept on them in that provincial milieu where everyone knew everything about everybody.

They were as despised as they were hated, and we can understand the situation of the bohemians in that bigotted small-town society when the cosmopolitan Georg Brandes characterizes his Norwegian admirers as: "That little half-debauched, poverty-stricken, Christiania gypsy camp."

Hard years were in store for those who were trying to keep in step with the "Dance of Life" as one of Munch's later paintings was called. Afterwards, Munch was to recollect these years and to write: *When is someone going to describe that period? Who would be able to do it? It would have to be a Dostoevsky, or a mixture of Krohg, Jaeger and perhaps myself who would be capable of describing this "Russian"*

41

The Hands,
oil 1893 OKK 646.

period in the "Siberian" city Christiania (Oslo) was – and still is. That was a pioneering time and a time of trial for many.

For many the trials were too hard, but with his unconquerable will to create, to reach the goal he had set for himself, Edvard Munch didn't succumb.

It must have been something of a shock for the young Munch to come from the puritanism, gentile poverty, and deeply religious atmosphere of his home to this group of rebels. Already in 1882, nineteen years old, he was to meet the radical naturalists. Together with several like-minded young painters he rented a studio directly across from the Parliament building. There the thirty-year-old Christian Krohg supervised the work of the other painters, approximately ten years younger. Through his artist friends and Christian Krohg, Munch was introduced into the bohemian circles where he made many close friends whose varying destinies he was to share.

It was a hard, strenuous life for the sickly young man. It took both time and money, even though alcohol was cheap and relatively free

Heritage,
oil 1897–99 OKK 11.

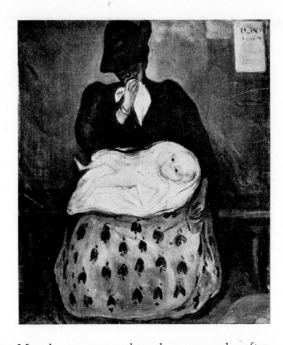

of tax in those days. But Munch was poorer than the poor, so he often had to leave his high spirited friends and return home to grace at the table and the stewpot on the stove. His shy, aristocratic ways kept him slightly apart from the others of the group – then as well as later in life. We can assume too, that he reacted against the disorder and shabbiness of the life – and of the clothing – that has been characteristic of bohemians of all times. Munch was more an observer than a participant, but a committed observer, who is already consciously studying the life of which he was to become the greatest contemporary interpreter. Everyone tells us that he was often silent in the group, but every now and then he would contribute an ironic, often self-ironic, comment or suddenly make a statement that would throw the whole subject into sharp relief. His ability to observe and to depict these often very revealing observations appears already in the first portraits he does of his friends, something even the derrogatory critics must admit, though they claim he caricaturizes his models.

Up to the days of the shared studio, the developing painter kept to

43

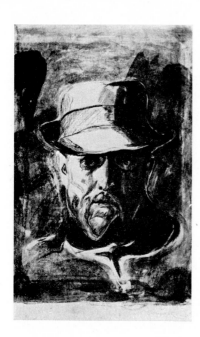

The Author, Hans Jæger,
lith. 1896 OKK 218.

Opposite: Rose and Amélie,
oil 1894 RES-OKK.

subjects close to home, family interiors where he simply and honestly depicts what he sees: his father reading, his aunt in her chair – and on his wanderings around the city and its surroundings he has his sketchbook with him. One day he comes home, looks into the mirror and begins that long series of self-portraits, these "self trials from the difficult years" as he was to call them. The difficult years were to be many, and, equally so, the self-portraits.

The self-portrait of the eighteen-year-old looks as though it were painted by a mature artist. In this painting one can clearly see characterized the slightly arrogant youth who hides his shyness behind the watchful awareness of his half-veiled eyes. There is real character in this face with its sharp, still youthful lines, the sensitive mouth, and the full round chin that he was to keep until the very end.

The year before becoming a pupil of Christian Krogh, he paints a picture that lies close to the naturalists in its subject matter. This too, however, belongs to the motifs from his home, being only an expansion of it: accompanying his father on his sick visits to the Military Hos-

44

pital. In this painting, "At the Military Hospital," we can perceive a coming master. Notice the convalescent patient sitting in the foreground, slightly bent over on the bed, and the same lines repeated in reverse in the two figures in the background. Contrasting positions like these often recur in his later work.

Contemporary, open, and receptive, Munch participates in the naturalist trend and in certain paintings he foreshadows what is to be the dominating movement of the times: impressionism. In the decades that follow he is never afraid to let himself be influenced by others. Restlessly he experiments with colour, with form, and various techniques in painting – and later in graphic art. An exceptional ability to draw, and his inborn skill, help him to master new techniques very quickly, but he uses them in an independent way – picks out what he needs to reach the goals he probably very vaguely conceives of at this time. He learns from many, but has no teacher, and because of this, works from a very individualistic standpoint and often anticipates the course of events – even what is to develop in his own art.

The "Naturalist"

In 1880 Dr. Munch had to resign himself to the fact that his son would not become an engineer, and the 8th of November Edvard notes in his diary: "I am now determined to become a painter." And a painter he steadfastly continued to be through all the ups and downs of life. Art was everything for him:

My art has its roots in reflections over why I am not like others, why there was a curse over my cradle, why I was brought into this world without any choice.

My art gives meaning to my life. I seek the light through it and it has become the staff of life that I need.

In the periods that he burned the candle at both ends, the times of crisis when he restlessly travelled from city to city, from country to country, persecuted as he felt himself to be, deserted by his friends – he was always painting, always experimenting, always trying new graphic techniques. During the major crisis that ended his wandering years, at the Psychiatric clinic in Copenhagen 1908–09, he writes to a friend:

My consolation in these times was that I felt my ability to work was not affected ... I have always been faithful to the muse of painting, and now she has been faithful to me.

When he was finished with the "wandering years" and settled down in Norway in 1909, his life became almost one continuous working day, a life of loneliness with the brush and palett, with the gouge and knife, with the drawing pen and the lithographer's stone.

He was so absorbed in his work as an artist that he renounced all family life and never tied himself down to one woman. But he had his "children" around him – for "children" is what he called all the works he couldn't bear to be parted with. Throughout his life he returned again and again to the old motifs and worked further on them. The paintings, and all the graphic works he surrounds himself with,

are in reality the material for his further work, and one can understand his agitation when the tax authorities want to consider these works as capital assets. If it was necessary to part with one of his major works, he would paint a replica after it was sold – as many as five replicas of "The Sick Child" for example.

Edvard Munch truly lived with, in, and for his art.

Whether he was trying to follow the naturalistic trend or trying to interpret "The Modern Psyche" as he calls his exhibition in Berlin 1902, it is always the eye of the painter that guides his hand, chooses the lines, decides the colouring. It is as a painter that he communicates with us!

All in all, art begins with a human being's need to communicate, to convey something of himself to others. – All means are of equal value to reach this goal. In painting as in literature one often confuses the means with the goal. Nature is the means, not the goal. If one can achieve something by changing nature, one must do so.

In the grip of strong emotion, a landscape will affect you in a certain way – and by depicting this landscape you depict at the same time your own emotion – it is the feeling, the emotion that is the important thing – Nature is only the means to express it.

How well the painting resembles in nature is not important – to explain a painting is impossible . . . but all the same you have to paint it – it is for the very reason that this emotion cannot be expressed in any other way that you must paint it – at least thus one can give some small indication of the direction of ones thoughts –

. . . I don't believe in that art which has not pressed itself forth through the need of man to open his heart.

All art, all literature and music, must be brought forth with one's life blood.

Art is nothing if not life blood.

These are thoughts from 1891 when Edvard Munch is seriously trying to break free from naturalism. We shall for the time being only note how he considered it to be the task of the artist to communicate, to convey to people the subjective experience the landscape gives him – even as he re-experiences it working on his canvas in the studio. He was always dreaming of speaking directly to people and during the

course of a quarter of a century, he was to hold several one-man exhibitions each year all over Europe. Paal Hougen calls attention to the fact that it is not a coincidental group of paintings that were to be presented to possible buyers. On the contrary, each exhibiton had its own title: "From the Modern Psyche", "Love", "Anxiety" and in the end, the "Life Frieze".

Very early Munch feels that precisely through seeing the paintings together in a pattern it would be easier to understand each individual painting.

When he prepares to exhibit in Copenhagen after the Berlin scandal, he writes to a Danish painter who was to help him with the hanging, that: *these works were perhaps difficult to understand – but when they are hung together they will be understood more easily. They are concerned with Love and Death.* The connection between one painting and another was something he hoped others would see – and in that way understand.

The desire to reach the largest possible public was something Munch shared with the others of his time. That is certainly one of the reasons graphic art begins to play a new role – especially lithographic series. It is enough to mention Max Klinger in Germany, and Odilon Redon in France. It is characteristic of Munch that he prints many of his graphic works in large numbers without giving a thought to collecters and so-called connoisseurs. He didn't try to make rarities by numbering prints in small editions. Against this background, one must admit that today's prices, and the speculation in Munch prints, yes even numbered reproductions, don't correspond to the original intention of the artist.

Already when the young artist meets Christian Krohg and the naturalists we notice that he's not as absorbed by the social content, the possible appeal, as he is by the problems of light and colour.

Rightly enough, Munch does make use of the themes favoured by the naturalists when he makes his debut in 1883 with the painting of a young girl lighting the fire, and he continues along these lines when he exhibits "Morning" the following year. Krohg had introduced "The Seamstress" in the new socialist painting, and so all the sour critics called these girls "seamstresses" whether they sewed or not. At any rate, she comes from that same environment, this girl with the reddish hair.

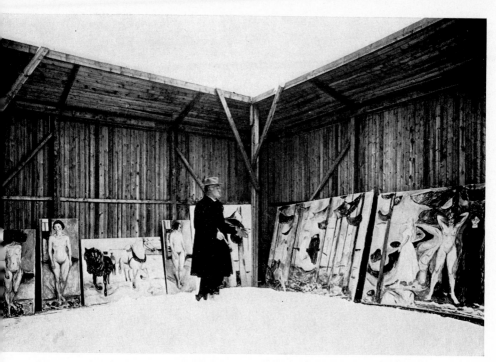

The Open-Air Studio at Ekely, winter 1927–28. Munch standing in the snow, working on new versions of "Life Frieze".

She is absorbed in thought, forgetting to pull up one of her stockings, as she sits there half-dressed, preparing herself for a new long day. But in contrast to the works of Krohg, the picture doesn't make any accusation. On the contrary, there is a light, happy mood in this delicate painting of morning, where the light slants in over the white bedding and enwraps the young blonde. What absorbs the artist is the motif and its artistic possibilities, not her position in society.

The clear morning light throws an unreal glow over things as everyday as the water jug and the glass. The simple outer reality must struggle to be noticed compared with the mood the artist himself is so taken by. We see the highly intensified colours placed against each other in large glowing sections. Already in this early work, Munch brings the colours and the details together in the central figure.

Even this "common" seamstress aroused both the critics and the public who decided that "the motif and its treatment are remarkably lacking in taste," and they write about the "rather sketchy execu-

tion," words that were to haunt Munch in the years to come. They were even said about paintings he had worked on for months – for years. A few, among them the best known older painters, understood what was new and good in the treatment of colour, and one of them (Frits Thaulow) bought the painting.

Paintings from this year (1884) show the breadth of talent of this man, only twenty-one years old. In the portrait of his sister Inger, he manages in a strange way to form space and to shape the figure through the help of the nuances of black between her confirmation dress and the background, through the realistic and detailed treatment of the

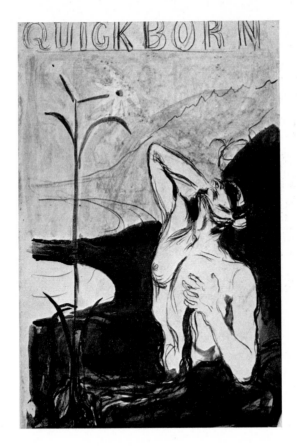

Blossom of Pain, drg. for the cover of the periodical, Quickborn. 1897 OKK 2451. A self-portrait illustrating his own statements (p. 47). The blossom (art) is nourished by the artist's life blood.

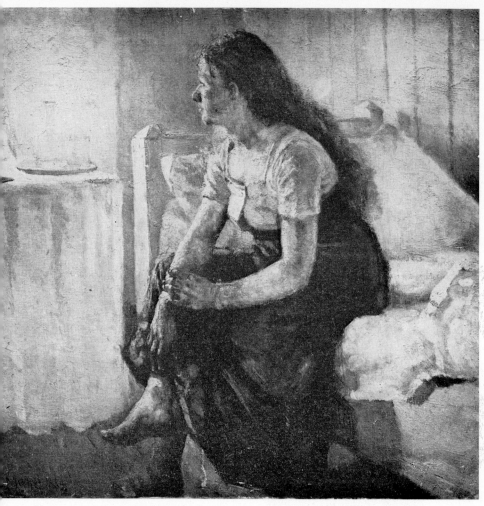

Morning, oil 1884 RMS Bergen.

half-turned head, and the hands. Concerning this outstanding portrait of a seventeen-year-old, the conservative newspaper, *Morgenbladet,* has nothing more to say than to name "his almost frighteningly ugly portrait of a lady in black."

In a third painting, "Olav Rye's Square," the dull and far from beautiful view from his family's flat, he literally "washes it in light," gives it an atmosphere from his own mood. The colours put one in

mind of the French impressionists; and a year later, in 1885, he paints two paintings that justly lead to his being called an impressionist.

No previous Norwegian oil painting had presented a segment of reality that to such an extent grasped the "impression of the moment" as Munch's "A Dance." The quick brush strokes in glowing spots of colour, the dissolving outlines give life and shimmering movement to the whole painting.

But the real sensation, and the very first Munch scandal was the portrait of the painter Jensen-Hjell. Just the size of the painting (approx. 75 in. x 39 in.) was a challenge in this masterly characterization of the bohemian – dandyish in all his shabbiness, arrogant and exhaustingly self-assertive. The loose impressionistic style of painting, the impudent white gleam from the lorgnette that takes the place of his eye, the nonchalant attitude "as though he were a Spanish grandee" says Thiis – all this is enough to make anyone react – and react

Olaf Rye's Square, (Oslo), oil 1884
Nationalmuseum, Stockholm.

Opposite: Sister Inger, oil 1884 NG.

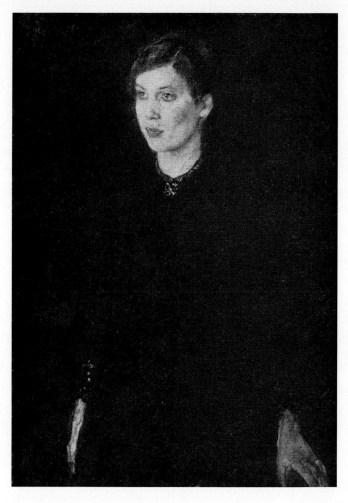

they did! "It doesn't have the right underpaint," they said; "and it appears to be painted with miscellaneous blobs of colour that remained on the palette from another painting." It is: "the reverse of art. As a caricature it makes people laugh, and possibly that is its only intention." It has caused "indignation, an indignation that also applies to the jury that has allowed a painting like that to be included in an exhibition."

Without means, as Munch was during all these years, he had offered to paint the portrait if the model would pay for the paints and canvas – and a good dinner at the Grand Hotel. For that matter, this was a solution Munch often turned to in order to get an opportunity to paint. And at the "Grand" he had his own waiter whom he paid in art. That art-interested waiter is said to have had quite a collection!

Three years earlier, Krogh had painted his life-size portrait of Johan Sverdrup, and a challenging tribute like this to the controversial leader of the liberal party, who had not yet become prime minister, was bad enough – but this painting of Munch's surpassed everything.

There is no doubt that the portrait of Sverdrup (and Manet) were influences leading up to Munch's portrait of his friend, which initiated his proud series of life-size portraits. The interesting thing is that he has here already found the basic pattern he was to use in most of his larger portraits: the neutral background, (uncluttered by any objects) with only the faintest line between floor and wall, and perhaps the slight hint of a corner. When Munch later on calls these portraits: "The bodyguard of my art" perhaps the portrait of his bohemian friend isn't representative. However at this time, Munch had no other "bodyguard" than his close friends and the one or two older painters who already suspected him to be a unique individual.

When one reads the reviews, one is almost happy that he didn't exhibit another painting from that year "Tête a Tête" a painting of the same Jensen-Hjell sitting at a table drinking whisky – strangely enough with Munch's sister, who undoubtedly never got near such a table in her life.

In the year 1886 he made his breakthrough, with three paintings that are considered principal works: "The Sick Child", "Puberty" and "The Morning After". The last of these was lost in a warehouse fire and it's evidence of Munch's lack of money that he can write home: *That was a lucky thing. It's done now, and I'm glad – it's nice to have some money.* He doesn't hide the fact that he is pleased with the insurance assesment (all of 750 Norwegian crowns for five paintings) and asks who the appraisers are.

Besides, he knew the paintings could be replaced: with his keen visual memory he was able to paint the lost "Morning After" again.

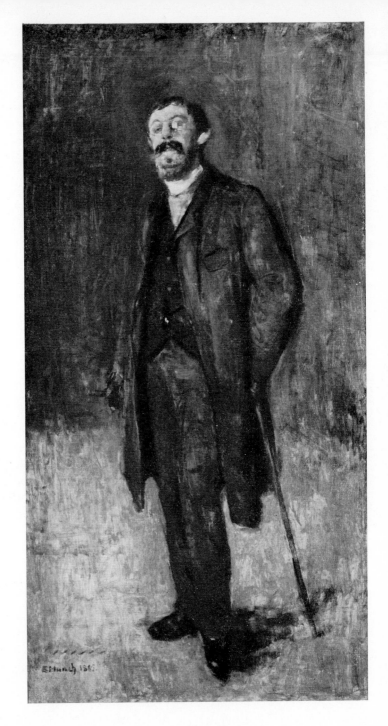

The Painter,
Jensen-Hjell,
oil 1885 PC
Oslo.

There are few paintings Munch has worked with as much as "The Sick Child":

I painted it many times during the course of a year – scraped it off – let it dissolve in turpentine – and tried again and again to get that first impression – the transparent pale skin against the canvas – the trembling mouth – the shaking hands. I had defined the chair and the glass too much, it distracted from the head. Should I take them away? No, they helped to accentuate and give depth to the head. I scraped them halfway out but let them remain in substance. I found out that my own eyelashes had also been a part my impression. I suggested them therefore as shadows over the painting. The head was in a way the painting. Slight wavy lines appeared – peripheries – with the head as the centre.

It is in other words something of the same effect that he achieved with other means in the portrait of Inger with the bright head against the black background.

The aging Munch was to recollect this painting as decisive for the whole of his artistic development:

"The Sick Child" was the turning point in my art. It is expressionistic in its concept, cubistic in its structure. You will find in the painting much of the basis for what I later developed in my art.

Leif Oestby has analyzed "The Sick Child" and shown how the square of the canvas is repeated in the pillow and the rough square that the figures make together with the fold of the blanket; how the diagonals cross at the point where the hands meet. Here the details are reduced to a minimum and perspective plays a minor role – it is the figures themselves that create space, and this they do! With contrasting colours and shifting planes space is moulded and in this way the 23-year-old artist anticipates the cubists. It's no coincidence that he himself uses the word "cubistic" when he recollects this work of his youth long after the golden age of the cubists is over.

After this effort, the task was solved for him once and for all, and he keeps to that same solution in all of the five painted replicas, as well as when he repeats the motif in an etching. It might surprise us to see that he called this demanding painting a "Study" in the cata-

56

Opposite: The Sick Child, oil 1885–86 NG
p. 57: Puberty, oil 1894 NG The first edition from 1886 is lost.

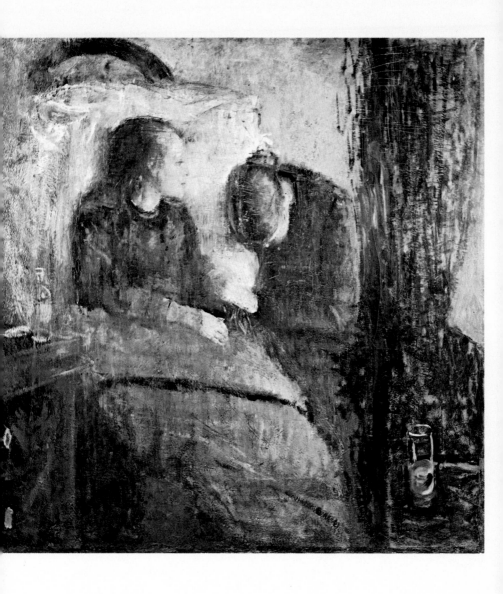

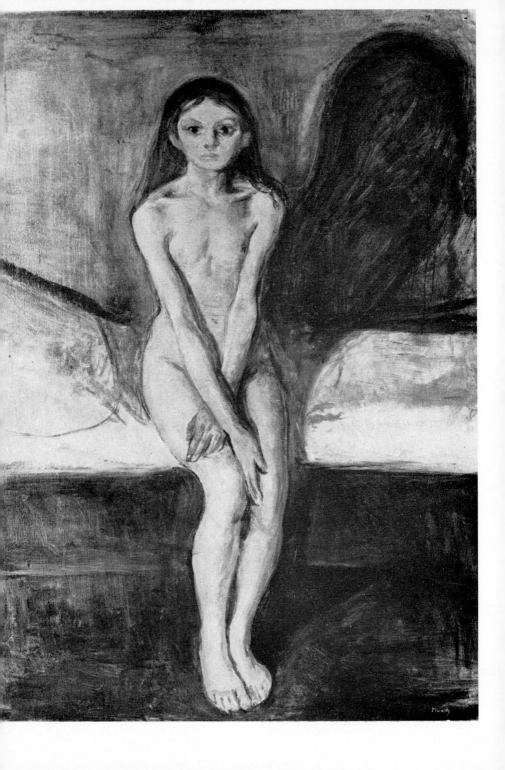

Men of Letters (Barristers) oil 1887 PC Oslo.

logue, but that was probably to anticipate the critics for he knew they would call everything he did unfinished and sketchy.

The public and the critics laughed in disbelief to see this "poorly prepared painting", "The Sick Child" hung in a very prominent place at the exhibition.

"When you stand far enough away, you can as though through a fog get a glimpse of what the painting represents ... but the closer you come to it, the more it seems to fade away and in the end you have nothing more than a completely disconnected collection of coloured spots ... madness! You hardly ever pass by that painting without seeing someone standing there laughing at it." But the height of nonsense is reached when we read that this spiritual presentation of a little reddish-blonde girl's encounter with death is "... completely lacking any emotional content."

That was a young girl's farewell to life, and that same year, Edvard Munch was to paint another young girl's anxious meeting with the life she vaguely suspects is awaiting her. In "Puberty" he doesn't paint her

expectations but the anxiety itself in the slim young form of the girl who draws her thighs together and covers herself with her thin arms. The surroundings are simplified, just the bed linen with spots of blood and a rough suggestion of the bed she sits on. All interest is directed towards the girl as she sits looking directly at us with wide-open frightened eyes. As he so often does, Munch has chosen here the front view to characterize a person, to express a mood.

The light comes from the left and throws an ominous shadow over the white bed and the wall, a shadow that perhaps seems even more threatening when the same subject is presented later on as an etching and as a lithograph.

It is strange that "Puberty" could be painted by a young man. Above all, the painting tells us of Munch's sympathetic understanding – how he is able to think, to feel himself into the position of someone else. We have seen earlier how he, in writing, identifies himself with his

Detail: The Morning After (p. 11).

dying sister (pp. 33,34.) This rare ability is seen especially in his many interpretations of women – and of men's relationship to them.

Edvard Munch's painting techniques, changing according to what he wants to express, are only means to reach the highest and truest representation of his own mood, his own feelings. The same year these two paintings are finished, he paints "The Morning After" in its first, later lost, version; but an old photo shows that the second version differs from the original. Masterfully drawn and painted is this young girl who, completely relaxed in heavy sleep, sleeps off last night's binge. But here the youthful master-painter needs the details to tell us what has happened: the bottles and glasses on the table in the foreground, the rumpled bedclothes are not just suggested, as in "Puberty." While the skirt and the legs are only sketchily painted, he works in a different, more careful way with the upper part of the body and the face so heavy with sleep, but all the same so expressive.

That "Hulda" that Hans Jaeger had on the wall of his cell, and argued with the prison chaplain about, was clearly another variation on this motif. In *The Impressionist* Jaeger writes that she is "... life-size, naked to the hips, lying backwards in a bed with both hands under her head, her elbows out to the sides ... and her dark hair down over one shoulder." Munch himself tells us that it was the first version of "A Loving Woman", the one that later came to be called "The Madonna", that Jaeger had on his wall.

In these paintings, especially in "The Sick Child", we can see how Munch had lost his dependence on the naturalists. Even the young people have trouble understanding him and a comment from one of the "everyday realists", Gustav Wentzel, who in these years was on his way to full recognition, illuminates the situation. He and Munch met each other on the stairs and Wentzel broke out with: "Phooey, I didn't think you would begin to paint in that way! That kind of mush!"

"No, no," answered Munch, "but we can't all be nail and twig painters."

And in the bohemian set itself, the shy and reserved young Munch felt himself to be – and was – isolated. One of the many writers among the bohemians, Herman Colditz, who followed the rules eith ruthless honesty to write of his own life, is for this very reason an

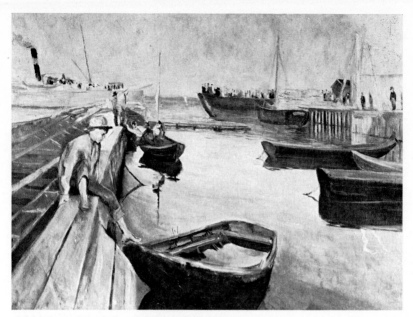

Arrival of the Mail Boat, oil 1890 PC Oslo.

accurate source. In *"The Church, a Studio Milieu,"* (1888) he gives his image of Edvard Munch (the character Nansen) whom he calls an "irritating fool" who "goes around all day bothering people with his eternal talk about paintings." Colditz repeats a little monologue by "Nansen" about detailed "nail and twig" paintings in a surprisingly free oral form:

"What's it to me that he sits there struggling with those revolting paintings of his; I take days for what he takes months to do – and yet what I do is a thousand times better. He doesn't use his head, and by God, there's got to be a difference between painting and mending boots; that's the way it is. He says I don't work; I work so hard it makes me sick; I can't sleep at nights, when I'm doing something that absorbs me – it makes me sick – nervous – I suffer. It may well be that he can paint a bed with a night pot under it better than I can – but put a fine suffering female up in the bed, one with hands, blue-white skin with yellow in the blue of the shadows – and those hands!

Yes, it would be enough just to paint a pair of hands like that – so tired, the hands lying on the blanket – fingering and folding the sheet – and imagine the light, if you will, breaking through with flecks of sunshine on the floor! Oh, that can be wonderfully beautiful – simple and peaceful."

Munch continues to paint his friends, "The Intellectuals", but sun-filled summers lead him to paint the "Meadow in Bloom" now in the National Gallery, and his sister Laura on a peaceful evening in "The Evening Hour." Here the composition is new, with the sister placed far forward in the left corner of the picture and her figure cut off, the way one had learned abroad to do it inspired by Japanese coloured woodcuts. "The Yellow Hat" as this painting has also been called, dominates the moody painting in blue, yellow, and violet. Such happy summer pictures are also the more descriptive "Arrival of the Mail Boat" and "The Seine Maker" on the wharf. In spite of the strong

Evening Hour in Vrengen, oil 1888 PC USA.

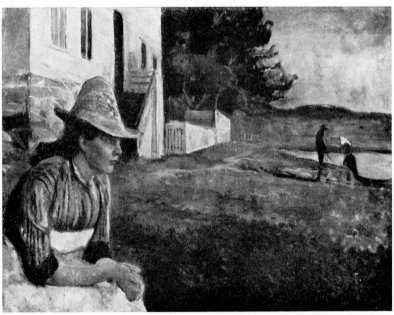

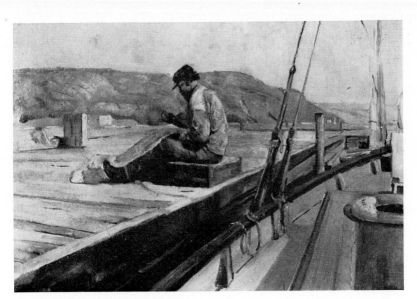

The Seine Maker, oil 1888 PC Oslo.

mood of peace and harmony, we suspect that Krogh and everything he stands for lies behind this painting with all the details of the boat. but Krohg himself was quite clear about the fact that Munch was withdrawing from all that Krohg represented when he writes: "Munch's art has in reality always been the same, most acute in its hatred of realism."

The short trip to Paris in 1885 had opened his eyes to the great art of the past, but he didn't really gain more than he could have had he stayed home. The previous year Gauguin had exhibited three paintings in the State Autumn Exhibition and among his friends there were several who had been in Paris and had much to tell.

But in the years around 1890 he finds himself in the Mecca of modern art, Paris, and he experiences the southern sun and the blue Mediterranean in Nice – "a rather large city on the Mediterranean that is popular among painters because of its natural beauty," as he replies ironically to Bjoernson who resented the state grant, given to this bohemian.

A Decisive Year, 1889

It may happen that the pattern of a man's life develops in such a way that the threads run together at a point of decision, and then continue in new directions.

For Edvard Munch, 1889 was such a point, a year of taking stock, a farewell to the old and the beginning of something new. Not only artistically, but also in his biography this year meant a break with the past and the beginning of a new period, a release from his family through the death of his father – at the same time that he gained the perspective and the will to seriously take up the most difficult motifs from his childhood. The road ahead was clear to him in a "Night in St. Cloud," but to begin with he was conquered and captured by the new French milieu.

A number of our best and most responsible artists recommended the 26-year-old, controversial Munch's application for a State grant. He himself made a great effort to show where he stood and what he stood for and in April he opened the first one man exhibition any Norwegian artist had ever held with all of 110 paintings – a review of everything he had created.

Here could be found most of the works we have already discussed, in addition to new works. Two of these are particularly important as the bravura numbers they represent in realistic painting:

One of them is the portrait of Hans Jaeger, the admired friend and spiritual guide. He sits there in the corner of the sofa, the leader of the bohemians, with his highball glass in front of him, shivering a bit, tired and disillusioned with a crooked smile, "déclassé" and isolated. But he seems strangely natural, relaxed, almost sure of himself in the midst of all his resignation. He's a loser, all right, but he knows what he stands for. The drawing is masterly, the characterization brilliant, a picture of the pessimism of that time.

With this painting Munch in a way takes his farewell with Jaeger and his circle. Later that year in Paris – he writes: *And then*

64

Opposite: The Author, Hans Jaeger, oil 1889 NG.

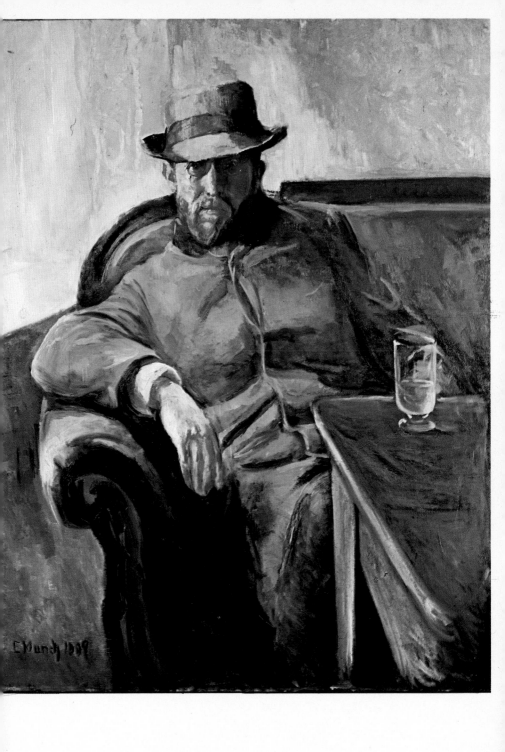

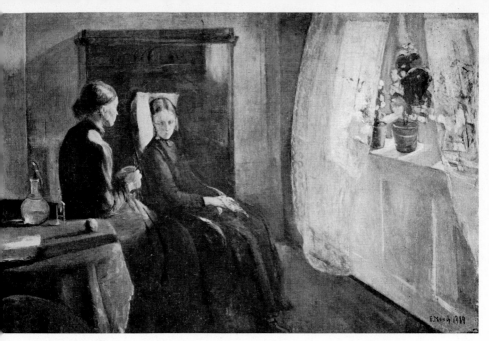

Spring, oil 1889 NG.

*there was Jaeger – perhaps my greatest sorrow. I almost felt hatred
towards Jaeger. – It was my conviction that he was right – but all
the same* ... In this "all the same" lies Munch's own breaking away
from the materialism of the eighteen-eighties, his meeting with the new
intellectual trends in literature and art, symbolism and mysticism –
the "fin de siècle".

Concerning the other painting, Edvard Munch himself says: *In
"Spring" – the sick girl and her mother by the open window with the
sun pouring in – I said goodbye to impressionism and realism.* Those
are true words, with the limitation that they refer to that impression-
ism he knew then, and above all with regard to content and mean-
ing. In the next years he was to paint a number of paintings in the
neo-impressionist style, where he learned from painters like Seurat
and Pissarro. Krohg characterized Munch as an impressionist – our
only one! It is no coincidence that later on the critics, thinking of his
French prototype, gave Munch the malicious nick-name: "Bizarro".

With regard to "Spring" one is tempted to think of "The Sick Child"
painted four years earlier. That painting was in every way a radical

painting, where everything was concentrated on the head against the pillow – where the contours were scraped away and objects reduced to insignificance. But in "Spring" we can't resist delighting in the details of the still life on the table, the varied light effects of the interior, even the curtains and the potted plants. But all the same, interest is concentrated on the two figures that completely fill a quarter of the painting, modelled so clearly and vividly.

Confronted with this masterpiece that was once used as a screen between two beds in a bed-sitting room, and is now hanging in our National Gallery, one gets the feeling that it truly is a grandiose fare-well to realism. The fight for the grant also lay behind this masterpiece – was he trying to show the "high and mighty gentlemen" that he could do something different from that "unfinished sketch" of "The Sick Child"? Was this an academic demonstration piece, as has been claimed?

"Inger on the Beach", or "Evening" as another painting orginally was called, was, however, no academic demonstration piece. "Pure non-sense" said the newspaper *Morgenbladet* about this masterpiece, which was actually something new in Norwegian art. The critics called it "making sport of the public" and another newspaper talked about "the scattered stones that seem to be made of some soft shapeless material." But we experience in another way this listening young woman in white, with the yellow hat, sitting on a boulder on the beach – the warm tones of the stones against the sea, the simplification of form and colour, the one coloured shape contrasted against the other, and the rhythm that ties everything together so naturally. All this is peculiar to Munch. This he himself saw, painted as the picture was before his stay in Paris, and before he was to listen to the new language of the symbo-lists, perhaps to experience the simplified forms of a Gauguin.

Paul Gauguin's son, Pola, says about "Spring" that there must be a change of course after the completion of such a masterpiece; it was impossible for Munch to go further along that line. Realism was a detour for him. We can only add that in "Inger on the Beach" he went straight to the heart of the matter – from the sensitive delicate awareness of his own impression directly to the canvas.

In spite of all the usual words of abuse, the critics are a bit more

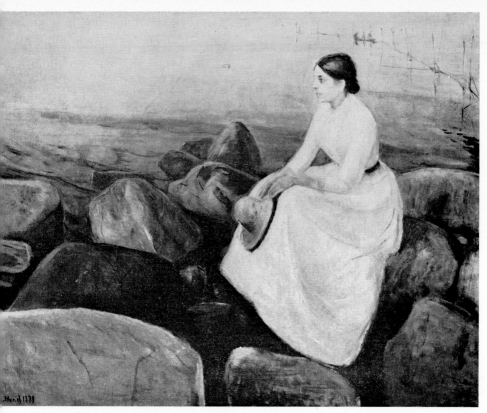

Inger on the Beach, oil 1889 RMS Bergen.

positive than earlier, particularly with regard to "Spring" and the portrait of Jaeger. Munch is now beginning to acquire his little circle of admirers and people who believe in him. The most responsible of the critics, Andreas Aubert, writes "on request" a strange belated report, full of reservations; though at the same time he finds traits of genius in Munch's talent and admires its delicacy, extent, and strength. However when Munch called this last work "unfinished" Aubert couldn't understand why he hadn't " . . . done the same with the greater part of the rest of his paintings." All the same, he concludes by recommending that the grant be awarded to Munch; but on the explicit condition that he look for an outstanding teacher in life drawing and in addition send in extensive samples of his work after the first year was up. He received the grant in July and surprisingly enough, complied with both of these conditions.

That summer he rented for the first time the house in Aasgaardstrand, the place that was to become his regular "summer refuge" for a score of years. It was to make an imprint on his conception of the landscape – let him experience the mysticism of the blonde nordic summer night and show him that soft curving shoreline that according to his own words was to wind itself through the "Life Frieze" and bind it together.

I was to be a tumultuous summer in the idyllic, sleepy, little fishing hamlet, that barely awakened during the short, hectic summer months. Its time of greatness, when wealthy shipowners and the captains of sailing ships lived there was long gone. His friends from the milieu of the capital had also found their way to Aasgaardstrand, the writers and painters. In spite of all the partying, (more or less jovial,) the minor and major intrigues, and the erotic conflicts, he creates a masterpiece this summer: "An Evening Chat" now hanging in the Art Museum in Copenhagen. It shows his shivering sister, Inger, and the critic, Sig-

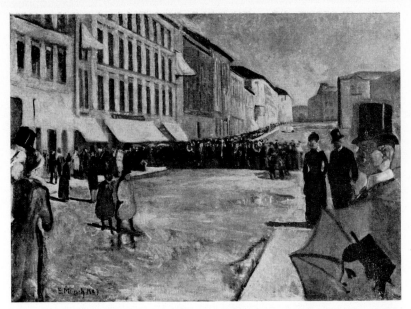

Opposite: An Evening Chat, oil 1889 Statens Museum for Kunst, Copenhagen.
This page: The Military Band, oil 1889 "Kunsthaus", Zürich.

urd Boedtker, talking together in front of the garden stairs, with a
view of the fjord where the sky and the sea fuse together – a vigorous
impasto summer painting, bold in colour and impressionistic in style.

We see the impressionist again in "The Military Band" also painted
before he left for Paris. Here we find something new in the composi-
tion itself, a tightening of the style. The street shimmers in the sun
and the band seems like a solid body irresistibly marching forward
down the almost empty road while figures boldly cut frame the scene
in the foreground on both sides. That he had the feelings of an impres-
sionist is evident in his own words: *I painted the picture and let the
colours vibrate to the rhythm of the music. Painted the lines and co-
lours etched on my inner eye – on the retina.*

In the beginning of October we find Edvard Munch together with
two artist friends in a little hotel in Paris. A mature and independent
artist meets the contemporary scene.

He follows the advice given him and enrols in the very strict

69

art school of the patriarchal academician, Léon Bonnat, who previously had had a number of our best Norwegian painters as pupils. It is evident that he determines to be dilligent and to get the most out of his stay, because he ... *is at Bonnat's in the morning, from 8:00 to 12:00 ... then we drop in on the centennial exhibition or some other place.* Hanging on the wall by the stairway can be seen one of the gods of the times in a large canvas by Puvis de Chavannes (Doux Pays), but inside in the flat the master instructed them on the great art of former times, by analysing the old masters hanging there.

Bonnat likes my drawings very much Munch wrote to his family; but when he started painting, the good relationship between teacher and pupil, between the academician and the rebel, was destroyed. Munch wanted to paint what he – and only he – saw! The reason for the break between them was supposed to have been a disagreement as to whether the white wall behind the model had a greenish or a reddish tone!

Whatever may have happened, he moved at the beginning of the

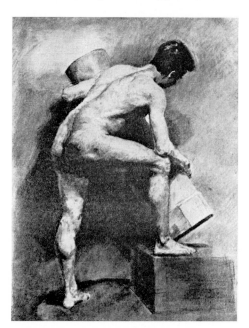

Nude from Bonnat's Academy 1889 PC Oslo.

Opposite: The Poet, Emanuel Goldstein, lith. 1908–09 OKK 272.

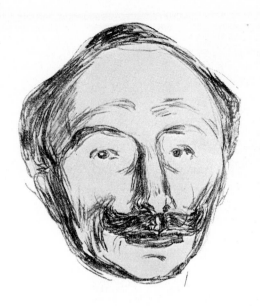

new year to St. Cloud where he became a close friend of the Danish poet, Emanuel Goldstein.

His father's death in November made a powerful impression on the lonely young man in the big city. His notes were plentiful that autumn and winter, and we realize how Munch, at the same time as he re-lives his difficult childhood and adolescence, also gets a better perspective on it and begins in earnest to see "motifs" in his own personal experiences, and their deeper meanings. We have mentioned earlier how he at this time turns away from Jaeger and the materialism of the Bohemians. After the religious pressure from his home is lessened – and under the impression of the new intellectual trends in Paris – there gradually arises a mystical and pantheistic feeling for life – a new attitude both to life and to art.

On a night out in St. Cloud he writes these famous lines, a true artistic manifest in protest against naturalism and all its ways, that he later re-worked with an eye to publication: *No longer shall interiors be painted with men reading and women knitting.*

I shall paint living people who breathe and feel and suffer and love . . . I shall paint a number of such paintings. People shall under-

71

Night in St. Cloud,
oil 1890 NG.

*stand the sacredness of them, and they shall take off their hats as if
in church.*

There is a new religious tone in this notebook entry; we suspect that
Munch is on the way towards what was then called "Stimmungs-
malerei". But overwhelmed by the new milieu, and with an uncontrall-
able desire to learn to master the techniques of painting, it was to take
time before he fulfilled this proud plan. But all the same in peace and
quiet out in St. Claud he painted one painting that prophesied what
was to come: "Night."

With blue as the principle colour, with other veiled tones blending
into the symphony, almost related to the paintings of the American,
Whistler, Munch gives us a true mood painting, a romantic, almost
symbolic, presentation of quiet reflection. The closed window shuts out
the world, but the blue double cross makes one think of death. Is it the
mood caused by the death of his father that is re-created?

Munch had experienced the French neo-impressionists during these
autumn months, and tries to get the same effect of depth as they did

by accentuating the lines going into the painting, but without creating a true perspective.

I didn't enjoy Paris, he writes home from St. Cloud, and . . . *in the twilight it's especially pleasant [here], with the light of the fireplace, and passing by my window the steamboats with their red and green lanterns.* In a letter never posted, written to a Norwegian woman, he writes about the moonlit evenings: *How many evenings sitting alone by the window did I grieve over the fact that you weren't here with me, so that we could admire together the scene outside in the moonlight . . . and all the steamboats with green, red, and yellow lanterns. And that strange half-light in the room – with the bluish square cast by the moon on the floor.*

We see how the painting to come had already began to evolve within his mind. When he places his friend Goldstein in the corner of the sofa, it is in reality himself and his own mood he paints – and how infinitely richer than words is his painting.

His friends at home admired this, in every sense "new" painting, and the popular poets of the time praised it in their poems. In addition a remarkable thing happened – for the first time Munch managed to sell a painting to someone outside his own circle of friends.

"Night in St. Cloud" stands alone among his works around 1890; but it points towards the "Life Frieze" and what he was to create in Berlin – after 1892.

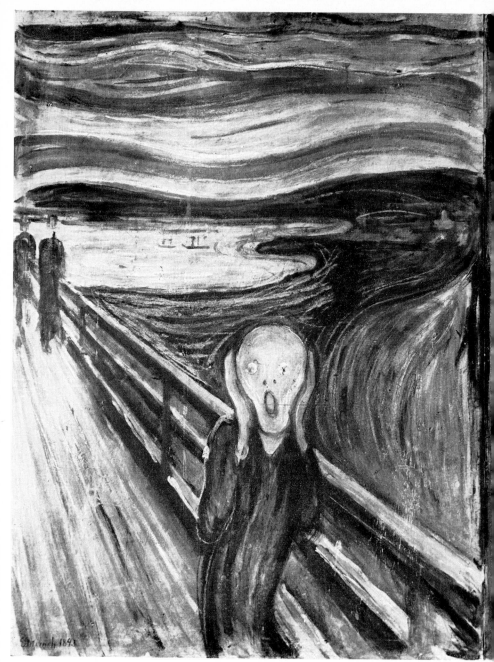

The Shriek, oil 1893 NG.

Confrontation with a New Era

Eighteen-eighty-nine was the year of the big exhibitions in Paris, the celebration of the centenary of the French revolution. It was the artists, especially, that came to the centennial exhibition where engineer Eiffel's tower was itself a symbol of what modern technique could do. "The Centennial Exhibition" presented what had been created in pictorial art since the revolution, while the "Exhibition of the Decade" presented contemporary art – and new developments. At the latter exhibition one could find the Norwegians of the Paris school, and in a favourable report on the Scandinavians it was said that "the Norwegian school will soon be of consequence in Europe." But among the names mentioned, we fail to find the one Norwegian who really was to become "of consequence": Edvard Munch, who, probably because the owner lived in Paris, exhibited his five-year-old painting "Morning" (page 51).

It was a time of upheaval and regeneration. Above all it was a literary time, for it was especially in literature, and in the many short-lived periodicals, that the new signal flags were flown. A time of struggle is always a time of new periodicals.

Everything that was beginning to break forth in earnest during the last part of the eighteen-eighties lies in embryo in the works of Charles Baudelaire, both in his philosophy of art and in the remarkable collection of poems that was published (and partially suppressed) a generation earlier: *Les Fleurs du Mal* – the flowers of evil. Here the romantic reader of the times could read of things morbid and macabre, a sensual work full of images and a deep musical quality. And in a time of steadily more influential naturalism you could read in the works of the esthetic Baudelaire that a work of art is born in creative imagination, in a world of fantasy that achieves a higher unity not to be found in the shifting and varied world of reality. In the creative moment, inspired, the artist builds a bridge between mankind's disor-

75

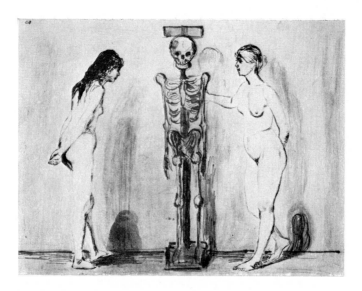

ganized and coincidental reality and the world of beauty that lies beyond what our senses can grasp.

If carried further, this line of thought develops into a tribute to the all-powerful subjective painter who takes the right to interpret the world the way it seems to him in the moment of creation. It concerns too, the most everyday things. On painting a chair, for example, Munch notes at this time:

A chair can be just as interesting as a person perhaps, but the chair must be seen by a man. It must in some way or other have moved him, and he must cause the viewer to be moved in the same way ... It is not the chair that he is to paint, but the emotion it has aroused in him.

Poets like Mallarmé, whose portrait Munch was to paint during a later stay in Paris, Verlaine, and the Belgian, Maeterlinck, became the literary leaders of the symbolists. Their – and Baudelaire's – thoughts permeated the entire milieu, and were carried further in all the periodicals, becoming decisive for painters too. These thoughts lay behind the rebellion of the "decadents" against naturalism. They called themselves decadent and grouped themselves around their two periodicals, *La Décadence* and *Le Décadent.* They cultivated what was rare

76

and sophisticated, the obscure, sick, and half-subconscious mentality. And in the middle of the nineties – in 1896 – thirty-year-old Sigmund Freud publishes his thesis on neuroses, on those neuroses that loom over the times like a nightmare. With his starting point in that thesis, Freud arrives at the conclusion that we are all of us "symbolists" in our dreams and that we through symbols cover up or interpret what is happening to us mentally.

Three years before Munch came to Paris, the Greek, Jean Moréas, wrote symbolism's literary manifest and was a collaborator in the publication of the periodical *Le Symboliste*. As a poet he attempted for a short time, like the others, to present in free verse subjective sensual experiences, bold creations, new, both in language and rhythm.

Their language was a language for painters. Two years before Munch came to Paris, in 1889, Gauguin and his painter friends returned to Paris from Pont-Aven in Brittany. This group called themselves "Nabis," a word from the old testament meaning prophet, and they broke with naturalism and impressionism, both the new and the old. They looked

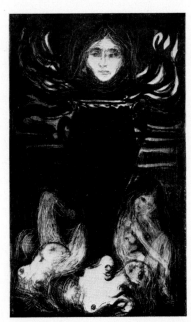

Opposite: The Girls and the Skeleton, etch. 1896 OKK 33.

This page: The Urn, lith. 1896 OKK 205.

Study for an illustration for Baudelaire's Les Fleurs du Mal, 1896 OKK 402.

LE MORT JOYEUX

for a synthesis of line and form and cultivated planes and more decorative effects. When the "Nabis" formed their own group, the symbolist milieu in Paris already existed with painters like Puvis de Chavannes, Gustave Moreau, Odilon Redon, and the Belgian, Félicien Rops. As theoretician and teacher, Moreau was to become the most important of them with his command that the artist should express his own soul in his work. As a painter he searched for exotic and mystical motifs preferably from classical mythology or the Bible. The sparkling enamel-like colours and all the literary characteristics made him different from what had gone before.

The steps from these trends and thoughts to religious mysticism was not great: the Catholic Rosecrucian order went in only for literature to begin with, but soon opened their own salon. "The artist and the author are midwives of ideas" – their programme claimed, "they give,

Rue de Rivoli,
oil 1891 Fogg
Museum, Cam-
bridge, USA.

with a single blow, life to the unconscious ... their art is a work of love in that deep discrepancy that lies between dream and reality."

Ingrid Langaard, who more than any other has studied this period of Munch's life, says that common to them all was the belief in an interdependence between the deepest feelings of the individual and the universe itself. Some of them ended up in mysticism, longing for far away countries and long ago times, a desire for the absolute and a religious compulsion that often led in the direction of occult belief and science. Others turned to nature and interpreted it in deeply personal ways.

Even though we find the major motifs of the times repeated in Edvard Munch's art of the eighteen-nineties, he is the least literary of them all. In contrast to the others, we seldom find pure literary motifs and description in his work, but to an extent that hardly any one

else achieved, he united the symbolic with a simplicity of style. And even if the motifs of the times were decisive for his art, it was his personal experiences from a difficult and turbulent life that he gives us in a form both simplified and universal – and therefore easily accessible to all of us.

During several long stays in France, Munch learned to know this milieu and these trends. When he came back to Paris as a famous, indeed an infamous "modernist" after the scandal of 1892 and the productive Berlin years, he drew very close to the French intellectual set.

Edvard Munch is no theoretican in the French meaning of the word, and, lacking in schooling as he was, his theoretical knowledge was probably rather haphazard. He thinks and writes above all as a painter and of what he dreams of creating. While he "schools himself" and paints impressionistic pictures, he spends his second winter in Nice, and in his violet notebook he makes two important entries. They are deeply personal confessions, while at the same time they form an artist's credo. They present a view of colour that is quite different from that of the analysing impressionists, and an attitude towards reality that lies miles away from any sort of realism.

It could be amusing to preach a little for all these people who now for so many years have seen our paintings and either laughed or doubtfully shaken their heads. They don't understand that there can be the least wisdom in these momentary impressions – that a tree can be red or blue – that a face can be blue or green – they know that's wrong –. From their earliest childhood they have known that leaves and grass are green and that skin colour is pink – they can't understand that anything else can be sincere – it must be humbug, and done in carelessness or madness, most probably the latter...

They cannot get it into their heads that these pictures are done in earnest, in suffering – that they are the product of sleepness nights – that they have cost blood and nerves.

And they keep on saying that these painters are getting worse and worse.

They think things are going more and more strongly in what is to them the direction of madness.

80

At the Wine Shop, oil 1890 PC Oslo.

Yes, – because – that is the way towards the painting of the future, towards the promised land in art.

For in these paintings, the artist gives the most priceless thing he has – he gives his soul – he gives his sorrow – he gives his joy – his life's blood.

He gives the man, not the object.

These paintings shall – they must – move people – first a few then more – and in the end everyone.

As when many violins are in a room and you play a note to which they are tuned – they will all begin to vibrate.

And in the other –:

The case is that men at different times see with different eyes. Men see things differently in the morning than in the evening.

The way in which one sees depends on one's mood.

It is this that causes a motif to be seen in many ways, and it is this that makes art interesting.

If you come from a dark bedroom in the morning in to the sitting room, you will see everything in bluish light. Even the deepest shadows have a light air over them.

After a while you will get accustomed to the light and the shadows will become deeper and you see everything clearer.

If you now try to paint a mood like the one you just felt, this
clear, blue morning atmosphere, you simply can't sit down and stare at everything and paint it "exactly as you see it", you have to paint it "as it should be", as it looked when the motif was most vivid to you.

And then, if it's not possible for you to paint from memory, if you have to use models, then you can't do it right.

Detail painters may call that kind of painting dishonest – to paint honestly is for them – with photographic accuracy to paint exactly that chair, or exactly that table, the way they see it at the moment. They call the attempt to reproduce a mood: "painting dishonestly".

He uses a drinking bout as an example and claims that if you see things incorrectly, you have to paint them that way too.

If you see double, for example, you have to paint two noses. And if you see the glass crooked, you have to make it crooked.

Or if you're trying to get at something you have felt in an erotic moment when you're hot all over from the act of love – you have at that moment found a motif, then you cannot present it exactly as you would see it some other time when you are cold. It's clear that the first picture you saw, hot, is quite different than when you have cooled off.

And it is exactly this and this alone that gives art deeper meaning. It is man, life, that you're trying to get a hold of, to reproduce. Not lifeless nature.

In notes like these Munch takes the practical artistic consequences of what lies behind the theories of the symbolists and the other groups. He wants to realize them in all-powerful subjectivity, to pass on what he and he alone experiences from the motif in the very moment he grips it – or is gripped by it.

But out there where he lives, he is *only together with French wor-*

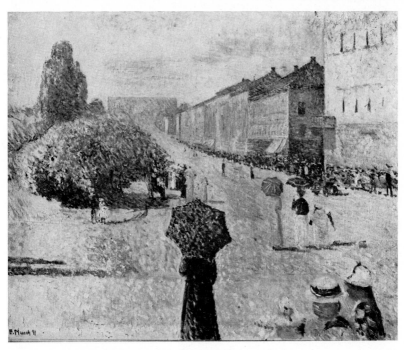

Spring Day on Karl Johan, oil 1891 Bergen Billedgalleri.

king men and other citizens in Saint Cloud, whom he paints whether
he meets them "In the Inn" or "At the Wine Shop" – realistic pain-
tings that show his ability to quickly characterize both people and
milieu.

In these years, when he divides his time between Paris, Nice, and
Aasgaardstrand at home in Norway, he follows the tendencies he meets.
He learns particularly from the post-impressionists. An American re-
searcher (Deknatel) sees "his impressionist paintings as a group ... like
a calm and untroubled island among his other works." It is true that
they lay apart from that programme he outlined for his art that night
out in St. Cloud (page 72), all these impressionist paintings. But in a
group of paintings that begins to take shape at this time, he starts
with a new cycle of motifs, new in form and in colour treatment. At
the same time he plays the role of a sort of esthete with "an art for

art's sake" viewpoint: at the yearly exhibition at home in Oslo he even has a portrait of his sister, Inger, titled "Harmony in Blue and Violet." It reminds us more of his admired contemporary, Whistler, than of the Munch we know from the eighteen-nineties, that painter and creator who felt he had a message for mankind.

These are busy painting years, in spite of illness and financial difficulties – the black art of prints had not yet captured him. In Paris he painted street scenes – and wrote home: *I live in a nice room with a balcony* and from just this balcony he paints "Rue Lafayette." The powerful glaring light dissolves all the shapes, horses, carts, people, in fireworks of colours, but consciously arranged and ordered fireworks. Both in this painting and in the more summarily painted "Rue de Rivoli" everything is in movement, and one can almost imagine, as has been said, that one were in the motorcar age and not the age of the horse and cart. But all that shimmering and colourful restlessness in "Rue Lafayette" is strictly controlled by the long perspective line of the railing and settles down in the free and loosely painted pattern of the balcony floor (pp. 23 and 79).

Safely home again, he uses his new knowledge when he re-lives Oslo's main street, Karl Johan, where the remaining bohemians still survive – both a sun-filled "Spring Day" in a more pointilistic technique that immediately makes us think of Seurat, and a "Rainy Day" that reminds us more of the older impressionists. While he was in France, Munch began to make notes for an autobiographical, self-revealing novel: *The palace lay in a blue haze – the shadows fell long over the street – the women's dresses, light and shining, the streets teeming with people.* He was daydreaming himself home to a "Spring Day on Karl Johan" with the yellow and green tones in the trees and the deep blue shadows.

In this productive year, 1891, he takes the "winter road" to Nice again, *the city of joy, health and beauty,* that gave him strength and courage in all his frailty during these years. He re-experiences the Promenade des Anglais that *lies bathed in sun – there is a crowd of people – bright with red parasols and gay spring outfits. Here were pale promenading young ladies – Parisians with their tiny lap dogs – Parisian dandies with their bell-bottom trousers wide as sacks – and*

Promenade des Anglais, oil 1891 PC Oslo.

tuberculosis patients wrapped in shawls in spite of the heat. The sea lying blue way out – only a shade deeper than the air – so wonderfully blue with the air as though painted in naphtha ...

Among the many paintings from this time is "Night in Nice", the first Munch painting to be bought by the Norwegian National Gallery. It is painted from the roof of the villa where he lived, a night scene in a multitude of blue shades. But the moonlight brings new colours into the façades and roofs, pale rose violet and golden red in the windows. Here the technique is carefully controlled impressionistic, but the outlines are solidly drawn, almost remarkably so for a night scene and it almost reminds us of the railing in the sun-bright "Rue Lafayette."

The distance from Nice to the cassino in Monte Carlo was not far, and like all those who become seriously interested in gambling, Edvard Munch had his infallible system. Whatever one may think of infallible systems, he did at any rate win rather regularly; but strangely enough

85

he was just as poor the next day. His painter friend, Christian Skreds-
vig, who shared these years in Nice with Munch couldn't quite under-
stand how this could be – until he discovered that Munch, after
cashing in the days winnings, squandered the money in more doubtful
gambling places afterwards.

But the man who was to paint "from the Modern Psyche" was as
absorbed by the milieu and the people he found around the roulette
table as he was by the gambling. He writes:

*A large hall – over there by the table a cluster of people – bent
backs – some arms and some faces lighted by the lamp...*

*I go farther on – new room – same stillness – same cluster of
people – at the betting tables.*

*As in an enchanted castle – where the devil is throwing a party –
the gambling hell of Monaco...*

Above: Despair, drg. 1892 (?) OKK
2367.

Opposite: Night in Nice, oil 1891 NG

We meet Munch himself as an active note-taking observer – he had
to check out his system – in one of these paintings where the people
around the table are characterized by their unbridled lust for money.
In another we see above all the loser in the foreground, as he leaves
the table resigned and ruined while the game continues undisturbed
behind him.

At this time Edvard Munch was working further on that simplifi-
cation and at the same time intensification that was prophesied in
"Inger on the Beach" even before receiving the grant (page 67) that
brought him to France. During the summers at home he got to know
the shoreline in Aasgaardstrand so well that he could re-live it, re-create
it wherever and whenever he wished in the simplified shapes and con-
tours of memory – without losing any of the sharp conception of
details that he needed.

In Paris and Nice Munch paints the first versions of "The Kiss"
and of "Melancholy" which we shall return to later; but what is

decisive is the fact, that during these years he seriously enters upon the motif cycle that was to belong to the "Life Frieze", that frieze that treated "love and death," and built upon deep personal experiences during a difficult life of almost thirty years.

His help and refuge when the world was against him, which it often was, was the painter Christian Skredsvig. He tells how Munch for a long time had "... wanted to paint his memory of a sunset. Red as blood. No, it *was* clotted blood. But not one person would feel it the same way as he had. Everyone would think of clouds. He spoke sadly about this that had gripped him with fear, because the poor medium of communication painting provided was so futile.

He longed for the impossible and had despair as his religion, I thought, but I advised him to paint it, and he painted "The Shriek".

It must have been a shock-like experience that lay behind, an overpowering feeling of anxiety, abandonment, and endless loneliness that suddenly gripped him as he experienced this sunset up on the road with the fence, the remains of which are still there.

I walked down the road with two friends. The sun was going down the sky turned blood-red and I felt a breath of sadness. – I stood still, deadly tired – over the blue-black fjord and the town lay blood and tongues of fire. My friends went on ahead – I stayed behind – trembling with anxiety – I felt a great shriek in nature.

When he later wrote about the creation of the "Life Frieze" he said at the end: *I painted this picture – painted the clouds as real blood – the colours screamed. It was to be the painting "The Shriek" in the "Life Frieze."*

It is the time of the so-called "Lebensangst" at home in Norway as well as out in Europe, in poetry as in painting. During these years a group of paintings with the anxiety motif become a part of Munch's art. They tell especially, perhaps, how Munch, even in his most expressive paintings, never lost he experience of reality that lay behind the motif. In all the versions of "The Shriek" and "Despair" we can find the same road with the fence slanting inwards and upwards to the left in the picture, the same landscape and the fjord with the two boats. Even in "Anxiety," where people come directly towards us with their empty, death-like faces and the basic experience with the two

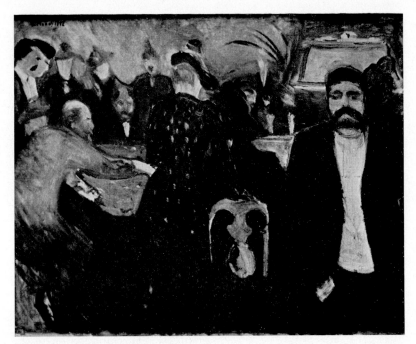

Gamblers in Monte Carlo, oil 1892 PC.

friends who go on ahead is missing, the landscape is the same. But in spite of this close connection to a real experience, that masterly simplification of both people and landscape keeps the pictures from being tied to any place or time. It gives them the value of universal symbols.

At home in Norway he, still a lonely wanderer, discovers anxiety in the dead faces of a group of good citizens, who walk in that same red evening sun in an "Evening on Karl Johan."

In an impressionistic way he analyzes in these years the world of things and people around him – at the same time as he looks within himself and re-lives his own life experiences. He begins even to concern himself with death, the way he had experienced it in his own family. He no longer experiences death as a motif, brought in from outside, because it's part of the times, and part of his personal experi-

89

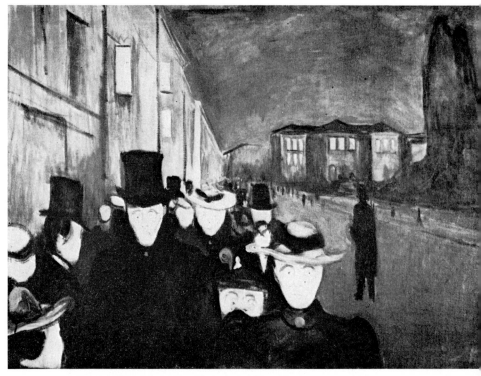

Evening on Karl Johan, oil 1893–94 RMS Bergen.

ence, as it was when he painted his "The Sick Child" and "Spring." No, now he becomes poet and prophet, but like the poet and the prophet, it is still his own deep experience he builds on when he attempts to communicate with people.

In the time that followed, he penetrated steadily deeper into the individual parts of the simple, and at the same time profound, cycle motif of the "Life Frieze," the cycle that was to absorb all his power as an artist and as a man far into the twentieth century.

Edvard Munch knew himself that he had reached the breaking off point from the past, from the France of the impressionists and from realism. The departure is definitive when he on a January day in Nice (1892) writes about . . . *that large wave that was sweeping over the*

90

world – realism. Things existed only when they could be proven, explained chemically or physically – paintings and literature were only what you saw with your eyes or heard with your ears – they were the "shell" of nature.

Men were satisfied with the great discoveries they had made – they didn't realize that the more discoveries they made, the more problems there would be to solve – men had discovered bacteria but of what then were bacteria made?

Mysteries would always exist – the more discoveries made, the more mysteries there would be ...

The new movement – we see its progress, its indications everywhere – will give expression to all which, for over a generation, has been suppressed – everything that man is always going to have a lot of – mysticism.

It will give expression to everything that is so refined that it only exists in presentiments – in suppositions – a mass of unexplained things – new-born ideas that have not yet been given shape ...

The Great Decade 1892 - 1902

Life was not easy for Munch home in Norway – the small town atmosphere, poor, dogged by bad luck, derided by the critics and the public – it was only natural that he should settle down in Berlin after all the uproar of 1892. He might be notorious and derided there too, but all the same he was becoming favourably well-known. He could live his own life in the big city and he had a circle of friends who admired his art and who stimulated his work through discussion, their involvement in the times, and the very vivacity of their spirit. The trends were different from the Christiania of the Bohemians and anarchists, but the way of life was similar and the people partly the same.

They gathered around the wine glasses in a little tavern in the old centre of town: Zum Schwarzen Ferkel, near the city's representative main street, Unter den Linden – where, during the day, you might meet the same young gentlemen at the more distinguished Café Bauer where they found Scandinavian newspapers on the second floor. It was Strindberg, by the way, who had discovered Zum Schwarzen Ferkel and – with the approval of the host – given it that name after the old blackened wineskins hanging outside the place. There was quite a non-German, at any rate non-Prussian, milieu at the "Ferkel." The drinking parties were sometimes violent, the arguments between these tempermental young men fierce, and fuel was added to the flames by the fact that there was an attractive, much-courted, woman among them. Dagny Juell was the daughter of a Norwegian county doctor, who married the most central figure in that set: the Polish-German author and medical student, Stanislaw Przybyszewski. They nicknamed her "Ducha" from the language of her husband, or "Aspasia" after the well-known girl-friend of Pericles. "Stachu", as they called the Pole with the difficult name, was a strange sort of person. From our point of view he almost seems a personification of the spirit of those times. But let us realize that we are only thinking of the spirit of a very limited

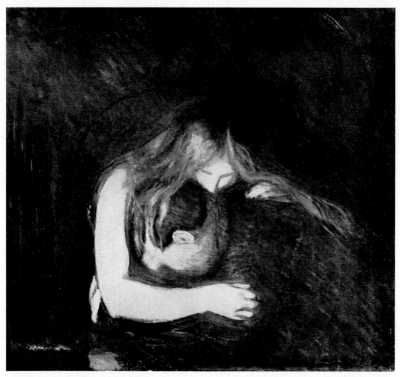

Vampire, oil 1894 PC Oslo.

set of people – those artists and writers who belonged to the *fin de siecle*, the "decadents."

It was in this year that the twenty-four year old "Stachu" published a paper: "Zur Psychologie des Individuums," where he analyzed first Chopin and Nietzsche, and added later a poet and critic quite typical of the times, the Swede, Ola Hansson. The latter was only eight years older than the youthful author, and certainly might be said to have fallen in good – even world famous – company! The choice of Chopin was no co-incidence, the many-talented Przybyszewski was an excellent interpreter of his music. This milieu comes alive for us when we read concerning the Przybyszewski home: "In Luisenstrasse, Berlin N., a red oil lamp burned until the small hours of the morning, in a

room on the ground floor where the Przybyszewski couple lived ... He, a pure Pole, who doesn't speak a word of Polish,* writing his risqueé literary pieces in German and suffering from hallucinations ... She a Norwegian, willow slim with the figure of a madonna from the four-teenth century, and a laughter that drove men insane. She was called 'Ducha' and drank absinth by the gallon without getting drunk ... Near the door was a pianonina, an extraordinary instrument. You could turn it off with a handle so that even when 'Stachu' pounded on it with his fists, it wouldn't disturb the others in the building. This pianonina, that could be turned off, was in a way the heart of this 'cave.'

Often you might find one man dancing with 'Ducha' while two others sat at a table watching; one of them was Munch and the other most often Strindberg. All four men in the house were in love with 'Ducha' – each in his own way, without showing any signs of it to the others.

'Stachu' thrived on it. Munch called 'Ducha' 'the lady', spoke to her in a matter of fact way, very polite and discreet, even when he was drunk ... The country to the west, Huysmans' and Rops' Paris provided the background material for 'Stachu's' descriptions of patholo-gical eroticism ... Strindberg talked about chemical analysis, Munch said nothing ... A few years later 'Ducha' was to go to Tiflis where she would meet the wrong man, a barbarous wealthy young Russian** who put a revolver to her forehead. When she just went on laughing, he calmly pulled the trigger and shot first her then himself. – It was in the home of the Przybyszewskis that the plans for *Pan* were hatch-ed in 1893. 'Ducha' christened the periodical, and that was probably why Munch was against the name ..."

The man who has described for us these intimate scenes from the mineties, is the art historian, Julius Meier-Graefe. Together with Przybys-zewski, and two other "companions-in-arms" he fought for the new

*This is an error, for Przybyszewski both spoke and wrote Polish, and later edited a Polish periodical. In his *My Contemporaries*, he gave a very subjective picture of the Berlin milieu – and of his friend, Edvard Munch.

**This too seems to be an error, for other sources tell us that it was a highly cultured Pole, a close friend of Przybyszewski, who accompanied her to Tiflis.

Opposite: Dagny Juell, oil 1893 OKK 212.

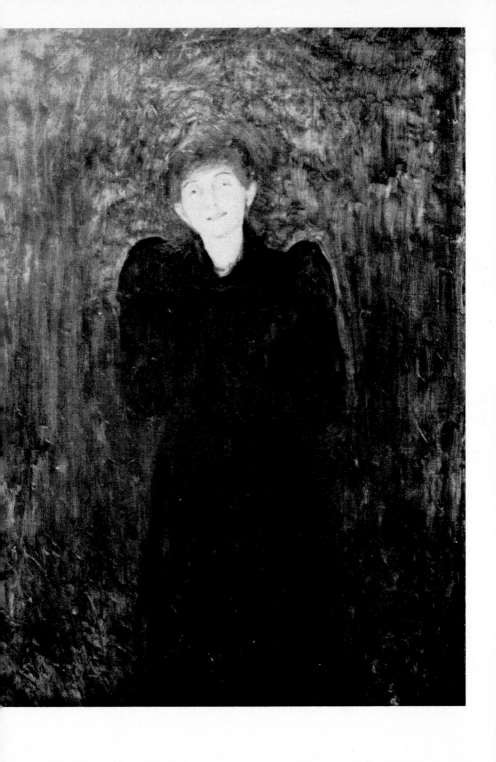

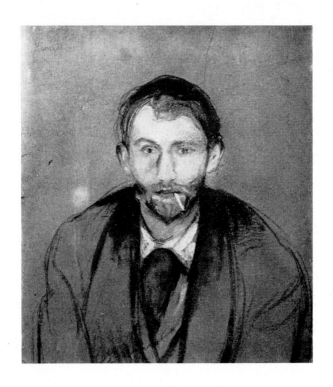

forms of art that were so despised. In 1894 he published the first book on Edvart Munch, the defensive tract: *Das Werk des Edvard Munch*.

Like Strindberg and many others of that time, Przybyszewski was a mystic and very interested in occult phenomena; he cultivated the macabre and demonic, considering himself a "satanist." One of his books, written in Norway incidentally, was called *The Children of Satan*.

In this non-German group, composed mainly of Scandinavians, intellectual Jews, revolutionists like Hermann Schlittgen (who characterized Prussian officers in "Fliegende Blätter"), could also be found the violent and temperamental Richard Dehmel. This "wild man" as Strindberg called him, was at the age of thirty, on the verge of his breakthrough as a lyricist. Out in his country villa at Pankow, near Berlin, he gave a memorable "artist's evening". Jens Thiis tells us it lasted

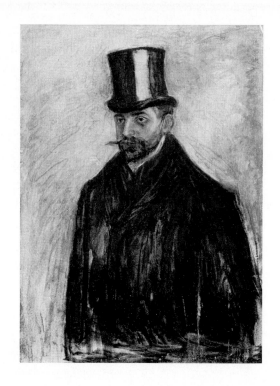

all day and night. His description gives us the whole milieu, and inclu-
des a presentation of the satanical "Stachu". Besides the Przybyszewskis
and Thiis, the guests were Munch, the Finnish painter Gallén, (who,
in spite of their differing approach to art, exhibited with Munch in
Berlin,) the Norwegian sculptor Gustav Vigeland, and the unique Nor-
wegian lyricist of the time, Sigbjoern Obstfelder.

Dehmel "recited his beautiful poems, and with his dark, rather me-
phistophelian appearance and his intense personality, he made an un-
forgettable impression. Obstfelder was forced to read a couple of his
poems with 'Ducha' as an interpreter, and her strange soft-spoken reci-
tation alone, gave the others an idea of the poet's character and the
new rythms of his poetry. Vigeland showed photographs of his works
– "Hell" and the first passionate "Love Groups" were the ones
that aroused the greatest interest. Munch talked away with his dis-

jointed but thought-provoking paradoxes. The music was provided by
Stachu, who played Schumann and Chopin with all of his violent
temperament; and Obstfelder, who often brought his violin with him,
played Grieg, Svendsen, and Bach ... The symposium moved from
Dehmel's place to Stachu and Ducha's (they lived in the neighbour-
hood.) Here the host disappeared completely, and when we searched
for him we found him not in his bed, but out on the woodpile, sitting
on top of a pile of logs, stark naked. There he sat, the madman, playing
the role of Satan, all alone. Such an impression had Vigeland's "Hell"
made upon him. Amazing that he didn't get pneumonia, as it was
10th February and bitter cold."

It was Munch who had introduced Schlittgen into the group that
gathered at the "Ferkel." Schlittgen wrote of his time spent together
with Munch during these years – how he moved from one boarding
house to another, how "Munch's paintings were all over the room, on
the sofa, on the wardrobe, on all the chairs, even on the washbasin
and the stove ... Often he started painting when he came home late ...
When you visited him in the morning you might stumble over a palette
or a newly-painted picture in the most impossible places."

Munch's studios were a pension in Berlin, in Paris, or wherever he
travelled with his exhibitions around Germany, such as to Weimar. Here
he painted his daily impressions or his remembrances. Here he worked
carefully and precisely with the engraving needle on the copper plate.
In spite of the restless life with his many friends, he was incredibly
productive during these years – at the same time developing that
philosophy of life reflected in his art. It is so personal that one can
agree with Jens Thiis who says that "his art is a display of tempera-
ment which shows a life philosophy". Edvard Munch was to such an
extent one with what he created!

As the savant Goethe had his Eckermann, the restless and agitated
Strindberg had at this time his rather irritating Finnish admirer: Adolf
Paul. He visited Munch as he was working with a model in his room,
a model "with flaming red curls that flowed over her like streams of
blood. 'Kneel before her!' he shouted to me. 'Lay your head in her
lap.' I obeyed. She bent over me, pressed her lips against the nape of

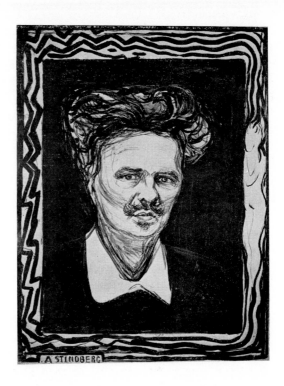

August Strindberg,
lith. 1896 OKK 219a.

my neck, her red hair flowing over me. Munch painted, and in a short time his "Vampire" was completed."

Apart from the summers spent at home, these hotel rooms were Munch's most important workrooms during these decades. In 1901, we find him, for example, in Weimar – present at a sumptuous breakfast with Harry Graf Kessler, whom he later painted in two characteristic portraits. As the gentlemen left the table, Munch suddenly remarks to his old friend from Berlin, Hermann Schlittgen: *That's the way I want to paint you, full size, happy and gay as you are now.* And Schlittgen continues: "He had a little room in the Elephant Hotel ... beside the bed was a miserable rug, which was the only decoration. The canvas arrived, six feet high. We are to start at 10:00 a.m. I arrive, but Munch is still in bed. He looks at his hands and says: *I'm still too nervous, first I have to calm down.* He orders a bottle of port

from the waiter. *Please come back in half an hour.* When I return, the bottle is empty. *Now I'm ready.* He begins to draw me. The room is so narrow he can hardly take one step backwards. After I've been sitting for him, the waiter has to carry the painting down to the back yard so he can judge the effect.

The miserable rug on which I was standing had become a magnificent oriental carpet in the painting; the shabby yellowish wall, a noble lemon colour, and my coat a pure ultra-marine ..." The result hangs today in the Munch Museum titled, "The German."

The most important – and most difficult – in the group, was, of course, August Strindberg. In 1892 he was about to embark on a new marriage building up to his later "inferno crisis" in Paris. He was a genius so much like Munch that the relationship between them would naturally be complicated and difficult, both attracted and repelled as they were by each other. Personal things such as their relationship with "Ducha" also played a role and made the whole thing even more complicated.

Much has been written about these two, and even today the Munch Museum can provide the researcher with more than fifty literary references. More will be written about Munch as a model for Strindberg and Strindberg as a model for Munch. Munch experienced Strindberg during his rich but bewildering Berlin winter in 1892–93, and during the terrible "inferno crisis" in Paris, the most unbalanced period in Strindberg's unbalanced life.

Little things can tell us a lot about the relationship between the famous and persecuted poet, fourteen years the elder, and the painter: To a friend Munch said ... *Strindberg had a way of making me trip over his walking stick so that I fell flat on my face in the street.* When it happened a second time, Munch threatened to give him a beating and – *he changed his ways.* When Strindberg modelled for him in Paris some years later, the poet came in without saying a word, laid a revolver before him on the table, and left as silently as he had come. Strindberg considered it very insulting that Munch had written his name as: *"Stindberg"* in the title of his famous lithograph. He was especially incensed about the naked woman which Munch had placed in the border around the portrait, "the woman he hated."

100

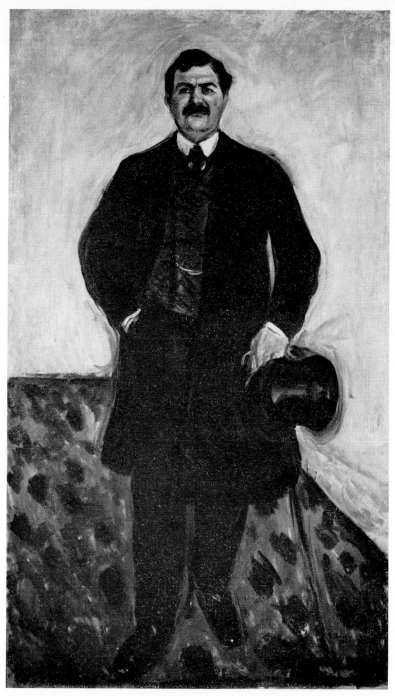

Herman Schlittgen, (The German) oil 1901 or 1904 OKK 367.

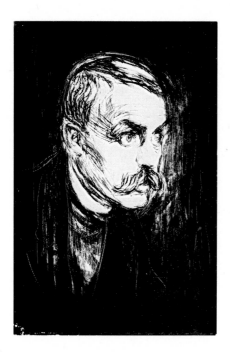

The Norwegian poet,
Sigbjoern Obstfelder,
lith. 1896 OKK 220.

Their paths separated, but they were both bound by the group to which they had belonged. An example of their co-operation is shown in the strange correspondance concerning the periodical *Quickborn* which intended to publish an edition with illustrations by Munch and a text by Strindberg. The edition came out in 1899; but showed very little connection between the contribution of the artist and that of the poet. How the "demonical Strindberg" continued to live in Munch's thoughts is shown by an episode that happened some time after the turn of the century. Munch was painting a woman's portrait on the beach at Warnemünde, when the wind blew his easel over. He packed away his equipment exclaiming: *The wind is Strindberg, refusing to let me paint!*

The whole thing ended in a distant, but respectful relationship, where at any rate they both accepted living in the same difficult world. Strindberg's portrait from Berlin that stormy autumn of 1892 was later donated by Munch, to the National Museum in Stockholm, to honour

102

his friend, and in later printings the spelling of the name was corrected and the woman's figure in the border replaced by ornamental curves. Strindberg was neither the easiest nor the most grateful of models. When Adolf Paul found the Berlin portrait both "a good likeness and quite characteristic" Strindberg answered sharply "I don't give a damn for the likeness! It should have been a stylized poet's portrait, like the portraits of Goethe."

Munch, however, understood Strindberg's greatness and how important he was for the group. In one of these notebooks entries in a style somewhere between prose and poetry, Munch characterizes his friend and gives us a picture of the group. One could say this entry seems to be Munch's own understanding of what I have tried to say above:

. . . At the end of the table in the "Schwarzen Ferkel",
surrounded by Germans, Danes, Swedes and Finns, Norwegians and
Russians,

lustily praised by the young German poets –
particularly Dehmel – who stood on the table
shouting his praises until the bottles fell over.
And the first time his plays were performed –
the lines ringing like rapier blows,
words like swords, words like daggers
– phrases seething like table wine – red-hot, white-hot,
dripping, glowing, burning around him –
you ascend to us carrying Inferno in your hands –
and legends – the strangest novels since Raskolnikow.

(It all started with "Roeda Rummet" ("The Red Room") for us Norwegians – the world which is called Strindberg.)

In addition to those already mentioned, there were many other Scandinavians in that group, poets and artists – even lieutenants. The cheerful and striking Danish poet, Holger Drachmann often came down from Copenhagen and stirred things up at the "Ferkel." During a roaring farewell party for Strindberg, who was leaving for Munich, to visit his fiancée at that time, ill-will spread itself among all these po-

tential geniuses. Drachmann tried to improve the atmosphere by poking a bit of fun at them all. About Munch, this great self-confident show-off said: "... nor am I like Munch, who came down here and made a success out of scandal – and is now so full of it that he cannot be happy because of pure self-importance."

Munch rose to his feet, returned a letter of recommendation that Drachmann had given him for an exhibition in Hamburg, and left the room.

But this little scene, late one night, didn't affect the tolerant Dane. Later he wrote a "Letter from Berlin" to a Danish newspaper, and in a few lines he gave a picture of Munch's situation as his friends saw it, in that difficult city so full of contrasts:

"For the time being the world is Berlin. And it's not always eager to open itself to all Norwegians.

We can catch sight of our friend Edvard Munch's slender figure there. He came, was thrown out, but won. The page turned, the Germans were competing for him; and that was good. Nevertheless, they didn't understand him – or rather he followed his own special ideas of art, a little too stubbornly for the Germans, who don't make great nervous leaps off the cliffs. Without doubt he's provided explosive ideas here, this anarchist among painters, and founded a school: you can see it at the exhibitons of younger painters. But his profile has become sharp, his cheeks sunken, his tall figure even more slim under the pressure of the present struggle that he now faces, with honest obstinacy and conviction, standing alone, because the younger men have partly defected from him – afraid to take the consequences he demands, with their more German carefullness, – more matter of fact, more 'clever', than creative. He did, in fact, fight hard, this lonely Norwegian! Good luck to him!"

When Drachmann wrote his "Letter from Berlin", his group of friends was larger than the group of buyers. It was after the turn of the century that the victory was his. After numerous exhibitions he won steadily increasing fame, that eventually gained him financial security. The years of small means were over, when he, in 1902, exhibited his "Life Frieze" at the Berlin Secession.

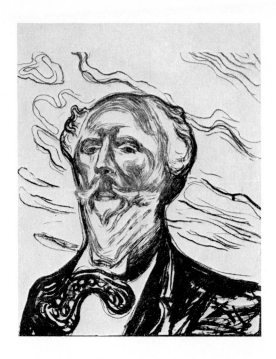

The Danish Poet,
Holger Drachmann,
lith. 1901 OKK 240.

THE LIFE FRIEZE

About the same time as Munch was writing his "manifest" in St. Cloud
(page 71), the four year older Knut Hamsun, the greatest Norwegian
author of that generation, was writing his famous article: "From the
Psychic Life of the Unconscious" which was printed in 1890. He de-
manded literature that would concern itself more with psychological
states of mind, rather than with engagements and dances and picnics
and happenings as such ... literature should be concerned with "inexpli-
cable emotions." ... "This new way of describing states of mind must
be more in accordance to the mental life of modern people." Who was
it who called his exhibition "Motifs from the Modern Psyche?"

This was Munch's most literary period, when he was looking for
ways to express his philosophy of life, especially as he worked it out
through endless conversations with Przybyszewski, the man who re-

105

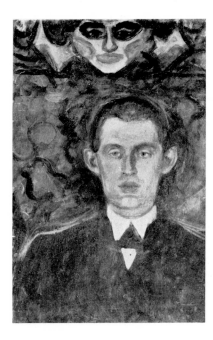

Self-Portrait underneath the Female Mask, oil 1893 OKK 229.

wrote the grandiose opening of the gospel of St. John: "In the beginning there was sex." The mutual influence they had on each other was clear to Munch, and after "Stachu" had written about his art in 1894, he says: *I am appalled that someone can affect me in my innermost creative moments – but I have affected you too.* Others, too, discovered the literary Munch, among them Krohg who once called him "the fourth of our great authors."

We have already read Munch's words about how "mysticism" had been kept down by "realism" and how he tried to take the pictorial consequences of the new theories of the times. One asks oneself if, during this time of liberation and breaking up, he formulates something that we could call a philosophy of life. Already in Nice in 1892, the cycle has a philosophical foundation. We find at any rate the beginning of a secular pantheistic belief in the *germ of life – the spirit of life* that lives on in the eternal cycle of nature. In connection with

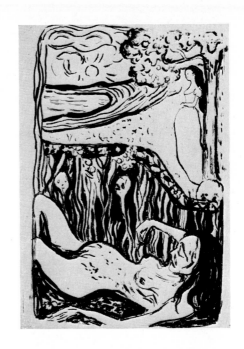

Life and Death (Metabolism)
lith. 1897 OKK 227.
The motif exists in several
versions in connection with the
large painting (p. 126).

the above quote he writes: *The germ of life – that is, if you will, the soul or the spirit –*

It is foolish to deny the existance of the soul – you cannot deny the existance of the germ of life.

You must believe in immortality – in so far as you can claim that the germ of life – the spirit of life – at any rate must exist after the death of the body.

This ability – to hold the body together – to cause elements to develop – the spirit of life, what happens to it – Nothing disappears – there is no example of that in nature – The body that dies – does not disappear. The elements separate – change –

But the spirit of life, where does that go?

Where, no one can say – to claim that it doesn't exist after the death of the body is just as foolish as to try to decide what type of existence it will have or where it will exist, this spirit.

This belief in a mystical and impershable life force, a germ of life in the eternal cycle of nature, lives within what Munch creates in these years.

Primarily we meet mankind through the numerous erotic meetings between man and woman in aspects, through conception, birth, and death. We meet nature in its life-giving decay, and the germ of life as a red flower, a plant, whether it germinates from the life blood of a man or from a dead love.

Munch wrote to his artist friend in Copenhagen, that if he hangs certain paintings together they will be better understood. Curt Glaser underlines what it meant to Munch to see his paintings all together at the big exhibitions – and in big rooms where they really came into their own. Here he discovered seriously the ideological connection between them, and in a letter to Copenhagen he says that he "is making studies for a series of paintings that shall deal with love and death."

The result of these "studies" was "Die Liebe" that was exhibited in Stockholm in 1894, and in Berlin the following year. And in 1902 the "Frieze of Life" has become a well-thought-out cycle in four movements:

Knut Hamsun, etch. 1896 OKK 40.

Opposite: The Voice, oil 1893 OKK 44.

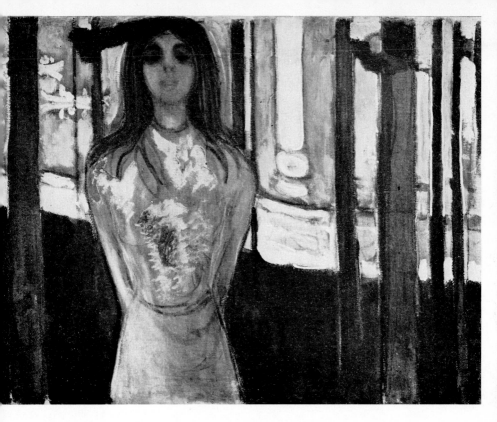

"Keimen der Liebe, Blühen und Vergehen der Liebe, Lebensangst, Tod."

In a draft of a letter as late as the 1930's Munch writes about how he wanted to have his paintings around him, now that he finally had enough room. Then he discovered the continuity of the themes: *When they are shown together they strike a chord; they become quite different than when shown by themselves. They become a symphony. That is how I began to paint friezes.*

As the lyric verse of the times searched for musicality, the painters did the same – Munch did so, both in his single "mood paintings", and in his series. He could even talk about his paintings as "musical notes." The painter-author, Krohg, more than any other Norwegian, had the ability to listen to the voice of the times, exclaimed in a review that Munch should be receiving a "composer's salary." When Munch himself listened to what he had created, he found that paint-

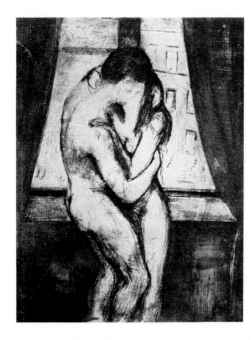

The Kiss, etch. 1895 OKK 21.

Opposite: The Kiss, wdct.
1897–98 OKK 577.

ings not originally composed as part of the "Life Frieze", found their natural place in it. As the paintings shifted positions in exhibitions some were sold – but often he painted replicas as he did with the first of the six paintings in "Die Liebe"

During these years many people were concerned with the young girl awakening to womanhood (even now people still are!) It is the time of Wedekind's unbelievably daring "Frühlings Erwachen." (1891) The motif was taken up both in literature, and in art, and Munch himself had already painted his famous painting "Puberty." In "Summer Night's Dream" we meet her again, on a pale moonlight night, one of these blonde nordic nights with its unaccountable mysteriousness, that Munch loved. A related painting from the year before is even called "Mystic Shore." Afraid of the life awaiting her, full of longing and fear at the same time, the young girl stands alone against the pine trees, while in the distance she hears the voices of young people out in the boats. Munch later agreed to the painting being called "The Voice." but we might dare to believe that she is listening to an inner voice. Uncons-

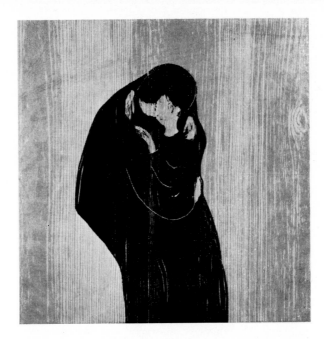

ciously she offers herself, raises her head and holds her hands behind her back so her young breasts, and her developing lovliness are shown to full advantage. Johan H. Langaard has pointed out two important positions in Munch's depiction of women – the one where she protects herself and keeps her distance, shutting herself in, with her hands in front of her – and the other with her hands behind her back, as in this picture and, for example, the enticing portrait of "Ducha" from that same year.

Dressed in the white of innocence she stands there, with wide-open staring eyes, her back turned to everything that would seduce her. In the background threatens sex itself, the phallic symbol of the moon's path.

This painting, like most of the "Life Frieze" pictures, breaks away from realism and unfolds itself along decorative planes, as in the works of Gauguin and the "Nabis".

Over many years, and in various techniques, Munch grapples with the themes of "The Kiss" until in the final woodcut he reached the

111

greatest simplicity. From a conventional drawing, and a small oil painting showing the couple to the left of the window, he makes, as so often before, the window with the life outside, into the most important part of picture, by moving the couple to the right – for example in the version exhibited in "Die Liebe." He does the same thing in our illustration, where the dark-clad couple blend completely against the light from the street penetrating the curtain in this almost impressionistic painting. But in the fourth version they stand, naked and shameless, in the middle of the window's axis, melted together in their erotic meeting. That is the way we meet them too, in the monumental engraving from 1895, where the figures are the one important thing, almost a plastic block without details against the lighted street. In order to reach even more simplicity, two years laer he takes the gouge, and attempts, several times, to cut into the grain of a block of pine until he finishes up with one of the strangest woodcuts in he hisory of graphic art. The figures, clad in black, melt together as one, against the vertical grain of the living wood. The contours of that black human shape, that appear here only as a decorative plane, tell, in their simplicity, of aggressive masculine lust and feminine submission. This meeting between man and woman is completely "de-individualized", the faces, only a light spot in all the black.

Here Munch has achieved the creation of a universal symbol of the "Life Frieze".

About the third painting, Munch says: *The name "Vampire" in itself is really what makes the painting literary, in reality, all it is, is a woman kissing a man on the nape of the neck.* The story of how the painting came about (page 99) confirms this. "Liebe und Schmerz" was the title in the exhibition, and Munch used it on the cover of the catalogue. The spirit of the age inevitably made the woman with the red-gold hair into a vampire just as Przybyszewski had already characterized her. Others speak from an ascetic bourgeois point of view, about this burden of the lust of the flesh, woman sucking the creative force out of man – it is the age of Strindberg and in painting, the highly-admired Felicién Rops.

His preliminary studies tell of how hard Munch worked with this motif before reaching a solution when Adolf Paul came up to his room.

Madonna, oil 1894–95
NG.

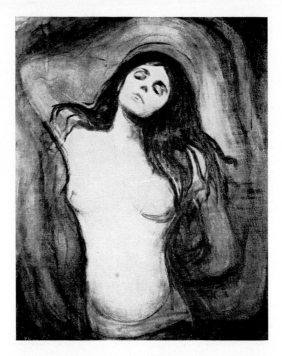

Working rapidly, there is good reason to believe that he then created
the pastel we know. The painting shows the figures coming out of the
same violet-blue shadow that we also see in the portrait of Dagny
Juell from this time – "a living fluidum which encompasses the figu-
res" as Heller says.

In spite of the times, and its view of women in this group of Nietz-
sche admirers, Munch's work of art shows both respect and admiration
for women – and an ability for empathy that we mentioned before
in connection with "Puberty." No woman-hater could have created an
apotheosis – a word the halo gives us the right to use – of woman
at the very moment of conception. Five times he painted his "Ma-
donna"; she was repeated both as an engraving and a lithograph. As
late as 1920 he made a new, larger and more naturalistic edition of
the lithograph. Munch knew that he had created a great work, and
in his large album *The Tree of Wisdom for Better or Worse* he has
given this noble lithograph the following text:

The pause when all the world stood still. Your face holds all the beauty of the world. Your lips, carmen-red as the ripening fruit, part as in pain.

The smile of a corpse. Now Life reaches out a hand to Death. The chain is joined that links the thousand generations that have gone before with the thousand generations that are to come.

Caught in the symbols of his time, he gave the lithograph of "Madonna" from 1895 a border of sperms and a foetus to remind us of the chain linking generations together – and perhaps to challenge the public – and it is no coincidence that today this version is priced the highest!

It is part of the programme for "Die Liebe" that the painting first exhibited with the title "Evening" and then as "The Sorrow" and later "Melancholy", is here called "Jealousy" – an equally expressive title. There are to be found a number of studies for this painting, particularly because Munch used the motif as a frontispiece for Emanuel Goldsteins collection of poems "Alruner", based on the same view of life, woman, and death as Munch's. While working in it, he writes to Goldstein: ... *the will is greater than the ability ... If I were home in Norway it would be easy, I could simply copy the painting – but now it will be luck if it goes well – I have never done this sort of thing before.* The final result was very close to the painting – as there was every reason that it should have been!

From that pallid face with the evil eyes, as Jens Thiis says, "there comes a force that infects the landscape itself, with perilous and gloomy colours, sorrowful violet, sulphurous yellow and poisonous green, and even the shoreline seems to slither along in helpless yearning. The landscape has become an expression of a mood."

I want to emphasize that here as in so many other paintings, Munch has materialized his own characterization of symbolism: "Nature is formed according to the mood of the viewer."

Concerning a version older than the one we see here, Krohg writes his little masterpiece *Thank You for the Yellow Boat* – a protest against a negative review. "A long shore curves into the painting and ends in a beautiful line, wonderfully harmonious. It is music. In a

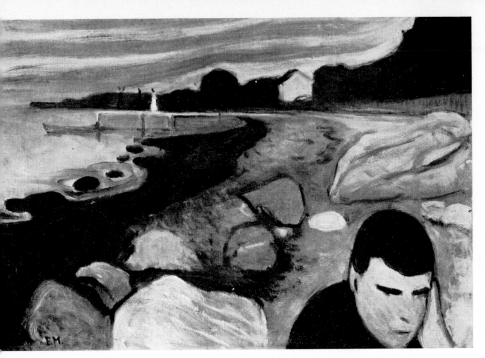
Melancholy, oil 1893 NG.

gentle carve it stretches down towards the quiet water, with small dis-
creet interruptions – the roof of a house and a tree – where the
painter high-handedly has ommitted suggesting even a single branch,
because that would spoil the line. Out on that quiet water there is a
boat parallel with the horizon – a masterly repetition of the line in
the background.

Munch deserves thanks because that boat is yellow; if it had not
been yellow, he would never have painted the picture ... The latest
slogan is 'sound in colour.' Has anyone ever heard such sound in co-
lours as in this painting?" – Then comes the exclamation quoted before,
that Munch should be receiving a composer's salary.

Krohg was a teacher both for his colleagues and for his fellow hu-
man beings: "The public writhes in front of this painting. Well, it's
true, any idiot can register the fact that the man looks as if he has
toothache and that he lacks nose, ear and mouth. But what in the
world does that have to do with the mood?"

In our reproduction of the version that was shown in Berlin, the

115

nose is suggested and the mouth too; but if such necessary items were lacking in those days it had to be mentioned. The most important thing is the evil triangular eye in the face, this head, which emerges out of the painting, isolating itself in this landscape depicting the drama inside the man. This isolation is emphasized in the contrast between the foreground, painted without perspective, and the space inwards in the painting, ending with the boat and the couple on the pier.

Finally this series of six paintings reached its climax in "Despair" – or "The Shriek", the creation of which Munch and Skredsvig have told us about. (page 88) We see here, not the painting that was in Berlin, but the version owned by the Norwegian National Gallery, where on one of the red clouds is written in pencil: "Could only be painted by a madman."

One of those who wrote about this painting when it was as new as it was shocking, observed that "the world is a madhouse." We know,

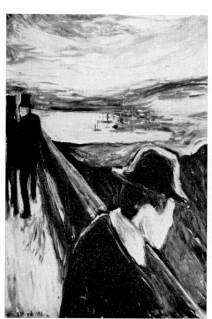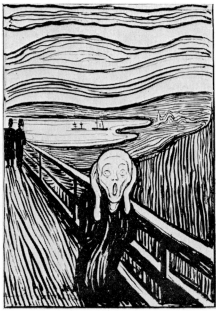

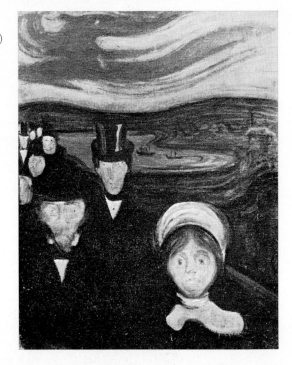

Opposite: Despair,
oil 1892 Thielska Gal-
leriet, Stockholm (p. 86)
The Shriek, lith 1895
OKK 193 (p. 74).

This page: Anxiety,
(Angst) oil 1894 OKK
515 (p. 135).

as mentioned before, that the painting is based on a deeply personal experience; but all the same the artist associates it with literature. On one of the lithographs Munch wrote in German "Ich fühlte das grosse Geschrei durch die Natur," obviously taken from the poem "Götterdämmerung" by Heine whose work Munch loved. We find it repeated among other places as "heaven's scream" in a key novel by Przybyszewski.

The mood is so strong, that the person here becomes one with the landscape, taking the form of the landscape and the clouds: hairless, sexless and impersonal. The experience has in all truth become universalized, with a meaning for all people, everywhere, in this, perhaps most expressionistic painting in the world of art. It is no coincidence that at the expressionist exhibition in Munich in 1970 "The Shriek" was on the cover of the catalogue and was used as a poster.

Behind this painting we find another that is directly connected to this experience on the road, we see the same landscape the two friends

going unaffectedly on, and a slightly camouflaged self-portait in the typical position at the railing: this painting has kept the title "Despair" and together with "Anxiety" ("Angst" belongs to this group. Like "Evening on Karl Johan" (page 90) also called "Fear on the Street" all of these from part of the "Life Frieze".

Among the fear paintings we must give "Red Virginia Creeper" a special place. Here there is drama behind the fear. The landscape is naked with leafless trees, but the house still flames with the lusty blood-red leaves of the creeper. Against the background of dangerous poisonous colours, we see a man wide-eyed with fear, come towards us. What has happened in that closed house this autumn night? Houses play a role in Munch's dramas, there they stood, to quote Ole Særvig, "as a dark destiny" a binding frame for human life.

Red Virginia Creeper, oil 1898 OKK 503.

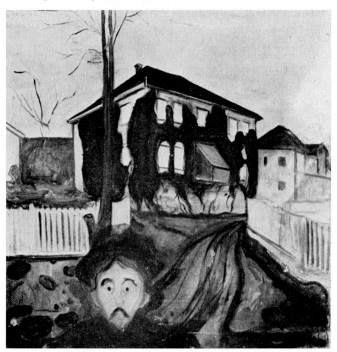

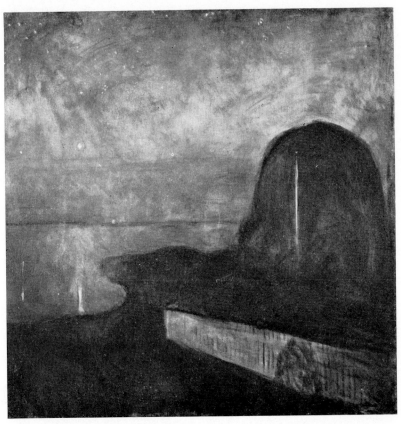

Starry Night, oil 1893 PC Oslo.

Jan Askeland has dealt with "The Fear Motif in the Art of Edvard Munch," and he points out how it is one of the threads in the "Life Frieze's" tapestry of life and death and love, a motif appearing again and again in Munch's art." In 1902 "Lebenangst" (Fear of Life) had become one of the four movements in the symphony. But the fear itself lives in his landscapes from these years, particularly the landscape which is the scene of the frieze. It lies behind all the paintings of sorrow that are tied to death and the death chamber.

The six paintings in the series "Love" were naturally divided into

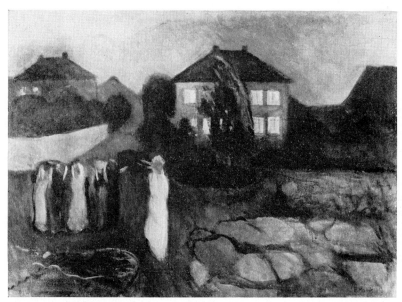

The Storm, oil 1893 PC Oslo.

Opposite: Mystic Shore, oil 1892 PC Sweden.
Dawn at Aasgaardstrand, oil 1901–02 PC Oslo.

four groups. "The Kiss" and "Madonna" were the last two in "The Dawning Love" which was probably introduced with the great "Starry Night" that once belonged to Fridtjof Nansen. This is surely a melancholy yearning, a "landscape of feeling" and tells us something of his basic mood in these years. The motif is from Aasgaardstrand where he that same year painted "The Storm": Pressed by natural forces, people cling together, frightened by gusts of wind which decide the direction of the quick brush strokes. Only the one white-clad figure has the courage to slip free and come towards us, while the lighted house lies there, closed and immovable. The motif lived on in Munch's work and, fifteen years later, when the storms were raging in his own being during his breakdown, he repeats it in a bold moving woodcut.

In such landscapes it is Munch's own nervous and sensitive being that demands expression. This is true of "Moonlight on the Beach"

120

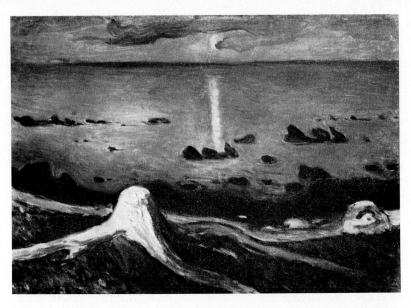

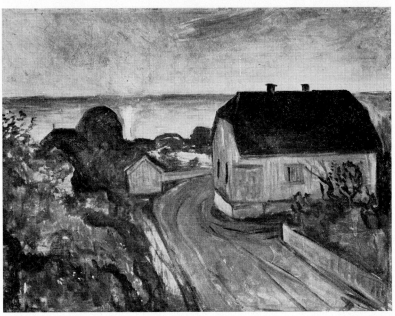

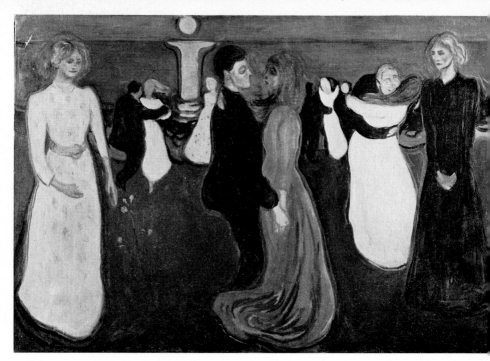

Dance of Life, oil 1899 NG.

from the previous year, where the moon is boldly reflected on the romantic shore with the pale stones in the foreground. In "Mystic Shore" from the same time, the romantic becomes almost literary, with the roots of trees becoming a bewitched octopus and the dead stone seeming to have a face. Deftly, this admirer of Rembrandt uses unknown sources of light, in addition to the moon tremblingly reflected in the sea behind. But also in these years he could experience impressions of nature refreshing and outward-going just as most other people and like other painters of those times. This happy and harmonious experience, is shown in the shading of the summer night into the summer morning: "Dawn at Aasgaardstrand". We see summer idylls from a sun-filled Sunday, with seemingly care-free holiday ladies, under a parasol.

The mood-filled depiction of the shortest night of the year, "St. Johannes Night", when Norwegians follow a programme that demands happiness around the bonfire's symbol of light, was placed by Munch in the section called "The Growth and Decay of Love." Be-

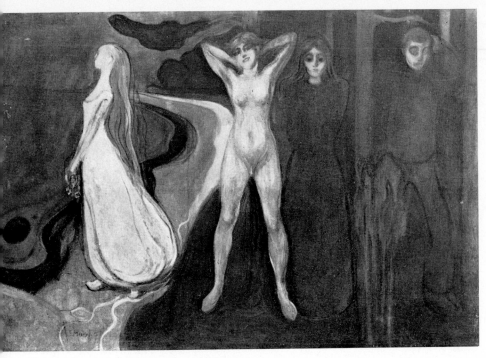

Woman in Three Stages, oil 1894 RMS Bergen.

hind the happiness live dark and mysterious forces, such as instinct itself, and this is expressed in the "Dace of Life,' that belongs to the series "The Dawning Love." The couple in the centre of the painting are completely taken up and absorbed by each other; she wears a red dress that almost wraps itself around the dark-clad man swirling in dance. Full of bitterness and disappointment, almost hatred, a dark-clad figure watches them, while a white-clad person leaving this arena of lust has only friendly curiosity for this "dawning love."

Previous to this painting, and in a way building up to it, we find "Woman in Three Stages" or "The Sphinx" as it was called in the exhibition of 1902 – "The Virgin, the Whore, and the Nun" as it has also been called. Munch had struggled a long time with this simple but profound motif before he painted this picture in 1894, and he was to continue with it. Together with several of the other "Life Frieze" paintings, this one was included in what was perhaps his most scandalizing exhibition in Oslo the following year:

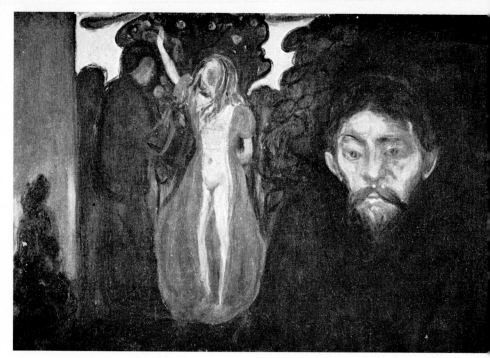

Jealousy, oil 1895 RMS Bergen.

The quarrel became violent about the paintings. People called for a boycott of the building, – and for the police!

One day I met Ibsen down there. He came towards me – it interests me a lot – he said. – Believe me – it will happen to you as it has happened to me – the more enemies you make the more friends you will have. He was particularly interested in "Woman in Three Stages" I had to explain it to him. – There is the dreaming woman – the woman with a lust for life – and the woman as a nun – the pale one standing behind the trees . . .

Some years later Ibsen wrote "When We Dead Awaken" . . .

The three women – Irene the white-clad dreaming of life . . .

– Maja, naked, lusting for life.

– The woman of sorrows – with the staring pale face between the trees – Irene's fate, a nurse.

– These three women appear in Ibsen's work – many places, just as in my painting.

124

Munch refers several times to this meeting with Ibsen, mentioning several points that he feels have influenced this drama about the sculptor, Rubek. While he spent more time with Strindberg, during these years, it is Ibsen more than anyone else, who was Munch's favourite author throughout his life. As late as in the 1920's he turns again to "The Pretenders" for inspiration.

There have been many interpretations of this painting, some of them comparing it with his other attempts to present woman symbolically. That there was a lot behind this simple symbolism is evident in the first exhibition title: "Sphinx," and in the catalogue Munch quotes a line from a Norwegian that delighted the whole generation: "All the others are only one. You alone are a thousand." The title alone lends

Ashes, oil 1894 NG.

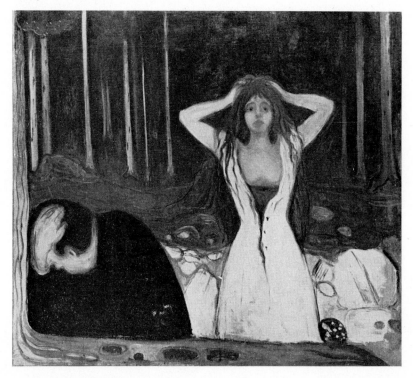

125

itself to mysticism; but we need hardly go deeper in our interpretation than Munch himself, when he keeps to the nearest and simplest explanation by saying:

The mystery of complete development collected together in one – woman, in her different phases, is a mystery to man – woman that at the same time is a saint – and a whore – and an unhappy, abandoned being.

The man in the picture who helplessly stands apart from the mystery of the Sphinx, divided from it by the bleeding, burning bush of life spirit, disappears in other versions. But in "Jealousy" he takes up the whole right side of the painting in a sort of ghostly realism. We see Przybyszewski's triangular pallid face in this painting as in so many others from that time – staring at us in hopeless loneliness and self abandon-

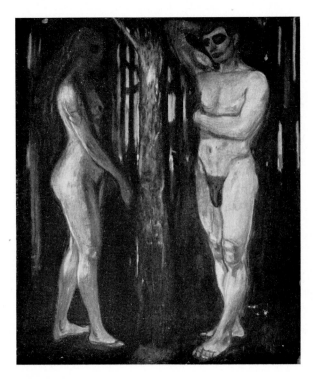

Metabolism,
(Two Human-
Beings) oil
c. 1898 re-worked
c. 1918 OKK 419.

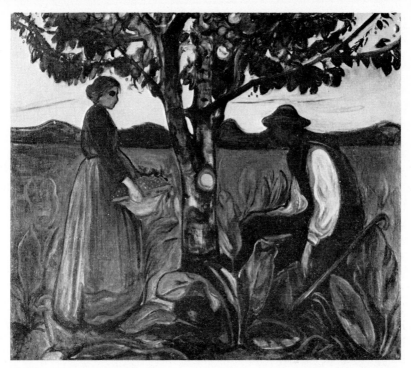

Fertility, oil 1898 PC Oslo.

ment, martyred by the pangs of jealousy. As we find the writer in the work of his painter friend, so we find the painter in the key novels of the writer. Here the self-tortured man has experienced man and woman at the tree of knowledge, where she stands dressed only in her warm reddish skin and the deep red drapery of lust. The merciless and eternally flaming bush in the left side of the picture – is it the spirit of life, the germ of life behind the drama?

Love dies, burns itself out to "Ashes", becomes emptiness and despair in the man from "Melancholy" so bowed down to the left on the edge of the picture, while she tears her red hair and dumbly cries her misery. Dark and threatening, stand the trunks of pine trees in the background. The pale middleground is dead and barren where the painted border from Madonna is repeated. As Ingrid Langaard has

remarked – it does not terminate in a living foetus, but in barren, cold stones.

In "Metabolism," (or "Life and Death"), as it has also been called Munch presents us with his form of belief in immortality, (see the quote on page 107) and in recognition of this, he says himself that this huge canvas (approx. 60″ x 57″) *lies somewhat apart from the ideas expressed in the other sections, but it is just as necessary for the whole frieze as a buckle for a belt. It is a picture of life as well as death, of the forest that sucks nourishment from the dead, and the city that grows behind the treetops. It is a picture of life's strong, lifting forces.*

These words may seem somewhat surprising, since we experience the painting in the Munch museum differently today but "decay" was once painted underneath the man and woman, standing there with the tree trunk between them, in healthy tangible beauty, newly formed, desiring life. One must study the contemporary lithographs on the same theme in order to understand the philosophy of the picture.

Now at the end of the century, Munch is working his way out of bohemianism and the "fin de siécle" with its pessimism, and its painting of the soul. He is saying "yes" to the eternal and inevitable cycle of life. Already the previous year he had painted the very positive "Fertility," that shows man and woman, on each side of the tree of fertility, she holding the fruits of the harvest in a basket. Before the turn of the century, he was interested, without any ulterior motives, in all the naked boys and girls that bathe on the shore in Aasgaardstrand – the same shore that had curved it way through the fateful paintings of the "Life Frieze."

Here the "fear of life", eventually disappears, but its sister from the same source, "fear of death" was master of the fourth section of the exhibition of 1902. "Death" was the simple title, and it tells us of the death Munch knew as a five-year-old, when death's dark shadow covered his home, and made an impression on him for life.

The motif was not new for the painter of "The Sick Child" and "Spring." But when he sat alone in France after the death of his father (page 71) he gradually gained courage to approach Death the way he himself had experienced it. It seems as though the paintings of the sick room, the bed, the chair, his father and the rest of the family

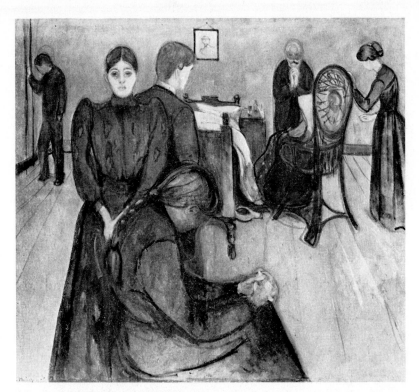

Death in the Sick-Room, oil 1893–94 NG.

were etched on Edvard's retina, as though he had even seen himself!
One would think he had just left the death chamber.

As we might expect, it is, above all, his sister's death that lives in his
mind, and from sketches and a completed pastel he painted his cen-
tral painting "Death in the Sickroom," that now hangs in The Natio-
nal Gallery. His notes (page 33) give the whole scene, even down to the
wicker chair. (The chair is owned by the Munch Museum.) In the
pastel, the moments before death comes are reproduced – the incom-
prehensible has happened: The father is stiff with sorrowful prayer, his
frontal position repeated in the figure of sister Inger in the fore-
ground, while the figure of the aunt by the chair of the deceased
has the hopelessness of its contours repeated in the figure of the brother,

who is quietly leaving the room. The sisters and the brother in the foreground, with the youngest bowed down in front of her sister Inger's stiffened figure, are connected to the central motif by Edvard moving towards the chair. Here as in other self-portraits ("Despair" for example) he is seen from behind, half profile. The firm composition makes the picture universal, something that was emphasized in the title "Ein Tod," when it was exhibited in Berlin.

The grudging public (and the critics) reproached Munch for not showing the dead person — Was it a man or a woman? It is the mood, expressed in the colours — mostly green and yellow in varying tones — and the survivors' reaction to the drama that concern the artist. Besides, perhaps there is something in the words of Pola Gauguin, that the lithograph that came later speaks "clearly, simply and more penetratingly to us," something he also says about "At the Death Bed." Here too the drama is reflected in those near ones, as they stand by the bed that we see from the headboard, and in towards the wall through the illusion of fever. In other versions, where the other figures are of lesser importance, the painting is called "Fever" or "The Son". (page 34)

Bathing Boys, oil c. 1895 NG.

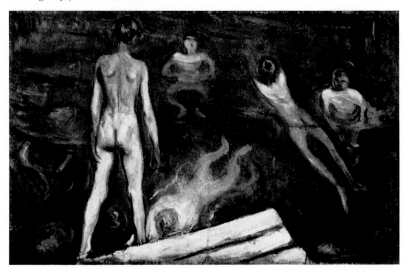

Death and fear of death can turn into a "death instinct," something which reminded Munch of the fate of certain of his bohemian friends. The path between Eros and Thanatos, love and death, is short. He lets the most fertile of women give "The Skeleton" the most tender and sensual embrace, letting two naked women pay tribute to it. Or he can also make that unique and technically new lithograph of himself with the skeleton arm underneath. In 1895 in Paris, that same year, he makes the wonderful self-portrait holding a sigarette. At last he felt secure, a gentleman due to his increasing success. – He was even recognized and admired by a younger group, in an international milieu.

Later in this book, we intend to take up a number of motifs that are closely connected to the "Life Frieze," with its highly varying content in the many different exhibitions. Munch himself dreamed about reproducing it completely in his graphic work. In 1918 he writes: *I have, with many pauses, worked on it for about 30 years* – and he emphasizes that ... *the idea for most of them (paintings) I already had in my early youth ... It was my intention that the frieze should have a place in a room that architecturally could provide a suitable frame for them.*

The thought lived so strongly in him, that in 1909 he could imagine a national monument connected with a plan still not realized today, to create a memorial for the centennial jubilee of the independent Norwegian state. This should house both his own "Life Frieze" and the sculptures of Gustav Vigeland. He was willing to go more than half way – this was that same Vigeland whom he objected to so much, that he later informed the authorities that his tax money certainly wasn't to go to that sculptor!

When Edvard Munch eventually got his museum, it was of course too late to collect togethert he paintings, which ... *after 30 years of privateering ended up like a wrecked ship with half the rigging gone. Finally they reached a harbour of sorts at Skoeyen (Ekely) – but they weren't fit any longer to be hung as a complete Frieze.*

One of his dreams was " ... *the whole Frieze painted very large, the motifs of shore and forest, depicted with more continuity in all the paintings. But what these paintings are to decorate, is apparently only a castle in the air.*

And a castle in the air it continued to be.

TO PARIS – THE PRINT MAKER

From his earlier days in Paris, Edvard Munch was aware, probably more than any other Norwegian painter, that it was in Paris things were happening, and that it was there it was important to make a name for yourself if you were to be taken seriously as an artist. At the same time his circle of friends in Berlin was breaking up – due particularly to the attractive Ducha, who sowed unrest among the young geniuses. The ambitious periodical "Pan", had received its name from that same Ducha who was inspired by Hamsun's wonderful novel. (page 94.) Several numbers had been published edited by, among others, Meier-Graefe. The periodical was given its tone by the French-Scandinavian avant garde. Prominent among the Norwegians was the author Arne Garborg – well known throughout Europe – and Andreas Aubert who had recommended Munch for the government stipend. This periodical was the first to offer Munch's graphic work for sale, and it also commissioned him to make a lithograph of Knut Hamsun. In addition we find many of the younger French poets of the time who were of importance, and illustrations by the leading artists – Toulouse Lautrec, Rodin, and Rops, to name three of the French gods of those times. But Germans were also represented – Nietzsche for example, with a selection from Zarathustra illustrated by Ludwig Thoma, poems by Dehmel, illustrations by the so highly admired seventy-year-old Böcklin and the French-influenced, still so controversial Max Liebermann. It was a periodical of the rebels, and already after two numbers, the reactionary Prussians removed two members of the staff; a professor, who had defended Munch during "die affaire", and Max Klinger, from whom Munch the graphic artist had learned something of his trade. It was said that "Pan" must become a German periodical. "The lack of a nationalistic, formal culture weakens our resistance to foreign literature, foreign art, foreign manners, and makes us, from the viewpoint of our neighbours, look like unlearned barbarians." Now the leadership was to go to a group of "geheimräte" says Ingrid Langaard and quotes from the third issue in 1895: it was to become a "German nationalistic, conservative, periodical."

The atmosphere of Prussian Berlin became too heavy for the Ferkel

circle. There was no longer room for an editor like Julius Meier-Graefe, and that same year Munch met him as a co-worker in Bing's Art Gallery in Paris, "L'Art Nouveau". It was this gallery that gave its name to the art movement which the Germans called "Jugendstil". It was at Bing's that Jens Thiis, then the director of a museum of applied arts, bought furniture designed by van de Velde – and it was at Bing's that Munch exhibited his work during his years in Paris. It was here they – and all interested painters – first experienced the Japanese woodcuts which were to have such an influence on their art, and to some extent on the art of Edvard Munch.

Two successive years (1896–97) Munch was to exhibit all of ten paintings in the "Salon des Indépendants". The second year he had been expressly invited. One of these exhibitions was re-created by Strindberg in the leading radical periodical "La Revue Blanche", where Thadée Natanson reviewed his paintings. The periodical also printed "The Shriek", while Vollard included "Anxiety" among the hundred prints in "Album des Peintres Graveurs", an honour Munch as "homo novus" in Paris shared with Bonnard, Renoir and Vuillard among others.

Natanson was, by the way, not very positive in his evaluation of Munch. After having mentioned that the new paintings on exhibition "show barbaric taste" he says that Munch, "this surprising Norwegian painter, uses violence and garishness in an attempt to express pictorially an exalted lyricism."

When Munch as late as in 1918, in connection with a Norwegian exhibition, publishes a small defensive paper on the "Life Frieze", he feels it never met any understanding home in Norway. *First and foremost the "Life Frieze" was earliest and best understood in Germany. Also in Paris it was recognized, and already in 1897 it received a place of honour on the main wall in the innermost and best room in L'Indepéndant – and of all my paintings, these were the ones best understood in France.*

By 1918 the exhibition must have been enhanced in his memory, because it appears that most of the French, from then until the middle of this century, have felt him to be too Germanic and philosophic – and also reacted against the colours he used. Concerning the exhibition at

Bing's in 1896, for example, an anonymous critic mentions "horrors in which one can find neither interesting conceptions nor pleasing execution," while another critic thinks "in this case there is not even a question of art."

That sort of thing could equally well have been written in Stockholm or in Oslo. But what has lived on in Munch's memory is more than anything else Edouard Gerard's review in La Presse, and he kept the cutting until his death, using it as the introduction to an exhibition catalogue at the turn of the century, and now in 1918: "Edvard Munch's art is not to be understood immediately and directly, but nevertheless it captivates us and sets free our imagination ... His pictures definitely make a strong impression on the viewer, whether he intends to impress us with the horror of his subject or entrance us with its grace. In all of them we sense a burning spark of life that inflames us."

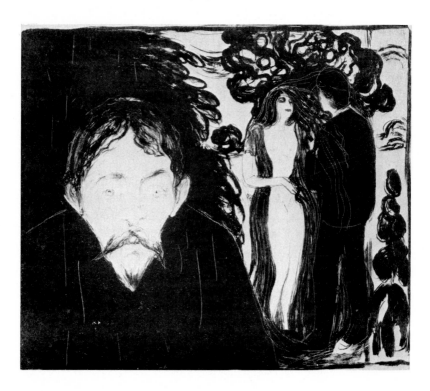

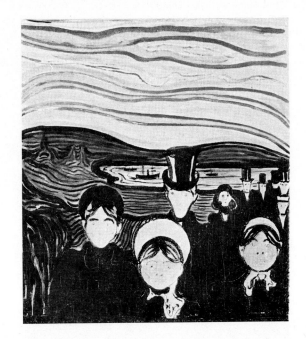

Opposite: Jealousy,
lith. 1896 OKK 202
(p. 124).

This page: Anxiety,
lith. 1896 OKK 204
(p. 117).

Gerard lets the paintings pass in his imagination, and he experiences: "... hallucinations, sometimes full of fear, always of suffering ..." He is surprised " ... about these strange countenances, these dark shapes, the children of soul's agony, that the artist has created out of his inner being, never copying them from outer models."

In each painting "there is so much of its creator and there is so much of those of us who understand them. Edvard Munch is a modern person and as such lives an intense and stormy mental life ... the person and the work of art are actually indivisibly tied together; the one serves as an explanation and illumination of the other. Here are revealed thoughts that are felt, experienced – he is impulsive in his mind, not in his emotions. He is anything but sentimental. His art is conceived and born from an idea, or perhaps more correctly: like Maeterlinck in his dramas and other literary forms, Munch reveals in his art the soul itself, uncovering its most secret corners." And after a long comparison between these two artistic temperaments – which many have done – he emphasizes strongly the literary aspect of Munch, scar-

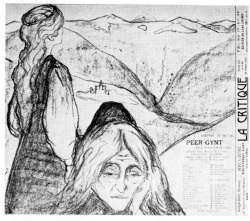

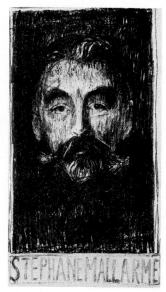

Programme for Ibsen's Peer Gynt.
Théâtre de l'Oeuvre 1896 OKK 216.
The Poet, Stéphane Mallarmé, lith. 1896
OKK 221.

Opposite: Henrik Ibsen and the Light-
house, lith. 1902 OKK 721.

cely touching the pictorial values. All the same: "... it is only as an instrument that Munch's colours make an impression on us. We never find them used only for the purpose of creating harmony. The colours underline, emphasize, describe, and prepare us. That is all. They are not the main thing."

Munch is a "colourist" it is said, not a "harmonist" because he "... even without the colour itself as an instrument manages to give our eye the impression of colour. This is definitely shown in his lithographs in black and white."

In the end Gerard discusses "Anxiety" (Munch's painting with that name was exhibited), the fear which drove that whole generation. "We are the slaves and martyrs of 'lebens angst'," says that vital Norwegian lyric poet from the 1880's, Niels Collett Vogt.

Why have I given so much space to Gerard in this book? Firstly because Munch himself must have considered the review to be "true". That shows how much he understood his art to be "literary" in that period. Secondly because it gives us more of the spirit of those

136

Opposite: Madonna (Loving Woman),
lith. 1895–1902 OKK 194

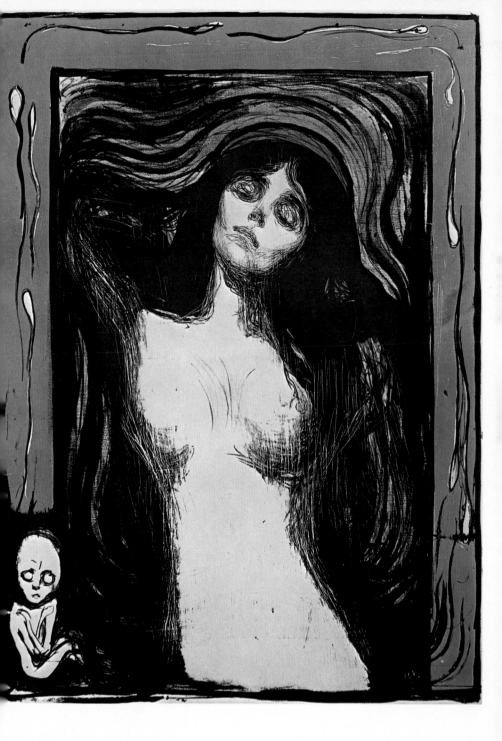

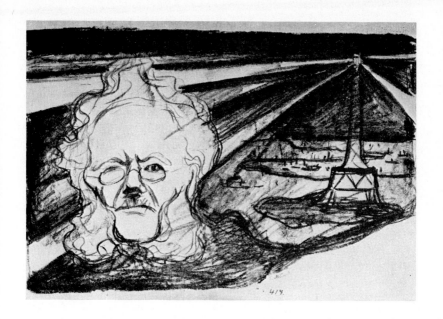

times than any text written today could. Thirdly because it tells us how Munch's admirers looked upon his art. He was not only a painter, but a "Nabi", – a prophet. Even in negative comments (from outside Norway at any rate) we find frequent attempts to understand him. In our home papers, *Aftenposten* for example, there isn't even room for such attempts, and in a strange undated little pamphlet, probably from some time in the 1920's, we find Munch's opinion of this newspaper which persecuted him so systematically both in articles and reviews: *In connection with a review of "Sick Child" ... (Aftenposten) revelled in insults and obscenities. This paper, so hostile to art, all the same serves a necessary purpose. A boogeyman can be useful, why chase him away?* (The critic Kristian Haug.) *It is perhaps not his fault that he writes there. The crude masses that make* Aftenposten *fat, demand someone like that ... These people need freshly slaughtered young painters for breakfast – like butter on their bread.*

In the following derogatory review – and there continued to be many of them – it is the same paintings that were in Paris that are

criticized, this time in connection with an Oslo exhibition two years earlier, 1895. "An influential citizen" encourages the private art gallery's regular customers to go on strike and the editors of *Aftenposten* add that . . . "the general public is of the same opinion as our honoured contributor." In general this "contributor" characterizes the exhibition in this way: "This is not art. This is artistic trash. This is smut."

The newspaper's critic, a museum director, keeps to the same low level of public appeal: "It is perhaps this sick tendency (need to sensationalize) which has gone to his head to such a degree that one can no longer consider Mr. Munch to be a serious man with a normal mind . . . he is a joker out to fool the public and poke fun at art and life. If only these false paintings were just to be laughed at; but the trouble is they are such poor revolting jokes that they arouse nausea and make one want to call the police . . ." The paintings " . . . can be divided into two groups: those that cannot be understood and those that repel us,

The Sick Child, lith. 1896 OKK 203.

Paul Hermann and Paul Contard, oil 1897 Kunsthistorisches Museum, Vienna.

the more or less vile. This last group includes a number of sensual phantasies, the hallucinations of a sick brain, as unpleasant as they are repulsive, reminding us of Mr. Jaeger's book, Sick Love." What seems to arouse the museum director the most are the various editions of "Madonna".

The other Scandinavian reviews weren't much better; but there were exceptions. Some critics have honestly tried to comprehend, and a really good understanding can be found in the writing of Rasmus Steinsvik. He was that "national anarchist" who edited the organ of the adherents of the "new Norwegian" language, *The 17th of May,* published in Bergen at that time where Munch's exhibition was also held. For this man Munch was "... the spirit of a known but secret world, and perhaps most important for those of us who know little of the art of painting ..." Henning Gran, who has written about the reviews of that year, quotes him: "There I make out in the dusky summer night, two lovers. Do I notice whether or not they have noses? I fall into won-

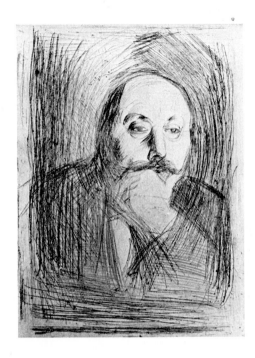

The Critic Mengelberg,
etch. 1894 OKK 1.

dering over the power that lets them forget all the world in their own
life-giving embrace." Munch is thus a soul reader who depicts in co-
lours "... our thoughts, our desires, our lusts, our fears, our sorrows
and agonies." It is the universal that Munch paints, and universal is
the interpretation Steinsvik gives of the individual paintings. A few
examples: About "Vampire", which he thinks is spoiled by its name,
he says: "She knew not that those who search for life in sensual plea-
sures, they lose it, knew not that the source of life is such a gift of
grace that the gods grant it to us only on special occassions. Now he lies
there empty and burnt out – an offer for inexhaustible lust." ("Ashes")
Or about "Jealousy": "... a face like that, green as gall, yellow
as sulphur, singed blue and scorching red in hair and beard – the
hottest corner in hell couldn't give more agony than what speaks to
us here."

When the situation at home, or for that mater, throughout Scandi-
navia, was so negative, in spite of exceptions like Steinsvik, one can un-

Death and the Maiden, etch.
1894 OKK 3.

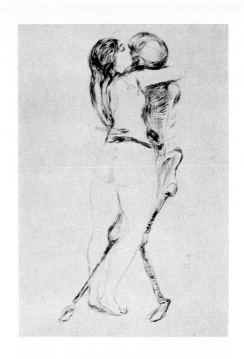

derstand very well Munch's need to look for recognition and a break-
through in the rest of Europe. The whole art milieu in Paris was open
to Munch, not only the many Scandinavians and Germans who were
members of his own circle. It is however only in the second Paris period
that the French milieu was open to him. This was largely be-
cause of the scandal in Berlin that gave him a sort of fame, and also
because things Scandinavian, particularly Norwegian, were in vogue
in Paris. It is the time of Ibsen and Strindberg; the Norwegian author,
Jonas Lie, quite well known in Europe, lived there for many years, and
later Bjoernson was to do the same. When "Die Liebe" was exhibited
in Stockholm (1894), Munch met Lugné-Poë, the one who more
than anyone else introduced the new Nordic drama in his "Theâtre
de l'Oeuvre". Already earlier artists like Vuillard had designed pos-
ters for Ibsen's *Rosmersholm* and Bjoernson's *Bankruptcy*. When Lug-
né-Poë had the boldness, in spite of Ibsen's own scepticism, to put on
the so very Norwegian *Peer Gynt*, it was Munch's task to make a litho-

141

graph for the programme, and the same again with *John Gabriel Bork-man*, where he drew the guiding lighthouse with Ibsen's powerful thead in the foreground. It as also during this time that he made the etching and the lithograph of Mallarmé who thanks him for "the knowing portrait in which I sense myself so intimately." And a French club, Les Cent Bibliophiles, honours him by asking him to illustrate Baudelaire's *Les Fleurs du Mal*.

But the decisive factor for Munch is that in his second Paris period he met the artists and the milieu which could inspire him and help him to plunge deeper into the techniques and finesses of graphic art.

As a black and white artist, we must consider Edvard Munch to be self-taught. Because he didn't have any "schooling", he was more unconventional and bolder in his experimentation than the many combined painter-graphic artists of that time – and also more original, often breaking new ground. His increasing interest in graphic art, which gave him the possibility of reaching more people with his message, has

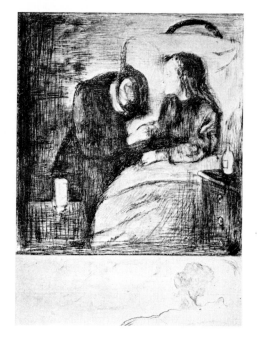

The Sick Child, etch. with landscape 1894 OKK 7.

Opposite: In the Man's Brain, wdct. 1897 OKK 573.

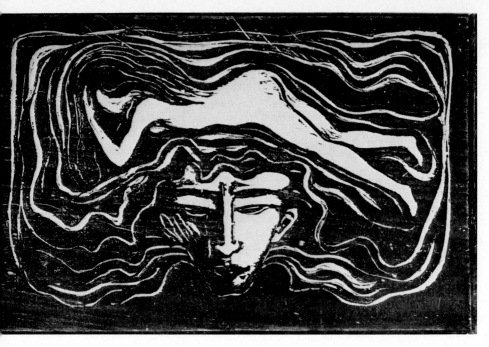

surely also been an important factor in his decision to settle down in Paris. To Ibsen's translator, Dr. Elias, he writes that this is "a critical time" and that he is working in a new area "of greatest importance". He becomes so involved that he doesn't return home to Aasgaardstrand during the summer of 1896. Even a commission to decorate a private home in Norway is completed in Paris.

It was during these years that painters in Paris were fighting a dedicated battle for the recognition of graphic art. But the public was unwilling to accept it, and equated what was created in this way with the work of the professional engraver. As early as 1885 there had been black and white exhibitions and four years later the association of Peintres-Graveurs held the first of their exhibitions. Technically there was no one who could equal the printers Lemercier and Clot, the latter was himself something of an artist and for that reason not always easy to work with. Because of the influence of the Japanese woodcuts displayed at Bing's, there was a particular interest in coloured prints.

Munch's very first colour lithograph, "The Sick Child" is already the work of a master. If we are to believe the German painter, Paul Hermann, the last step in the printing process happened in this way: "The

lithographic stones with the great head lay side by side. Munch comes in, stands in front of the row of stones, *shuts his eyes tight* and blindly stabs the air with his finger, directing: 'Print ... grey, green, blue, brown.' He opens his eyes and says to me, 'come on and have a drink.' So the printer makes prints until Munch returns again and shutting his eyes again orders: 'Yellow, pink, red ...' and so on in the same way, several times."

Another section of Paul Hermann's writing tells us more about the milieu – and about Munch's indifference towards his pictures, and obviously towards the pictures of others also. Pictures, he thought, should "have their own lives." The German comes up to Munch's studio with his very first etching plate. "... there was only a chair and a saucepan, and in the next room a bathtub without a tap. In the bathtub was a solution of ferrous chloride Munch tossed my plate which I had with me, into the bathtub, and said, 'come on and have a drink!' After we'd been sitting there for à while I happened to think of the etching. 'It must be gone by now?'

Munch answered calmly, 'Yes, it probably is.' The strange thing was that it hadn't completely disappeared ... in spite of the fact that it was a zinc plate ... the chloride solution must have been quite old."

Man and Woman re-drawn for publication by Munch c. 1925 OKK 365.

Opposite: Lovers in Waves, lith. 1896 OKK 213.

144

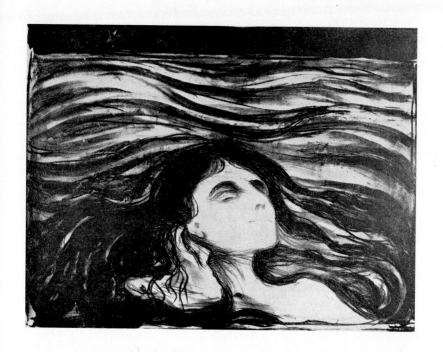

The names we've mentioned in these pages, his solid base in the milieu of Paris, the dawning recognition of his work – all these things would lead one to think that Munch would continue the struggle to succeed in Paris. But it didn't happen in that way. Perhaps it's because he felt a certain mental estrangement from the predominantly esthetic artistic milieu, perhaps it's because he became increasingly more committed to Germany. At the beginning of the unsettled and difficult "wandering years" after 1902, Munch found his German patrons who aided him in times of crises, and contributed towards tying him ever closer to Germany and Central Europe. •

It was in the last two years in Berlin that the draughtsman Munch, whom even the strict maitre Bonnat had accepted, took up graphic arts. He knew how the new graphic arts had begun to receive attention on the continent – among Danish painter friends for example, even though the Norwegian traditions in this field were rather slight. In the spring of

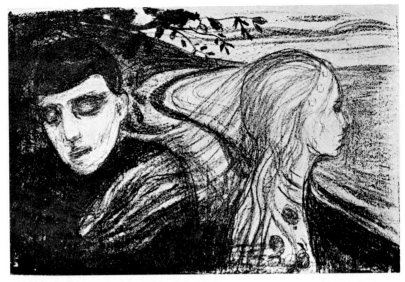

Separation II, lith. 1896 OKK 210.

Opposite: Separation I, lith. 1896 OKK 209.

1893 a graphic exhibition was held for the very first time in Oslo. Most of the participants were foreigners, among them Munch's friend Schlittgen. The critics pointed out that Norwegian participation was weak, even though the names were good enough – at any rate from a Norwegian viewpoint. It was just at this time that Munch and Schlittgen were much together at the Ferkel, and considering the exhibition in Oslo, there is good reason to believe, as does Ingrid Langaard, that conversation between them, good advice on techniques and the like, can have influenced Munch's decision to begin engraving. He became so involved in the possiblities which this technique opened for him, that he went around with a copper plate in his pocket and would use it almost as a sketch book.

He began carefully with portraits and reproductions of his own most central works. When this time of trial and experimentation was over, the first engraving he acknowledged was said to be "Brustbild eines Herrn mit Schnurrbart" – the critic Mengelberg who had gone in for

146

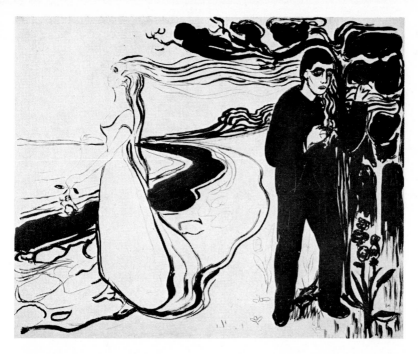

Munch's art in the *Frankfurter Zeitung*. The engraving, as we might expect, is closely related to the portraits painted at this time with lines that continue the contours of the figure. Among the other early engravings here, is every reason to pay attention to the subtle and sensitive portrait of "American Woman" and "Death and the Maiden", a masterly simplification of a painting from the previous year (1893). How powerfully he still looks for pictorial effect during these early times, in spite of an engraving like this, is evident in "Girl in a Nightgown at the Window". In this pictures he is particularly absorbed by the quivering moonlight in the room – as he was when he recreated "Night in St. Cloud" in the same technique. Other paintings that he reproduced in mirror image in Berlin are "The Morning After". simple and down to earth – and the picture he considered a key to his artistic development: "The Sick Child", that he subtley and sensitively redrew with the drypoint needle on the plate. The original square picture has become rectangular because Munch has lightly sketched in a sum-

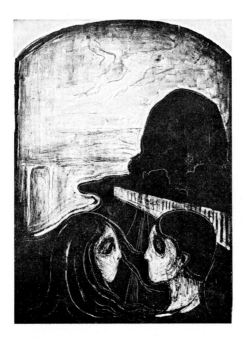

Attraction, lith. 1896
OKK 207.

mer landscape under the portrait – the landscape she dreams of?
When Jens Thiis was leaving Berlin in 1894, Munch came down to
the station with a trial print (and a flask of cognac!) on which the
landscape is merely drawn in with a pencil. It is no coincidence that
this very head of a "Sick Child" was the first colour lithograph he made
at Clot's.

We usually connect the lithographs with his Paris years; but never-
theless, already in Berlin, in 1894 and the first half of 1895, he had
made several lithographs, for instance: "Puberty" and his "Self-
Portrait with Skeleton Arm." Munch was no novice in lithographic art
when he settled in Paris.

In connection with Munch's Berlin exhibition in 1895 we find Paul
Scheerbart writing in something elegantly called, *Adels und Salon-
blatt:* "Munch receives most of his sensual impressions from recollec-
tions and imagination – the sort of thing with which poets are wont

148

Eye to Eye, oil OKK 502.

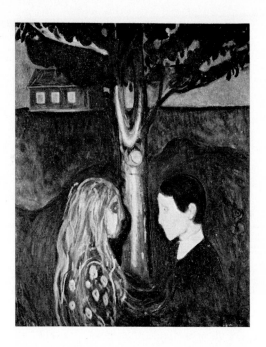

to deal ... in that way he is more closely related to our literature than to our pictorial art." This is gospel truth when we considert his literary period where the "message" itself was important. An example of a direct loan from literature can be found in his friend Przybyszewski's novel, *Overboard* (1896) where we read: "Was this love? He felt fear. How could it happen that a woman could, during the course of an hour, slip into his brain as a sort of foreign body." The following year Munch made the woodcut: "In the Man's Brain!" It was precisely a motif that appealed to the painter of "Vampire" – which, of course, was also produced in a number of graphic editions. Munch himself spoke of ... *the woman who demands everything for her own sake. Insatiable in her lust for what she feels gives life meaning.* She demands, as in this woodcut, the whole of man's thoughts. (page 143)

One is reminded of the anecdote about the Norwegian recruit who was to be tested according to Rorschach's famous ten inkblots. His answer to all the questions put by the well-intentioned psychologist as

149

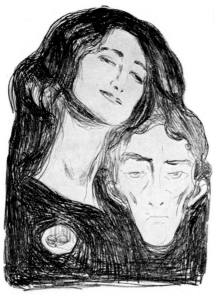

Salome, Eva Mudocci and Munch,
lith. 1903 OKK 256.

to what they made him think of was: "Women". When the confused
psychologist expressed surprise the recuit answered simply: "I'm allus
thinkin' of women you know."

Until the banal and superficial sex-culture of our times with its
greater porno-public, there has probably been no other period so taken
up by sex and eroticism both on a small and a large scale – even
to its cosmic aspects – as that small coterie at the *fin de siecle*. In
Munch's own notes, the St. Cloud manifest (page 71) developed from
a vision he had in an amusement house in Paris – a place similar to
the one he describes in the lithograph "Tingel-Tangel" from Berlin in
1895. He saw ... *a strong naked arm, a brown powerful neck – a
young woman leaning her head against the curving chest. – She closes
her eyes and listens with quivering open lips to the words he whispers
into her long flowing hair. I would form it the way I now saw it, but
in that blue haze – These two, at the moment when they are not them-
selves but only a link in that endless chain that binds generation to
generation.*

These are almost the same words as he uses in the text to "Madonna",

150

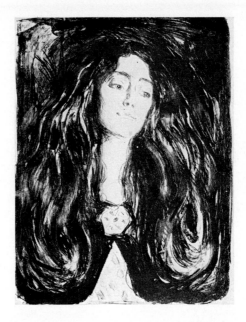

The Lady with the Brooch
(Eva Mudocci), lith. 1903
OKK 255.

and they are written (and later printed) in connection with the drawing
we reproduce here. (page 144)

There is an inner relationship running through all of Munch's crea-
ions; the motif is repeated and changed. To begin with, his most cen-
tral paintings – and the portraits – form the basis of his graphic
works. Later the path would lead him from graphic work to painting,
and in the paintings his experience with print making would influence
the execution, making it simpler, with larger areas and more powerful
contours.

Munch's poet friend, Obstfelder, tells us of his dream about the couple
who celebrated their wedding on board ship – the storm that sank the
ship – and how they were joined in the waves. This dream may be the
source of inspiration for "Lovers in Waves", but the motif, accord-
ing to Sarvig, " ... has been enlarged until the cosmic is involved,
the ocean of the subconscious and instinct in which the pair floats
like a wrecked ship, the woman supporting the man in her un-
conscious devotion" – or in Munch's own words under one edition of
the lithograph: *They are rocked in the embrace of life's waves, and the*

151

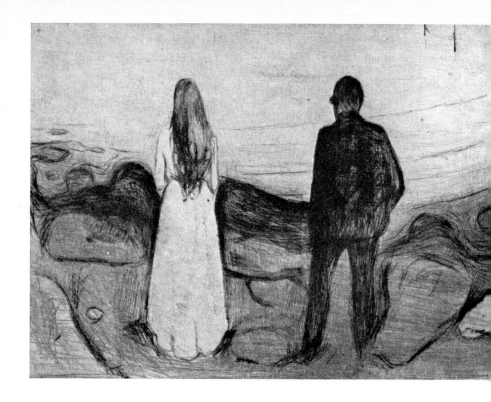

woman's smile is the smile of death. And with his "Meeting in Space",
where man and woman accidentally glide past each other – just as
accidentally as sperms in passing, the motif is raised literally to the
eternal and the cosmic, they become nameless in the ... *endless chain
that binds generation to generation.* And underneath a drawing Munch
makes another comment: *People are like planets. They meet in space
only to separate again. A complete union – a melting together in flame
– is a seldom thing.*

Munch's erotic symbols are simple: "The Urn" with the flame of lust
burning in the night, the victims of lust at the foot of the vase, and
the dreaming girl whose flame is not yet kindled. It is strange and uncon-
ventional that in the middle of all the symbolism there is a portrait
likeness of a woman. (p. 77) Munch has also made a note concerning
"The Urn". *Out of the dregs rose a face full of sorrow* – and beauty.
In that way he suggested what the urn might contain. But the flame

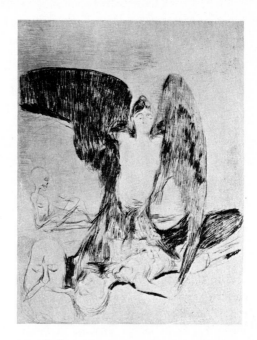

of lust is pure. What a powerful personal experience even the symbolical
pictures are, is evident in "Harpy" where Munch himself is the victim
of the monster, and is also portrayed as the skeleton with a sketchbook.
His relationship with Krohg was stormy too before they finally broke
with each other, so we see Krohg's disinterested mask in the foregrond,
and it brings us to think of an imagianry or real three-sided relation-
ship.

The harpies are related to the vampire, and the vampire motif was
typical of that time. The Danish poet, Goldstein, who was very close
to Munch in St. Cloud as well as later in life, asked his friend to
draw the frontispiece for his collection of poetry, *Alruner*. It became
a re-creation of "The Yellow Boat". In one of the poems we read:

> "You are the vampire, sucking my blood,
> It flows fully from the pulsing arteries
> Drawn by the icey allurement of your eyes.
> Like the sand of the desert, glows my body, burnt and ashy."

153

With this group, too belongs the Salome motif that takes manifold forms in Munch's work. We find Przybyszewski's satanic head on a platter, an ennobled edition, where Munch's own head is hidden in Salome's hair – Salome being the English violinist, Eva Mudocci (1903). We also find her, by the way, as one of Munch's noblest and most sensitive lithographs: "The Lady with the Brooch" from that same year. In that marvelous coloured woodcut, "Man's Head in Woman's Hair", we find the Salome theme universalized. The clearest possible characterization of woman's role, as a vampire however is in the etching where she holds the bleeding heart of man in her hands.

Edvard Munch dreamt of reaching as many as possible with his message. He held numerous exhibitions and dreamt of publishing a large graphic collection: *In my art I have tried to explain to myself life and its meaning. I have also intended to help others to more clearly understand life.* "His tremendous expansion as a graphic artist, is tied to this wish to overcome the isolation a privately owned painting suffers," says Paal Hougen in a catalogue, and he quotes Munch himself: *A painter's work doesn't have to disappear like a patch on the wall, in a home where only a few people see it* – though here Munch was thinking of monumental paintings in public places seen by many.

The painting "Woman in Three Stages", (page 123) that takes such a central position as an expression of Munch's views on life and women was naturally re-created in many variations, both on the copper plate and the stone, in the same way as his other important works. He wanted them to reach as many as possible, this "naturalist par excellence of the phenomena of the soul", who wanted to clarify for us the mystic regions of psychic landscape. He was concerned with, as has been said, not "l'art pour l'art", but "l'art pour la vie". Especially in the graphic works he created his own sign language and continually varied it by setting his symbols into new combinations. These two stare at each other, "Eye to Eye", lost and fascinated. We meet the two heads again both in paintings ("Dance of Life", for example) and in other works. In the powerful lithograph "Attraction" he places that same couple in the landscape from the mysterious "Starry Night", which he had painted three years earlier, in 1893. It is certainly more than a coincidence that precisely during this year the painting "Eye to Eye"

154

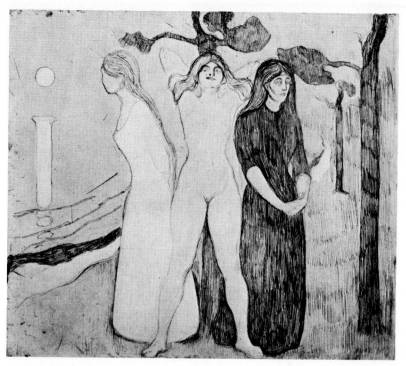

Woman in three Stages, etch. 1895 OKK 20.

was made, now they appear in a higher union. Woman's hair has it's clear symbolic meaning as Munch also expresses in his notes: *Man and woman are attracted to each other. – Love's underground cable sent its current into their nerves. The wires tied their hearts together.* In "Separation" the young woman from "Three Stages" has withdrawn from the group, and goes in the white of innocense dreamily towards the sea with her flower, while *her hair has entwined itself around him and infiltrated his heart.* From the stream of blood pouring from that torn heart grows the flower of life, or of art, as in "Blossom of Pain", the cover picture for Quickborn's Strindberg issue. It must be one of the most moving pictures in the world of art, this portrayal of the creative artist's martyrdom! (page 50)

In spite of the simple symbolism in "Separation" we find, as always,

personal experiences and the thoughts connected to them lying behind the motif. Munch writes: *When you left me over the sea it was as though fine threads still joined us,* and in a later note "the cable" from "Attraction" has become a telephone wire: *I symbolized the connection between those who were separated with the help of long wavy hair – that long hair became a sort of telephone wire.* (page 147)

A Swedish poet wrote about "the irremediable loneliness of the soul". Never before have two backs represented such introspective isolation and loneliness, such a reaching out for contact and closeness, in vain – as this etching of "Two People" so very aptly called, "The Lonely Ones". We see the woman so self-conscious in her white dress, and the man, so clumsy, dark and heavy in the hopeless contour that the etching needle has drawn. Only one step forward and he has reached her! The woodcut that he printed in different colours in the various editions, as well as painting further on it himself, belongs among the noblest works that Munch has created.

What he could tell us in lines and shades about the unhappy, isolated person is convincingly shown in his presentation of "The Lonely One" – not to mention the manifold editions of "Melancholy", the man on the beach that we recognize from "The Yellow Boat". Perhaps he achieves it best in the strongly simplified coloured woodcut. Loneliness impermeates event he moment of physical contact in the woodcut of "Man and Woman" as they kiss. But in the coloured woodcut with the reddish brown pine woods, between blue sky and pale green meadow, two people have found each other; the sensual lop-sided group – the dark-suited man and his woman – tumbling towards the woods that will give them shelter.

The erotic symbolism can all the same be obtrusively vulgar in prints like "Lust" with the three lascivious masks and the hand – greedy, grasping – on the woman's body. We find it again in "Hands" where again they grasp for a half-naked woman, who runs the gauntlet between two rows of dark-suited gentlemen with top hats. We experience the marketing of women's flesh – to use an expression from our own times – and we meet the same item on sale in the sorrowful-ironical varieté picture, "Tingel-Tangel" from Berlin, related as it is

156

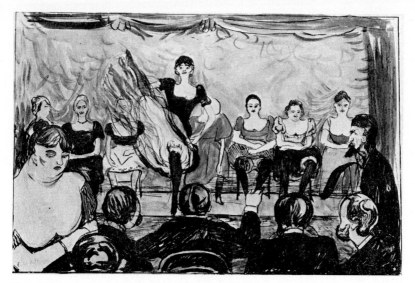

Tingel-Tangel, coloured lith. 1895 PC (OKK 198).

to the works of Toulouse-Lautrec from this same milieu. Munch learned from him, as well as from Degas, in his Parisian portrayals.

In the fat woman on the left we meet Munch's symbolic whore. She appears again in many connections – he can even find consolation at her voluminous breasts. We find her very essence in the monumental brothel painting of "Rose and Amelie". It was no coincidence that at no other place in the Munch Museum was the old carpet so worn, as the spot just in front of this grotesque painting of these two priestesses of sin, painted with such jeering disgust in sharp colours.

The brothel belonged to hte bohemian way of life, and the sensitive and refined Munch tried to follow the pattern, but not very successfully:

The air was thick and full of cigar smoke, smelling of punch and beer.

A strife of daylight fell across the sticky table with its wet rings from beer glasses and bottles, on the filthy floor full of dirt from so many men's shoe soles – it sent a cold blue light on the dusty curtains – over the bed, the sheets, the thick arms of the prostitute and her fat bare breasts –

157

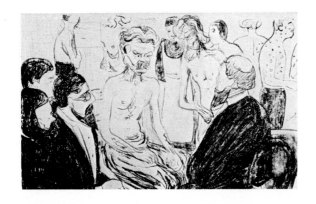

After a helpless conversation, he treats her to a beer and takes his farewell, suggesting chivalrously that he might return. Already earlier in his description (part of a attempt at a novel) he breaks out with: *I was disgusted!* and lastly he remarks: *She was too loathesome... he clenched his teeth – a strange feeling of hate rose up in him – he didn't know against whom – but he felt as though she had committed some crime against him –*

No, it wasn't always easy to follow the pattern.

As has already been pointed out, the artistic effect of the interiors from his childhood sickrooms and death chambers, seemed even more powerful in his graphic work. We find variations, we even find he himself in one of his many periods of illness in "The Son" or "Fever", where he sees the hallucinations of fever in mask-like monsters on the wall. We find "Anxiety" in new versions, in black and white and in colour. To an even greater degree, than in the oil paintings, they show the lines and ornamentation of the times. The curving lines of the Jugend style were well suited, both for the soft ink brushes of lithography, and the knife of the woodcuts. They entwine themselves through the ornamental "frames" of the pictures, live in the anguished skies and fever hallucinations. They give movement to the pictures and pull the compostion together sometimes almost concentrically around the main motif as in the lithograph of "The Shriek". I can confess now that almost a generation ago I called it a woodcut – a mistake I can still understand.

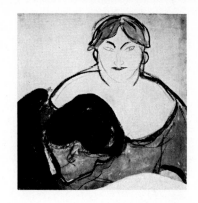

Opposite: Strindberg at the Clinic,
lith. 1896 OKK 199.

This page: Young Man and the Whore,
drg. 1895 OKK 2445.
It is his own head that Munch places
against Rose's bosom (p. 45).

We find universal philosophic motifs in "Metabolism" or the unap-
petizing Darwinistic "Heritage", the mother with the syphilitic child
in her lap, or others that are more related to the "Frieze of Life".

All-embracing as his painter's eye and mind was, we can also find
quick sketches as in "The Woman's Ward" or the malevolent portrayal
of Strindberg, who, by the way, was also afraid he had contacted syphi-
lis in "the woman's ward" of that "inferno" time in Paris.

From the very first portrait etchings in Berlin, he gives us penetra-
ting analyses of friends and people he met. Several of them have al-
ready appeared in our illustrations, and Munch the portrait artist will
be dealt with later. All the same we should like to take up some of his
unique self-portraits here:

The powerful "Self-portrait with Skeleton arm" belongs to his early
lithographs, number four in the series, and was printed in Berlin in
1895. It was created just at the time he was concerned with the death
motif – we see that by the skeleton arm. The full name and date
written almost across the whole picture, gives the lithograph something
monumental almost like an epitaph, a characteristic further emphasized
by that pale sculptural head against the very blackest background. It
is, as though the thirty-two-year-old man, in the midst of his thoughts
on the majesy of death, wanted to give himself posthumous honours.
Noble, resigned, inspired, the withe face glows towards us. (p. 10)

Even if we are here mostly concerned with the graphic work, we
have reason to compare this lithograph with our first illustration, the

Self-Portrait in Hell,
oil c. 1895 OKK 591.

National Gallery's "Self-portrait with a Cigarette", painted in Paris the same year. In this picture we find a new, victorious Munch, more sure of himself, but chastened through struggle and crisis. We have a feeling that the sensitive, immature, unfinished young man, who suffered the pangs of jealousy and painted himself "Under the Female Mask" two years earlier – in the power of this cruel vampirelike sex now has freed himself. He has passed through his "Inferno" where he painted himself standing naked "while the yellow-red fires of hell lick his body and purify it with their flowing fire." Ingrid Langaard is certainly right when she says that it is this purified Munch we see in the National Gallery's self portrait. Soulful, almost spiritual but concentrated and deliberate in his expression he steps towards us against the many tones of the romantic blue he was so fond of – his face lit in a Rembrandt-like way from an unknown light source. In his sensitive hand, however, we still see a play of nervousness, where he holds a cigarette in a sophisticated careless manner, its blue-grey smoke blending into the strong blue shadows of the background. It was,

160

Marche Funèbre, lith. 1897
OKK 226.

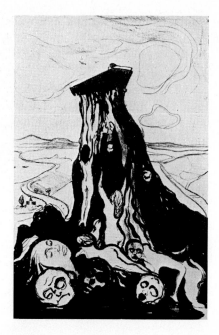

by the way, a triumph for Munch that the National Gallery bought this picture after his hotly discussed exhibition that year.

These self-portraits give us background material on his moods and cast light as well on his graphic works during this decade.

Manifold and shifting are the symbolic prints during this rich decade – Edvard Munch's brain teemed with ideas. In "The Swan" his towsled head drowned in the sea of reviews, while the white swan of art glided untouched over the water. "Kiss of Death" becomes the kiss of a woman; in "Marche Funébre" a pyramid of people lifts the casket with the dead man who looks out over the lightly sketched landscape, while the foreground is filled with caricatures of people's heads from that world he leaves behind him. The motifs are varied "In The Crystal Land", where the delicate young dead girl stares towards a strange foreign country, while what she leaves behind live on in the two large stone blocks, full of demons, in the foreground.

Also during these years Munch's painter's eye was captured by

motifs he found along the wayside – in the middle of his attempts to explain the secret life of the soul, love and death. Towards the end of the stormy days in Berlin he etches the delicate light study of "Girl in a Nightgown by the Window", a variation of the window motifs he was concerned with for many years. Or at home in Aasgaardstrand he would be entranced by "Girls Bathing" or make one of his finest and most sensitive colour zinc etchings, "Boys Bathing", as well as taking up again the theme of the National Gallery's "Moonlight", that dark-clad woman in front of the moonlit wall of the house – here he omitted the fence, which appears in the painting. Naturally the motifs from the paintings live on as in the quite independent re-creation of the National Gallery's magnificent "Mother and Daughter" in "Women on the Beach". This is a woodcut where the plate is sawed into three sections and (apart from the trial print) no black and white print exists. He prints it in steadily shifting shades of colour; yes, he even emphasizes the contours with water colours on the finished print. In an equally free relationship to the painting (page 180) we may study the coloured woodcut, "The Storm", where he tries to describe the storm in the material itself. The closer we come to the turn of the century, the more often we find objective depictions of the reality which surrounds him – for example in "The Old Captain", where the grain of the wood contributes to the characterization of age, or from after the turn of the century, the moving "Old Woman" in the hospital. Just in that year, 1902, when he exhibited the "Frieze of Life" with the main works of the decade in Berlin, he produces his quick and surprising impression of "Potsdamer Platz" with the street life around that monumental hearse, and the "Old Woman on a Bench", probably because of the influence of Käthe Kollwitz, who had worked with graphic art since 1890. (page 164)

Yes, his world of motifs changes. He no longer circles within the motifs of death and childhood in the same way as before, nor within the symbolic representation of the relationship between man and woman. True to habit, of course, he often takes up his old themes again, and during his breakdown and stay in a clinic, 1908-09 he could even put down his "philosophy of women" in the satirical series "Alpha and Omega". All the same, there are grounds for claiming that with the

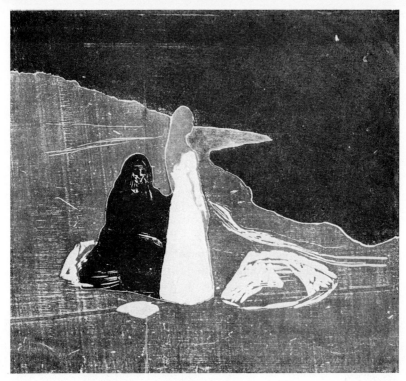

Women on the Beach, wdct. 1898 OKK 589.

pathetic and expressive coloured woodcut "Old Man Praying" he
settles accounts with his past and frees himself from his father and his
home. At the same time, his style changes: He wants to create space
in a new way, not by contours, curving shorelines, and things like
that. No, especially in the graphic works he develops the rela-
tionship between masses, contrasts and displacements. We can see
it in his treatment of landscape and in a woodcut like this. The back-
ground for the woodcut has already been suggested (page 31) and we
can with certainty assume that this momentary impression of the pray-
ing man has lodged in his mind, and been quickly put on paper. A
dozen years later he cuts his impression into the wood, re-experienced
and re-arranged.

163

Let's experience the picture through the eyes of Eli Greve: "The light from the door opening falls as a square into the room. It strikes the father's kneeling figure and his shadow breaks the patch of light on the wall, while the head and foot of the bed lie within the light. But we don't really see these tangible aspects, they only help our eye to find its way so that we can make out the essential thing in the picture, the kneeling man in a niche of light in the dark room – the room, look at it! There are no lines of perspective that outline it for us, but all the same we feel as though we were standing in the doorway looking in. It is the placement of the dark areas against the light that do it. For example that the upper edge of the square of light are not parallel with the edge of the picture but slanted in relationship to it. The areas of light are yellowish, but the father's night shirt is white. In that way there are three 'colours', that also adds to the feeling . . ." She mentions the monumental, the "greatness of form and of mood that suit each other so well. It (the turn of his head) has

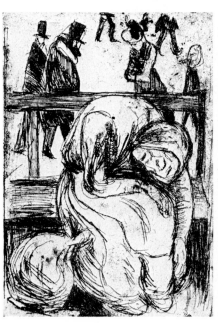

Opposite: Old Woman on a Bench, etch. 1903 OKK 62.
Old Man Praying, wdct. 1902 OKK 607.

This page: Moonlight, wdct. 1896 OKK 570.

something of the old testament in it, irrefutable. And this is surely just the quality Dr. Munch had in the eyes of his son. It has become a picture of authoritativeness for all time."

A more dignified farewell with his past and its problems would be difficult to find.

In his indispensable catalogue of Munch's graphic works, Gustav Schiefler says in 1928: "It's permissible for a great artist (while not allowed for a lesser one who only strives to become skillful) to treat the problems of craft and technique in a careless way, as the subordinate things they are, because the daemon of a great artist will, all the same, lay the right means of expression in his hand." And it is true as Johan H. Langaard says in his forward to a catalogue, that when Munch experimented it was to find expression for his personality. One

165

can however add that it often seems as though he gave himself tasks that made things difficult for him, particularly when working with wood. But it was exactly in this struggle with his material that he realized himself.

Langaard mentions people who tell how the creative desire could descend on Munch like a storm " ... with the consequence that he quickly worked on copper plate, stone, and blocks of wood during the printing process itself."

Such re-working, above all of the coloured woodcuts, means that the copies are seldom perfectly identical. The results can seem to be variations of the same print, but in a way they are monotypes. Their value – and of course their price – can for that reason vary quite a lot.

Many dreamt of renewing the graphic arts at that time. They called themselves "peintres-graveurs", Munch's few modern predecessors and the increasing number of contemporaries. More than any of them, perhaps with the exception of Gauguin in his use of the structure of wood, Munch has contributed to making the graphic arts an independent type of art, to free it from being mere reproduction. Already in 1911 it was valued so highly that a print of "The Sick Child" was sold for 1,200 Norwegian Crowns.

It would be hard to overrate how much this self-trained artist, with his arrogance towards what had become tradition and accepted technique, his struggles with well-known printers, and his experimentation, has signified for the recognition of the graphic arts. This is true, in spite of the fact that the content of his work, not its form, was given the most attention in the beginning.

Naturally, technical experiments, were carried on by most all of those who were working in this "virgin territory" and Munch had many from whom to learn. He had, however, a new comprehensive attitude towards all branches of the graphic arts. In many cases he achieved special results through working with the same motif in different techniques – for example "The Kiss" that went from the naturalistic starting point of drawing through etching, and lastly reached the simplification of the final woodcut's ornamentation, where the white and greenish veins of the wood became an important part of the whole. (pp. 110, 111)

166

He was completely free when it came to questions of technique and made use of all the possibilities available – even coincidence and accident – at the same time that he knew his tools well and used them to play with the material. This play on techniques, this use of new methods, give the different copies their own value and character. He made trials with water colour and oil paint, he re-worked his material, hand coloured his prints, printed woodcuts over lithographs and vice versa. In woodcuts he made what was perhaps his most interesting contribution. He made coloured prints using a single plate that he covered with different colours. He wasn't the only one to do this; but he still became a sort of Gutenberg in woodcuts: in the same way as Gutenberg cut the single letters out of a printer's block, Munch took his jigsaw and divided his plate into picture areas. The white contours along the edge of the areas add something extra to the picture, at the same time as the separate areas give endless possibilities for variation. An East German specialist, Rudolf Mayer, concludes in an unpublished manuscript: "In Munch we have the very first artist who wholly accepts his material as a factor in the formation of his art and who tries to allow it to come into its own." He takes up old techniques such as the "art of scraping" on zinc and other materials, but achieves new effects by using, for example, paper templates in order to add or subtract something from the picture. He can even use a hectograph when there is one available.

Since Munch has received world-wide attention as a graphic artist, there is reason to emphasize his innovations in technique as well as his new uses of motifs and the esthetic values of his work. Among those who have appeared later, both expressionists and others, only Picasso can touch him when it comes to innovation, according to Rudolf Mayer.

Art is crystallization is one of Munch's aphorisms. A graphic plate, above all a woodcut with its need for simplification, demands just this: crystallization of what is important. Therefore the graphic prints often seem like a conclusion, a summing up of what he had expressed through his naturalistic drawings or his more sketchlike paintings. It is strange to find how much his painting, influenced by the symbolists and the Japanese woodcuts, makes one think of a graphic treatment of area. While his paintings during the early years of the new

century became freer, more like sketches and studies, he often achieved the final solution in his graphic work. During and after his nervous crisis in 1908 this tendency became stronger. The graphic arts were for Munch – and through him for others – an independent form of art, the sort of thing the "peintres graveurs" had dreamt of when they first began to sign each copy of their works.

Gustav Schiefler, etch.
1905–06 OKK 112.

THE DRAWINGS

After the turn of the century Munch – with two exceptions – never exhibited his drawings at the different exhibitions. But just as he wanted to keep his paintings as material to work with, so he kept his drawings as a basis for further work, particularly those connected to his dream of a "Life Frieze". The Munch Museum owns almost four-and-a-half-thousand registered drawings, all the way from sketches and outlines of ideas, to large, often coloured, completely detailed drawings – invaluable material for a deeper understanding of the work of Edvard Munch. It was therefore a major event in the history of art when the museum in 1970 exhibited two hundred and fifty drawings and water colours in the Kunsthalle in Bremen.

All the doctor's children drew eagerly under the oil lamp in the dark of the winter evenings. But with Edvard it became a serious thing, and when he received his first "commission" and had painted the sitting room of his great aunts (page 26) he was rewarded with a cup of hot chocolate and a "really beautiful sketch book". We can follow the master-to-be from the time he, as a seventeen-year-old, experienced the fireworks and triumphal arch, set up in the palace park for the wedding of the Crown Prince in 1880, through the changing flats they lived in, and on walks through the surroundings of the city. We have the academic drawings of nudes from The State School of Arts and Crafts and from his time at Bonnat's in Paris. We can trace this increasingly more independent artist to his studio where we experience his ideas for paintings in their very earliest form, some with the trial shades of water colours. He is however always creating something of himself, – we have yet to find a single example of any notes, much less any copy of any painting, of any masterpiece that he saw on his many visits to museums and galleries throughout his wandering life. The closest he came to copying anything was the reproduction of the work of sculptors, for example Rodin's "The Thinker" in connection with a commission like the "Linde Folio".

He, himself, is said to have remarked – and the paintings from the nineties support his – that line with its rise and fall interested him more than colour. This may have been just talk, but the quote tells us

at any rate of deep interest in drawing – an interest that certainly is documented!

Of course the quality of the drawings that have been preserved varies. There is everything: the quick sketches on his pad, the small drawings in his letters – almost a part of his quick nervous handwriting, the charicatures, the trial attempts at new solutions to the problems of composition, both in his older works and in new ones he planned to create. Years might pass between the first sketches and the completed painting. Munch tells us for example that the Alma Mater figure in the University Aula murals is based on the sketch of a nursing farm-wife that he made when he was eighteen years old. We find completed

drawings too, often on a large scale, where he creates pictures of the very highest quality.

Drawing could be a goal in itself almost to the same degree as his graphic works. The form he used in his coloured chalk drawings show us this; they were often as large as ordinary paintings. It is interesting too to see how in all his restless experimentation and search for new effects he mixes techniques – uses charcoal and coloured chalks, chalk and water-colour, on the same sheet – yes, even pencil, printer's ink, guache, all together as in "Self-portrait with a Lyre" (approx. 25″ x 20″). Water colours were, before Munch, much as they are for most people today – mainly a sophisticated art on a small scale for pleasure; but

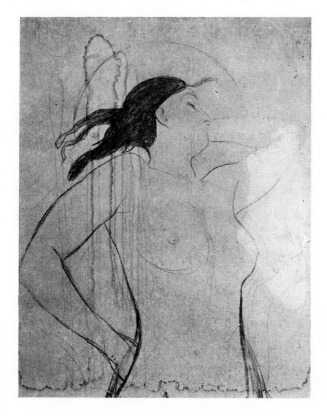

Opposite: Adieu,
first study for
The Kiss, drg.
1890 OKK 2356.

This page:
Madonna, drg.
1893 (?) 2430.

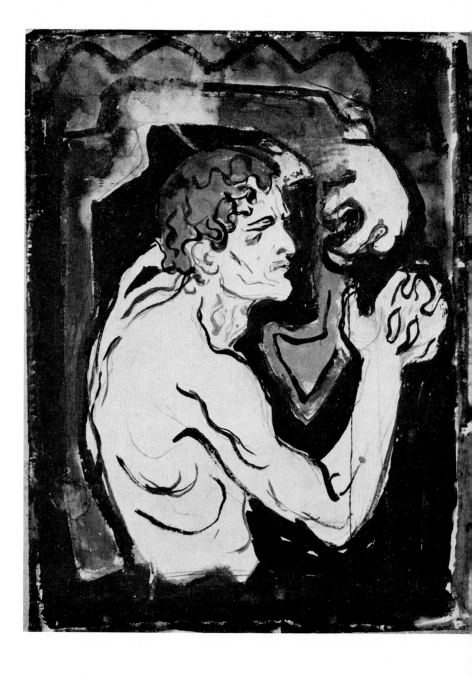

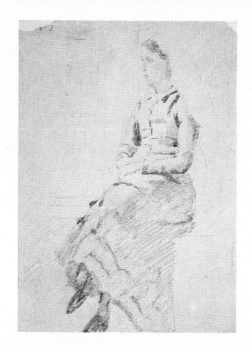

Opposite: Self-Portrait with
a Lyre, drg. 1896–97
OKK 2460.

This page: Inger Munch,
drg. 1882 OKK 2377.

Munch presents water colours "in the style of paintings" as large in-
dependent works of art, and others have continued this tradition.

When one takes up this part of Munch's gigantic production, one
realizes that each material, each technique, had its own value for him.
With increasing ability and experience he was to give his very best in
each area.

AT HOME IN NORWAY

Berlin and Paris were his most important places of work during this decade; but every year (with one exception) he finds his way back home, to Aasgaardstrand and to his family in Oslo. Even when he is abroad, we still find the fjord landscape of his home alive in his heart and in his art. His exhibitions are held abroad before he submits them to the critics at home. This was true of, for example, the great exhibition in 1895 that we have already discussed. He exhibited these pictures in Berlin, strangely enough together with the Finn, Gallén Kallela, who was such a different type of artist and who, as might be expected, received much more favourable reviews than the "unfinished" Munch, particularly because of his technical skill. Their differences apart, it is evident that the Finn has understood important aspects of Munch when he could write: "Munch doesn't produce art for art's sake, which would

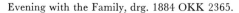

Evening with the Family, drg. 1884 OKK 2365.

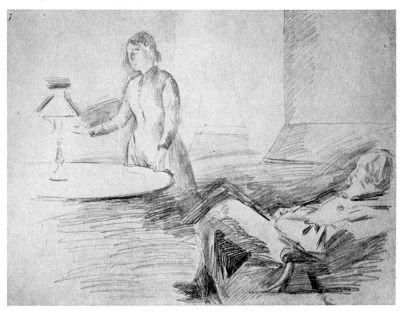

The Island, oil 1901 PC.

be child's play for him, but art for the sake of the fears that plague him." Even though their companionship led among other things to Gallén's excellent, sensitive, very characteristic potrait of Munch, the exhibition did change their relationship: "I think," writes Gallén, "that Munch is becoming more and more self-centred and self-impor- tant... It's a shame that he should become a megalomaniac, for he really is very talented." He has apparently met the new self-confident Munch, that same Munch who was forgetting his fears, particularly when he was home in Norway. We have already mentioned how in the midst of this tumultuous and disruptive time he could paint small idylls from Aasgaardstrand; how in pure landscapes he could use the "scene" and the moon from the "Life Frieze" as in a painting like "Moonlit

Birch Tree in the Snow, oil 1901 PC Oslo.

Night" from 1895. Only two years earlier however he had raised land-
scape painting to real monumental art, as in "Starry Night" and
foreshadowed how he, in the coming years, was to create mood land-
scapes with new means. As in the woodcuts, the simple perspective dis-
appears; the masses are arranged in planes. We find this in the blue
summer night of the monumental "The Island" painted at the turn of
the century, and also when he re-creates his "Woods" through the
changing seasons, or in a lonely "Birch Tree in the Snow" where the
trunk stands almost in the axis of the picture perpendicular to
the landscape, arranged in planes turning inwards the masses of
the snow, the stone, the almost symetric little hill, and the pine woods
behind. It is this same ordered design that is repeated again in the
National Gallery's "White Night" and in "Train Smoke", or when he
puts the little row of wondering children in front of the strongly de-
lineated, fantastic "Magic Forest".

Melancholy, The artist's sister Laura, oil c. 1899 OKK 12.

It is obvious that he is searching for motifs outside of his own complex personality, even if it is his own mood that lives in these pictures. pressive "Mother and Daughter" which was painted a few years before these paintings, and which is the basis of the freely formed woodcut, "Women on the Beach", we can see the desire to give this characterization of the two generations a value in itself. "The Loneliness of the Generation Gap" could be the title of this picture of the reserved, introverted, young woman, and her authoritative mother. (Inger and his aunt were the models.) They share that same inability to make contact with one another as "The Lonely Ones" or "Young People on the Beach", (where Munch in 1904 again takes up the old romantic curve of the shore line in new, fresher, greener colours for the "Linde Frieze".) With his ability to put himself in the other person's shoes, to identify himself with their mood, he manages to give us a powerful picture of complete isolation in "Melancholy" where we meet his unhappy sister,

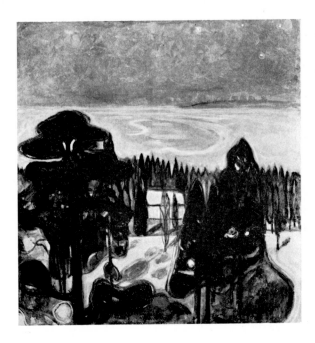

Laura, confined in her own world. Shivering, she sits there, with the cold winter landscape outside the uncurtained window, emptily staring out of darkened eye-sockets at nothing. The strong red of the table-cloth cancels out the life of the tulips on the table, and the restless pattern tells of the confusion in her mind. "If anything can be called expressionism, it is this," exclaims Jens Thiis, and adds that with this painting Munch concluded his series from the inner life of man.

There is yet another work that is connected to these subjects, however, a work that tells us again of Munch's unequaled ability to observe and to identify with others. "The Dead Mother and the Child" is found as drawing, as an etching, and in two painted versions, the one in the Munch museum, the other in the *Kunsthalle* in Bremen. I feel that this portrayer of inner life, this painter of children, achieves his very best in the latter painting: The child, so alone and lost now, doesn't

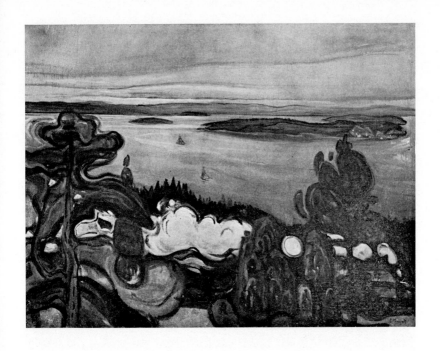

cry out her anguish as in the other versions. No, in nameless and utter fear she clumsily holds her ears as though she were hearing her own cry. It is the gesture small children make and observant parents will recognize it. Petrified, in confused thought, the pale childish face looks at us with widened eyes. How old is she? Edvard was five years old when his mother died.

A break-off-point for Edvard Munch came in 1902, a turning away from his praying father, from the death chambers, from his friends in Oslo. He tries to find a place for himself in the world around him. But that doesn't mean that he ever in his conception of the "Life Frieze" forgets the motifs from that most important creative decade of his career. The neo-creative time of the "Life Frieze" with its motifs "from the modern Psyche" draws to a close, and Munch works his way towards a more affirmative life philosophy. The motif

179

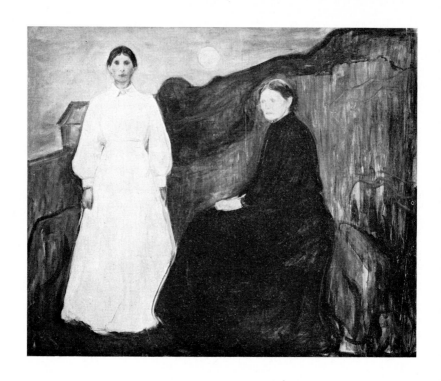

with the two people beside the tree becomes the harmonious "Fertili-
ty", a hymn to the richness of nature and humankind: the tree of life has
become an apple tree full of fruit, and under it we see a woman heavy
with child, bearing the fruits of the harvest to the man who rests from his
labours. And – as in the graphic works – he records the happiness of be-
ing alive in his paintings of boys and girls swimming, done early in the
1890's. It is as though the struggling and neurotic thinker is still,
throughout the whole period, looking for reality and harmony. This
comes out particularly in his first "Girls on the Quay" from 1899, that
later became "ladies" in different groups. Reidar Revold has regis-
tered all of twelve oil paintings with this subject through a period that
continues way into the 1930's. In all of these works, Munch maintains
the wonderous feeling of harmony in midsummer, the quiet around the
silent house and the magnificent tree beside it – and peace of mind.

180

Opposite: Mother
and Daughter,
oil 1897 NG.

This page: Girls on
the Quay, oil 1899
NG.

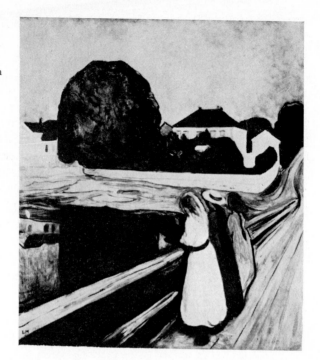

This peace lives on when the house and the tree are gone, and the light has changed.

It was going to cost him struggle and crisis to find that same peace of mind which was in nature and in the people around him.

The Wandering Yearsi - The Crisis

There are few of Edvard Munch's lithographs that make such a deep impression on one as "Sin" from 1901, and it seemed slightly surprising in connection with an exhibition, to find her as a poster on every street-corner, and served upon the cover of the menu at an official dinner. "It is", according to Ole Sarvig, "such a picture of a model with that intense expression of inveterate eroticism, that it takes on a symbolic character, becomes a figure in Munch's world of legends. Everything about this woman is passive and limp, her pale stomach seems to spread out endlessly, you don't see any contours, any hips. The hair however grows as in a thunderstorm, the nipples are full, taut, and the green-blue eyes stare emptily, apathetically straight ahead." A better description of this strange lithograph is impossible – one can only have the desire to add: it is made in hate.

Behind this hateful "portrait" lies something that was to have a decisive meaning in Munch's life, an episode that he regularly turns back to in his notes and letters. Munch fought for his freedom and to develop a framework for his life that would let him realize himself in his art. He fought hardest when a girl from the upper-class world, a girl with money, began to try seriously to get him to marry her. She even went so far as to arrange a very pretty deathbed scene with burning candles. In spite of a raging storm, a mutual friend agreed to fetch Munch in a boat from Aasgaardstrand on the other side of the Oslo fjord. The whole thing ended with a stay at Aasgaardstrand, and during a quarral there, a revolver went off. (We understand something, too, of the interests of the group when we hear that the revolver was being used as a bookmark in Otto Weininger's *Geschlecht und Charakter*. The shot cost Munch the loss of one of the finger joints on his left hand. The missing joint bothered him when he tried to hold the palette, so for the rest of his life he was eternally reminded of what had happened. Behind it all he suspected a conspiracy of his friends, they were on her side, and he

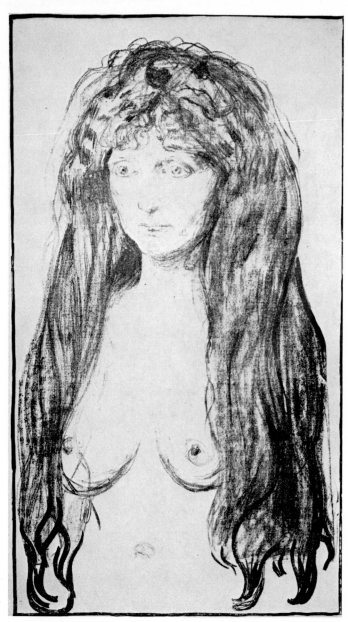

Sin
(also called
"The Red-
Haired
Nude")
Lith. 1901 –
OKK 241.

broke with the whole group from the nineties, with the exception of a few, and began his restless wandering on the continent. When he was back in Norway he avoided Oslo and isolated himself. Those were years of drunken parties and work, interrupted by stays at sanitariums, yet years of success with better income and fame. They were also years of home-sickness, but the finger reminds him of what has happened. He feels himself always persecuted and slandered, both at home and out in the world.

When his breakdown finally came, and he sought help in the clinic in Copenhagen in 1908, he summed up the difficult years he had gone through. He felt himself to be driven away from his home:

... my pictures are painted in foreign countries – and not with the same spirit as at home ... I haven't left home like Sinding (Norwegian sculptor) because I was insulted – I was simply driven out. Or he talks ironically about Norway, *the nature there is supposed to be important for my art ...* and even before the breakdown he writes in

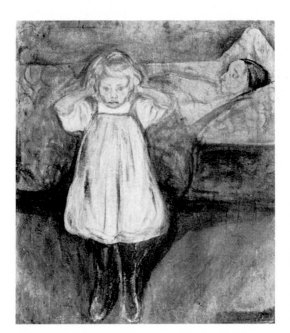

The Dead Mother and the Child, oil 1902 (?) Kunsthalle, Bremen.

Opposite: The Artist. Ludvig Karsten, oil 1905, Thielska Galleriet, Stockholm. The Critic, Jappe Nilssen, oil 1909 OKK 8.

184

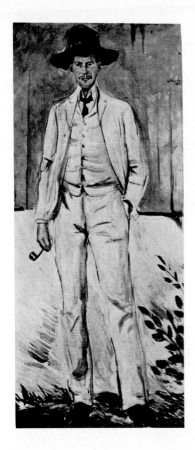
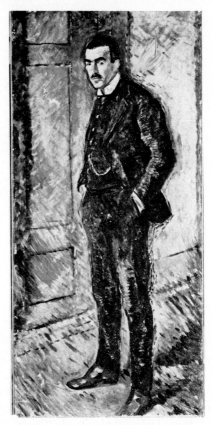

deep seriousness to Thiis: *Now I must stay away from everything that has to do with Norway if I want to regain my health and feel like a human being again. It's a shame, because I feel that art should have its root in the country where one is born and received one's childhood impressions.*

With an attitude like that it is obvious that he would return home when he was cured, even to ... *the city of pain (Oslo), I have to face it eye to eye if I don't want to lose my motherland. As it is now, I am losing it, piece by piece.*

Munch still felt that he needed illness, both to create, and as a part

185

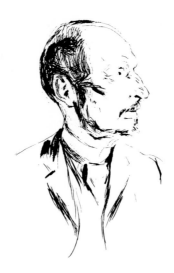

Albert Kollmann,
etch. 1902 OKK 69.

of his art, but in the middle of his forties, as he is in this period, he knows what it has cost him: *I have had some dangerously early autumn storms – They took away my best years – the midsummer of my manhood.* Or he compares himself to a tree that loses its branches in a windstorm.

The damaged finger reminded him of what had happened, and a bleeding hand was used as a vignette in Schiefler's catalogue. After an unfortunate fight with the painter Ludvig Karsten three years later, in 1905, he painted himself "With a Bandaged Hand". Everything in his life was to be registered in his art! But the most decisive even were connected with the time the revolver went off. And to his friend, Jappe Nilssen, the model for the man in "Melancholy", whose love story was re-created in that painting, he writes: *her shabby behaviour has ruined me for life... can you imagine what the deformation of a hand means... damaged, that marvel of God which a hand is... for the pains of love can be forgotten, but not physical injury. Yes, even in Germany where I had taken shelter, there was no peace.*

During these years, the feeling of being pursued could make him change trains during a trip – without any real reason. How he could never rid himself of his fixation with what had happened, we can see

186

from an example given us by the Norwegian illustrator, Blix: "In the autumn of 1908, just before his breakdown, Munch held an exhibition in the Salon des Independants. Blix and the painter Karsten, with whom Munch had fought, sat in Munch's studio drinking. Munch began to tell about a huge painting he wanted to make 'Heaven and Hell' shall be its name and it shall be at least eighteen feet long! Gunnar Heiberg will be sitting closest to the devil, and then all of Munch's enemies and friends would be ranked upwards towards heaven. Closest to the Lord would be Karsten."

THE FIRST PATRONS – FAME AND COMMISSIONS

In a rather superficial way we might say that the imaginary painting, "Heaven and Hell", mentioned in the last chapter characterizes Munch's life and his varying moods during these years! This is what lay behind the years leading to the break-through after 1902 when he finally found his prophet, the tireless and influential Albert Kollmann, his patrons, new groups of art-interested friends, and a number of commissions – more or less desired. The year before his breakdown he wrote to Thiis: *My fame is increasing, but happiness is another thing.*

Home in Oslo, the struggle for recognition was still not won, in spite of success abroad. *Aftenposten's* persecution broke out again when in 1904 he had a fight with a Norwegian author in Copenhagen – a man who often had a chip on his shoulder. They almost succeeded in getting his exhibition boycotted, and when Thiis was going to give a lecture on Munch, the hall was two-thirds empty. During the preparations for this lecture Munch wrote: *I ask you not to forget Dr. Max Linde and his family – they have made a bridge across that depth into which my countrymen would have plunged me a few years ago . . . His book with the bold title:* Edvard Munch and the Art of the Future *mustn't be omitted. Nor must you forget that strange apparition from he time of Goethe, Albert Kollmann, who almost like a ghost in the art world, a sort of conscience, has passed by the many degrees of developing German art, and in the end stopped at me, a foreigner. No, you must not omit him – his fine old Italian face can be seen*

187

in the exhibition. Other places too, Munch makes it clear that it was to Kollmann he owed his success in Germany.

This extraordinary spiritualist and mystic who always popped up in some strange way, wherever one seemed to be, had long played a seemingly modest role in the German art world. He encouraged what was new, and worked so conscientiously at it, that he even went round to the studios of those he belived in, and showed them pictures from the French impressionists to help them along. However, after he experienced Munch's exhibition in 1902, it was this Norwegian (–and Barlach) who took possession of Kollmann's sensitive mind. He had reached that point – and there he stayed – this connoisseur of art, about whom Max Liebermann has said: "He understands the art of painting better than all the professors and art-researchers put together." His friend, the lyric poet, Theodor Däubler, states that "Munch was not always mentioned first in Kollmann's conversations, but was always mentioned by the end." He also tells us how this 75-year-old lover of art, popped up at the great international exhibition in Cologne in 1912, where Munch and Picasso were the only living artists honoured by their own "rooms" in the exhibition. For several weeks, Kollman sat for hours at a time in the Munch room. Munch's biographer, Curt Glaser gives us a good picture of Kollmann's unflagging enthusiasm for Munch: "He found him friends, brought admirers to him, and whenever there was an exhibition, he shadowed the spectators, watching for a glance of understanding, a word of recognition."

That Kollmann, with all his admiration, could also be a burden is apparent from Munch's letters. A young German painter friend (Ivo Hauptmann) tells us of a meeting in a Weimar tavern: "A lean man dressed in black gets up from the opposite side of the big round main table and nods slightly to Munch. In answer to a question as to who this is, Munch says: 'Yes, I can tell you who it is, it's the devil. The girls like him and he has goodwill towards me. Now and then when I don't have any money, wherever in the world I might be, a door opens, the devil comes in and says: 'Munch, here's some money', and then he leaves without a word.' Several years later I made this devil's acquaintance; his name was Kollmann."

Linde had already bought one of Munch's works when Kollmann

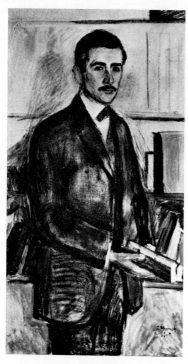 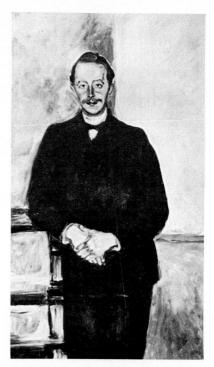

Herbert Esche, oil 1905 PC Switzerland. Max Linde, oil 1904 RES OKK.

got them together. To begin with, he sent Linde 39 etchings, which, however, Kollman had to redeem from the printer for 233 marks.

Dr. Linde himself tells us about his "stimulating time together with this shy refined and spiritual artist." The Linde home in Lübeck, with its generous hospitality and high culture became Munch's refuge and place of consolation during these difficult years. That Munch wasn't always an easy guest to have in that narrow bourgeois milieu, is evident from many anecdotes; but there were never any difficulties in his relationship with the Linde family. We have proof of this in the many letters we find all the way up to Linde's death at the age of 78 in 1940. This patron of art had lost his wealth during inflation and sold his collections; but their mutual friendship lasted through all the crises. Munch was always loyal to his past, both in regard to his works of art

189

and to the friends who "hadn't betrayed him." Another of these was Walther Rathenau, who shortly before he was murdered, invited Munch to his country residence in northern Italy. Other life-long friends were Chemnitz stocking factory owner Herbert Esche and his wife – particularly his wife as a matter of fact. They kept up a close relationship with Munch in spite of his drinking problems and other "irregularities", paying the bills he ran up at taverns and regularly helping him with his day-to-day problems. "He is a little strange, imaginative, but a good fellow," wrote mutual friend, van de Velde, the architect of Esche's new house. "I've painted the whole family," wrote Munch in 1905. He had politely accepted an invitation; but neglected to mention when he would arrive, until a telegram suddenly informed them: "Bin morgen Chemnitz. Munch". And there he was in the newly finished house, without luggage or painting equipment. The cognac bottle on his night table was empty every morning. He spent most of his time in the tavern, but he did come to meals with the family – and so days passed, and a week, two weeks. Suddenly he ordered everything he needed from an easel to terpentine. Now he knew the family, and the time to start working had come. Linde, however, had prepared Esche for Munch's methods. "Munch can go for weeks just observing, without putting a brush to canvas. "Ich male mit meine Gehirn," he says in his broken German. He works in that way – absorbing impressions, and then suddenly with primitive force and emphasis he quickly forms what he has seen. His paintings can be finished in the course of a few days, yes even in the course of a few hours. Then he gives everything he has. It is in this way that his paintings get their breath of greatness, of genius." During this painting rapture he used, the expensive wallpaper designed by van de Velde to test his colours. A charcoal drawing on the canvas was his only "sketch", the structure of the canvas gave him texture, and he painted the standing Esche in oil and crayon; Esche seated was done partly by squeezing the contents of a tube of oil paint directly on the canvas. He was probably the very first to do this. When Esche protested, he said that it was a technique he had learned from van Gogh, something Esche later found not to be the case at all. The model also complained that the oil paint applied in this way wouldn't dry.

190

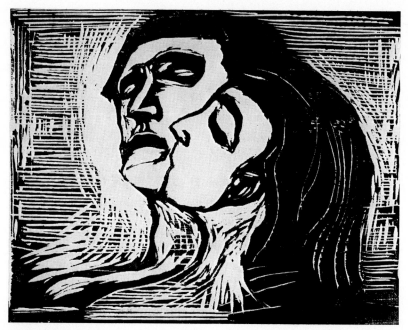

Head by Head, wdct. 1905 OKK 612.
In the wandering years as well, Edvard Munch was a busy graphic artist.

Munch left the family after a dinner with the van de Veldes in Weimar, and a letter to Munch shows how close the relationship between them had become: "To us you seemed like a poor deserted person, driven from house and home, who didn't really know where to lay his head... Now it's a question of taking up the struggle against the devil alcohol and painting as hard as you can."

Van de Velde's dinner invitation to Weimar could have been a contributing factor to Munch's sudden burst of energy in Chemnitz. He stayed in Weimar or rather at the nearby health resorts, when he started to paint Nietzsche on commission from the Swedish patron, Ernest Thiel, who was a great admirer of the poet-philospher. Thiel had already started buying Munch's paintings. It seems now that this so persecuted and critisized painter has become a central personality in the

191

art world. He has signed a contract with Bruno Cassirer who receives the exclusive right to the sale of his graphic art in Germany, and in 1906 he does sketches for Max Reinhart's Berlin production of Ibsen's "Ghosts". The restless round of exhibitions continues. The most important exhibition for Munch himself seems to have been the one in Prague in 1905, where he was lionized by the younger generation. They felt these paintings to be a declaration of independence from the dominating, provincial, academic type of art.

Munch the soul-searcher has given us an unforgettable picture of himself in Weimar: "With a Bottle of Wine" – a self-examination – as he called this merciless self-portrait. Moving loneliness grips us when we see this figure sitting in the morning in the empty club room, his forlorn empty plate in front of him and the bottle of wine that failed to cheer him. Tired, empty, limp, but sensitive and a bit nervous, with one evebrow raised – and his loneliness seems increased by the long perspective line with its disappearing point behind his head. That strange red square on the green wall frames the head and seems to bring it towards us. The red and the green are repeated again in the figure that stands out against the violet and yellow of the table and the shadows. He cannot escape from his loneliness the way the sleeping old man in the background has done – and the two disinterested waiters are also lonely and isolated from each other. In this painting we see the real Munch, the man behind the tireless working artist, the exhibitions, the forced and hectic social life, and the false sophistication. We are told that his rented dress trousers split a seam when he was at the home of the Grand Duke, and they had to be repaired by ladies of the nobility!

Van de Velde had shown Esche photographs of Munch's Linde portraits, and so the Esche family went to Lübeck to see them for themselves. As might be expected, they were particularly taken with the painting of the four boys, which has even been called the most meaningful group portrait of children to be painted in our century. Munch himself wrote about how interested he was in children and "Dr. Linde's Boys" shows in the characterization of each child their age relationship, their obvious family resemblance, and how well he knew and

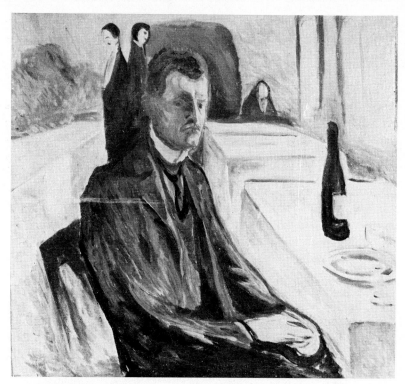

Self-Portrait with a Bottle of Wine, oil 1906 OKK 543.

understood his small models. They are placed in a very natural way in the door opening with the oldest boy distant and dreaming leaning against the wall in the corner to the left, and to the right the more self-assured and outgoing number two with his legs wide apart, solidly planted on the floor. Arranged? Granted – but what a dynamic arrangement! It moves through a space created by the figures, circles around the boy in the axis of the painting. It begins with the youngest boy standing in front of the dreamer in the corner, moves past the strangely detached little chap standing in the middle who is only interested in the painter, and it stops with that forceful left leg of the budding man af action. The lines of the nouveau art style live in the sharply drawn division between the floor and the wall that Munch has

used in so many portraits – in the right hand section the line is pur-
posely "wrong" in order to stop the movement through the three planes
the boys are placed on.

Even if Munch also in the 90's was interested in children, he became
even more interested in them in the first decade of the "children's
century" as Ellen Key's slogan called it. It was at that time that he
painted the bathing boys and girls, as well as the litle girls in Aas-
gaardsrand that we so often see. In the Munch Museum's "Four Little
Girls" we find again the children from "The Magic Forest", this time
in their home environment, standing in front of the yellow wall of
the house and its white foundation, with the multicoloured stones
superbly and cheerfully painted. Here again the children are carefully
individualized and accurately characterized, like the Linde boys. This
individual characterization is emphasized, say Langaard and Revold, by

Dr. Linde's Boys, oil 1903 Behnhaus, Lübeck.

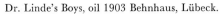

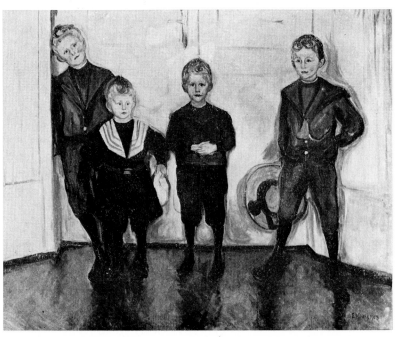

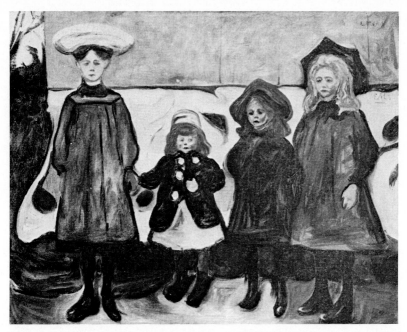

Four Little Girls in Aasgaardstrand, oil 1904–05 OKK 488.

the "way of painting and outlining that is at the same time strong and finalized but gentle in the depiction of the oldest child, restlessly moving in the youngest child, and almost sketch-like in the other two." A bit stiff and clumsy, self-conscious and shy, in an almost absent-minded way the oldest girl takes care of the youngest, while the two in between have found each other, apart from the others.

Edvard Munch during these years no longer puts his main emphasis on deeply personal inner experiences, but looks for motifs where the painter becomes increasingly more important, the painter and – in the pictures with human figures – the observant psychologist. The psychologist is also concerned with the group, when he, for example, paints that dark gang of boys and the colourful group of girls in "Village Street" down in Thüringen the same year as he did the "Four Little Girls" in Aasgaardstrand, 1905.

His new social connections, commissions and orders decided by others also forced Munch to be concerned with things outside himself, and we shall see how he, in his struggle against the illness that threatened him, more or less deliberately looked for other motifs that involved more the painter Munch than the person.

Already in 1902, Dr. Linde brought Munch assignments from outside and they were certainly what was needed in this difficult year. Besides being connected with Munch as his greatest patron, the Dr.'s name itself lives on in the "Linde Folio" with its fourteen etchings and two lithographs, including pictures of the mansion that today is the office of Lübeck's city magistrate, and the park with Rodin's sculptures, as well as portraits of members of Linde's family. His name is also connected to "The Linde Frieze" in which the subject material had its roots in the past and in the "Life Frieze", but which was to be redone and fitted into the big chil-

Munch is Arrested in the Palace Park, drg. 1903 lith. 1911 OKK 334.

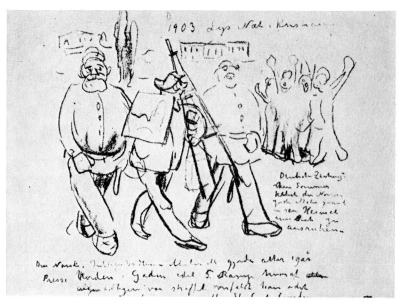

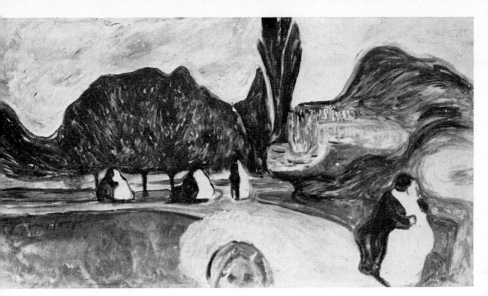

Lovers in the Park, oil 1904 for the Linde Frieze OKK 695.

dren's room in Linde's house. At last a part of the central work in the artist's production was to find its home. Back home in Norway he worked on it according to the measurements that Linde had given him in a little pen sketch, and although Linde would have preferred that the work be done in close contact with him in Lübeck, he writes at the end of the summer of 1904 to Munch: "I'm very happy to hear that you already have some sketches for the children's room finished. Please remember to develop the motif in a childlike way, I mean in accordance with the nature of a child, in other words: no kissing or loving couples. For children do not yet have any concept of such things. I think it would be best to choose something along the lines of a landscape, as landscape is a neutral thing and also easily appreciated by children." The background for Linde's good advice can perhaps be found in an unposted letter from Munch where he writes in his strange German: *Something very funny happened in Christiania, where I was ten days ago to make a sketch for your frieze "Lovers in the park", and it set me back a little. If you could read Norwegian you would have been able to read about it in the Norwegian newspapers. What a conflict! This time it was against a bunch of Christiania toughs and the police. I threatened the bunch of toughs with a revolver, and the*

police took me down to the station, me and all my painting equipment – I won over them all. It was quite amusing but not good for my angina pectoris. The background of this episode, which got Munch headlines in the papers, was that he happened to be painting in the early dawn together with a friend in the palace park. He started to argue with some drunks who disturbed his work, and as often happens, the police took the wrong person to the station house.

At the Munch Museum, Curator Eggum has recently reconstructed the "Linde Frieze", The whole frieze may be found there, and it can be seen that Munch has really tried to follow Linde's well-intentioned advice to make the motif "childlike". The frieze consists of several landscape paintings, among others youth on the beach, summer with happy children and adults in a park, a large painting according to the given measurements, that however both Kollmann and Munch himself found weak, girls picking apples or watering flowers – and

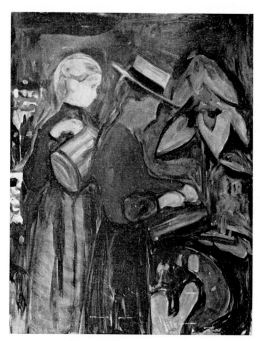

Girls Watering Flowers, oil 1904 for the Linde Frieze OKK 54.

Opposite: Young People on the Beach, oil 1904 for the Linde Frieze OKK 35.

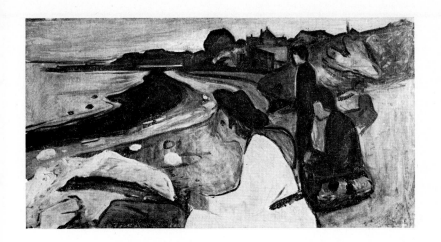

also the painting "Lovers in the park", done exactly to fit the given measurements, but with a subject matter which surely did not please Linde. In spite of heavy pressure put on him by Kollmann that almost led to a break between him and Linde, the whole case ended, according to our documents, with a letter from Linde in April, 1905 where we may read: "It hurts me to think that the development of this matter of the frieze has disappointed you so." But in a postscript he asks if he may continue to "determine over the frieze", whatever he may mean by that. As a consolation in this miserable affair, Linde offers to buy the last version of the large "Summer Night" for 4,000 marks. We have here evidence of Munch's objective attitude towards his own work in that, while Kollmann feels that the house should adapt itself to the paintings, Munch understands that they do not suit the pure empire style of the room. While the great "Life Frieze" is still housed in a "castle in the air" to use Munch's own words, at any rate the paintings of the "Linde Frieze" are under the same roof!

Other possibilities were to develop for the placement of, at any rate, a part of the frieze. In 1906 Max Reinhardt decided to open his new highly innovative intimate theater "Kammerspiele" with Ibsens's "Ghosts", in the spirit of Ibsen and in his honour. The only artistic

decoration in the new theatre was a bust of Ibsen by that same Max Kruse whom we previously have quoted (p. 18). This cautious commission first asked for only a sketch "or something that will inspire him (Reinhardt). One of those who was involved in the project, Arthur Kahane, says that according to Reinhardt's principles "it is necessary not only to find the best artist, but the *only* possible artist for each piece, and in this case, the only possible artist would be Edvard Munch." A close cooperation developed between the artist and the producer, and Munch was given the auditorium on the first floor as a work room. "In that way the cycle of work was created that later became famous under the name of "the Reinhardt frieze" as a great by-product of the commission for 'Ghosts' ". Munch lived and breathed in the theatre mileau during this time: "he worked during the day and drank during the night"; but "he continued to be a stranger, to be a puzzle to us."

Munch was deeply engaged in the drama itself and identified himself with the painter Osvald. As so often before, he built upon himself and his inner feelings and found a starting point in the story of his

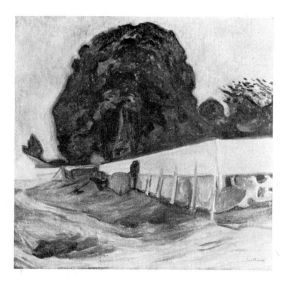

Summer Night in Aasgaardstrand, oil 1904 PC Oslo.

Opposite: Study for the Reinhardt Frieze, oil 1906–07 OKK 869.

200

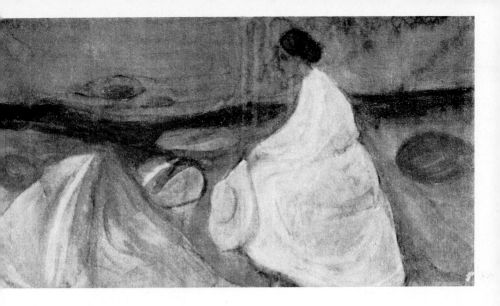

own convalescence: the painting "The Son". In Mrs. Alving's sitting room hangs the family portraits, from his own home, on the wall. All of fifteen of Munch's sketches were exhibited in the theatre, and in the reviews after the now so legendary opening night, Reinhardt must share the honour for his success with Munch.

"A hundred times I've heard Reinhardt assure us that no other painter had ever given him such powerful and stimulating creative impulses as Edvard Munch" says Kahane, The theatre painter Ernst Stern saw an oil painting for "Ghosts" in Reinhardt's workroom and thought that it wasn't detailed enough, but Reinhardt answered: "Perhaps so. But the easy chair alone tells you everything! Its blackness gives you the whole atmosphere of the drama! And the sitting room walls in Munch's picture!" And then he continued: "The colour is like a pair of diseased gums. We must try to find wallpaper with this colour. It will put the actors into the right mood."

After having gone through the reviews, Hans Midboe, who has collected this material, has established that Munch's paintings for "Ghosts", are the only Norwegian theatre decorations that have "attracted international attention in the history of the theatre."

When producers, particularly Reinhardt, at that time needed help from creative artists, it was because it was part of their program to

Scene from Henrik Ibsen's Ghosts, drg. Kunstmuseum, Basel.

"synthesize the mood of the drama". It was the task of the artist to give his own mental experience, his "vision spirituelle", his interpretation of the work and his placement of the figures on the stage. It was this that Munch had succeeded in doing, in spite of all the realistic suggestion of detail that he was given while he worked. "On that commision which Edvard Munch, the great more-than-realistic painter, Ibsen's countryman, has produced, there are real ghosts," writes Julius Bab. Others emphasized what the colours meant for the mood of the play. Yes, even Reinhardt's merciless critic, Alfred Kerr, must admit this time the greatness of the production and concerning the stage set he says: "All the rawness of his driving imagination has been avoided, but all the same the room has been changed in an incomprehensible, yet indispensible way to a torture chamber." – Munch knew what fear was: Osvald's, Mrs. Alving's, his own.

Munch also did sketches, yes even puchased furniture in Oslo, for "Hedda Gabler" which was to be put on at the Kammerspiele Theatre the next year. The production was – with another director – a fiasco.

A CHANGE OF STYLE

I believe there is a close connection between Munch's deeply felt need to get away from himself and his own problems and the fact that during these years he gradually developed a new relationship to his motifs. For example, he let that wonderful, subjectively experienced lyric poem "Starry Night", a deeply felt mood painting – to describe it in the words of that time – serve as an introduction to his exhibition of the "Life Frieze". Also in other landscapes without figures, we find evidence of the mood that gripped his being during these years, in the National Gallery's "White Night" or "The Island", for example, both of which were painted in the second year of the new century. But already in "Train Smoke" from the same year the artist is interested as much in the smoke from the train as the mood of the landscape – or rather his own mood in relation to the landscape. In "Summer Night in Aasgaardstrand" from 1904 we notice, in spite of the title, a quite different observant attitude toward the motif.

The new and the old attitudes seem to struggle with each other in the Munch Museum's "Avenue in Snowy Weather" from 1906. The two cut-off figures in the foreground don't represent any mood: they are simply there to give a depth to the perspective and they belong to the picture as a part of its composition, not a part of Munch's mood. We are looking at the reproduction of a factual observation of nature; it is not the mood within the artist's own being that finds its expressions through depiction of nature. He has experienced the perspective of the avenue, a perspective that seems to draw us into the picture, with its daring colours and boldly painted expressionistic trees. His use of line and the forcefulness expressed in the picture remind us immediately of another, older masterpiece, "The Shriek".

Many of the landscapes from these years give the impression that he – as in his years of apprenticeship in Nice and on sunny, happy days at home – is again beginning to discover the everyday world around him, either in Aasgaardstrand, at a health resort in Thüringen, or in Warnemünde. He can be fascinated by a park, by moist newly plowed fields, by a tree with a house in the background, just in the way he feels them, and the brush reproduces them – without his own mood

Avenue in Snowy Weather, oil 1906 OKK 288.

being projected into the picture. He even discovers the city, painting that large picture of Lübeck's harbour or Holstein Tor, not to mention the houses and streets and the wash hanging out in the small town, Warnemünde. It seems that he experiences people from outside. It is the drama itself that he experiences and depicts as a coincidental spectator in "The Drowned Boy", not his inner feelings about the accident. In the same way he experiences "The Fisherman and His Daughter", where the child clothed in bright colours runs to meet her father as he comes foremost in the row of darkly dressed fishermen. In the same way, he grasps the situation in "Old Men and Boys".

The painter of "The Seine Maker" again discovers the everyday life of other people, working people, nd paints "Mason and Mechanic" in pure, harmonious colours, where the darkly dressed mechanic stands like an exclamation point beside the white mason, who almost disappears into the background. Or he suddenly sees "The Fish-

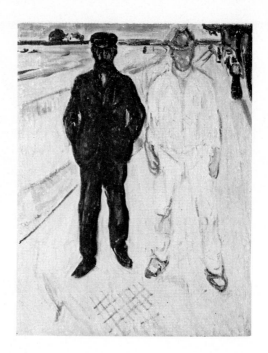

Mason and Mechanic,
oil 1908 OKK 574.

erman", yes, even in the year of his break-through, 1902, he was suddenly so taken by an old "Lady With an Umbrella" that he cuts and scrapes her image in on a zinc plate.

There is also the painter Munch who experiences Woman in these years – she is no longer so demonical and momentous as in the times when he was creating the "Life Frieze" – though during those times too, he continued to paint his nudes. Now Munch paints "Brunette and Blonde" in Berlin in 1903, more of a "bust" than a picture!

His more or less forced stays in the landscapeless Berlin lead him to create some of his finest nude pictures. In the Reinhardt year he gives us that sensitive and graceful poem about a young woman looking down at the street through the almost transparent, sunfilled curtain. There are few paintings of nudes that tell us so much about youth, innocence – and curiosity towards the rest of the world as this painting. In his tribute to Munch as a painter of women, as a painter of

205

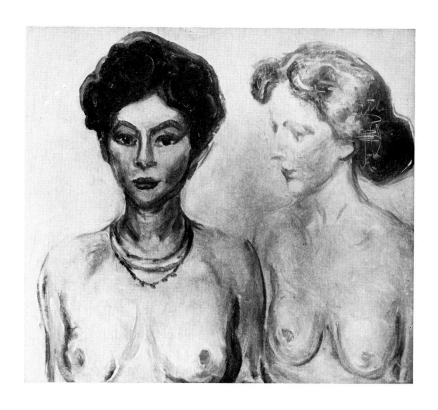

nudes, Jens Thiis reminds us of his relationship to Degas and says: "Munch and Degas have the same feeling of distance from the motif, the layer of air between." There truly seems to be a "layer of air between" in much of what Munch creates in this time of crisis.

It is also present, this feeling of distance, in another way in the expressive, one could say expressionistic, "Old Man in Warnemünde" with the strong contours and powerful colours – mostly shades of blue with a strong element of green, yellow and red.

It seems as though Munch through work itself is trying to struggle with, even to get away from, all the things that are troubling him. He wants to conquer life, to be as vital as the marvellous naked men he paints in Warnemünde. He is no longer fascinated by boys and girls bathing. No, it's naked man in all his sun-washed glorious power. He

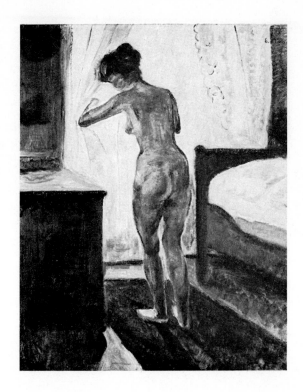

Opposite: Brunette
and Blonde,
oil 1903 PC.
This page: The Girl
at the Window,
oil 1906 PC Oslo.

makes many preliminary sketches for these paintings, new versions, and repetitions of the motif were to follow; but the great monument to masculinity is the so called "Bathers Triptique". In connection with an exhibition in Brussels, Jens Thiis writes "I have taken the freedom of christening this picture 'Triptyque de l'Homme' 1. Youth 2. Manhood 3. Old age." – One is tempted to believe that Munch wanted to create a striking contrast to his old motif: "Woman at Three Stages" – and so he painted healthy and conquering man.

The main picture in this great work, great also in size (80" x 90"), a powerful paean to courage and vitality, centers on the two muscular men who come decisively towards us with the full force of manhood's prime. The completely frontal standing shapes seem even stronger because they break across all the horizontal lines in the almost skyless

207

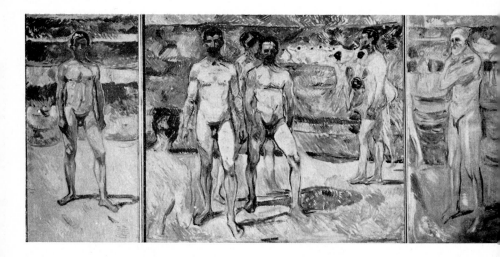

landscape. There is nothing aesthetic about this painting, no thought of subordinating man to nature, no attempt to let a soft play of line seduce us. In the sharp sunshine on the beach man himself meets us directly, after a refreshing bath, while the youngster in the picture to the left, hesitates, but has both legs firmly planted on the ground, and the old man on the right stands with his arms crossed and something of the harmonious peace of age about him. Edvard Munch had, throughout all of his life as an artist, cultivated woman and her body, but aside from the necessary practice during his years of apprenticeship, scarcely concerned himself at all with man in the nude. Is this tribute to health and virility a link in his own struggle against a threatening illness?

This more or less conscious new line in Munch's art that is described briefly here tells us of his attempt to break out of his self-concern. But it doesn't mean, of course, that he completely broke out of that circle, and his old motifs were taken up again throughout his whole life. The new elements recurring again and again in his paintings and graphic works consist of this "layer of air between", increasing the distance from the motif, and a recording of his life determined by his memories. When the old curving line of the beach from "The

208

Opposite: Eros and Psyche, oil 1907 OKK 48.

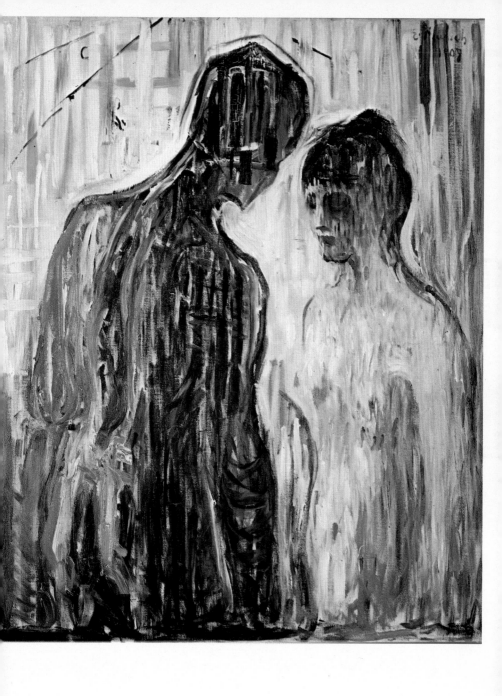

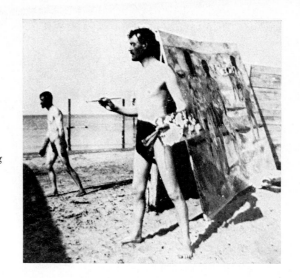

Opposite: Bather's
Triptyque, oil 1907–09
(Youth, RMS Bergen,
Manhood, Ateneum,
Helsinki, Old Age,
OKK 704: photo-
graphed together in
connection with the
Exhibition in Japan,
1970).

This page:
Edvard Munch painting
on the beach in Warne-
münde.

Yellow Boat" appears again in the Linde frieze's "Youth on the Beach", the colours are new and bold, but it is still loneliness and lack of contact that he is telling us about. Likewise there is a new use of colour in that dramatic beach in "On the Beach" with the wandering couple, done around 1905. She bows her head in obvious resignation, while he, dressed in a deep blue that contrasts against her white dress and large summer hat, looks away from her towards us, unhappy and full of desire.

The year after he had revealed himself in "With a Bottle of Wine", 1907, came his showdown in painting with what he claimed was the real cause of the world's being so against him: the great and strange "Death of Marat" (60" x 59") that also evidences a will to renewal. Up to this time one can easily maintain that Munch's art is an interpretation of his own life from childhood and up; but now, as Eli Greve says, "His art becomes his life – the only form of life he recognizes."

It is now that we meet his new attitude towards colour and a complete new technique in that picture which has been given the name "Eros and Psyche". In letters he has sent, as well as in letters he didn't send, Munch writes that he felt the need to *break the surface*

and the line – get away from mere technique ... I painted a number of pictures afterwards with a definite broad, sometimes yard-long line or stroke, that would run through the picture vertically, horizontally, and diagonally. The surface was broken ... And that is certainly what has happened in this painting of the naked man and woman, standing, diagonally, against each other, in the picture, with a strange source of light between them, that throws light over her, while the man's back is in the shadow. It is almost incomprehensible how Munch has managed to characterize their attitudes through many long, forceful strokes in shifting colours from reddish brown and blue to the palest yellow, how small twists in the course of the stroke give quivering life.

We see the same technique in "Death of Marat"; but here the horizontal strokes play the important role and turn the painting into a realistic-unrealistic interior. The figure of the murderess is firm, statue-like, and painted with strokes that flow almost parallel to one another, while the victim lies on the bed with his legs inward into the picture, limp and dead, shaped with quick brush strokes, though the contours also play a role. Behind this picture, magnified by remembrance and nourished by fantasy, lies the shot at Aasgaardstrand and the woman who so affected his mind. We often recognize her features in his work, and a lithograph from 1906, "Hate", where the room is the same as in the other preliminary studies for "Death of Marat", has even at one time had the title "The Ghost". Another preliminary study is, for example, "The Murderess", where the victim is lying on a Biedermeyer sofa, with his head towards us. In this picture both figures are dressed, and the murderess, paralyzed by her deed, stands deeper into the room. In another version (44" x 48") that also may be found in the Munch Museum, the victim lies further into the picture, while the murderess stands between the round table with its fruit and wine and the bed. In the picture we show here, abstraction is carried further, the painting has become more universal, reduced to its bare essentials – two people and the bed. The rest has been peeled away – only the deed itself remains.

This settling of accounts with the past has been hard, and to his Swedish friend and patron Ernest Thiel, Munch writes: *"It will take a*

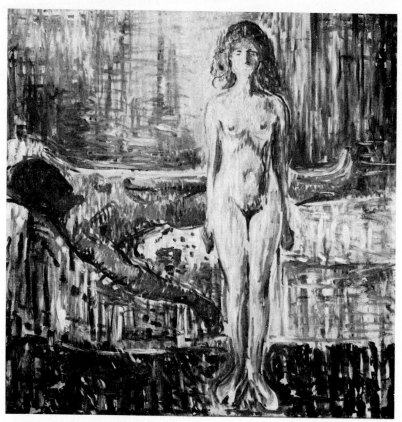

Death of Marat, oil 1907 OKK 4.

long time for me to recover my strength after having painted that picture." But when he writes to Christian Gierloeff, the friend he called when his breakdown came, he writes in a more humerous way:

"This child of my mistress and mine: 'Death of Marat' (I was pregnant with this picture for nine years — it was a difficult painting. Besides that it's no major work — more an experiment) — you can if you will tell the enemy that this child is now born and christened and hangs in Salon des Independentes."

BREAKDOWN AND HOSPITALIZATION

In the letters he sent and letters he didn't send – many of them written many years later, yes, even as late as in 1943 – Munch continually returns to the years of catastrophe (1902–05–08). He even wants to write a book that will *explain the whole story.* As the historian he, in spite of everything, wasn't, he asks Gierloeff to keep the letters and to give others instructions to do the same. At home in Norway again, he even visits people to check the sources. He doesn't forget the malicious postcards he sent his enemies, these *postcards that popped out of me like champagne out of a bottle.* Besides writing about his "nervous illness" and all his stays at health resorts he writes continually about the three determining fights he had, about the "conspiracy" and the vicious intrigues that harrassed him.

It was precisely in 1908 that Jens Thiis settled down in Oslo as the first director of the National Gallery, something that was to be very important for Munch's Norwegian break through. Even though be belonged to the same circle, he fortunately remained apart from the whole thing, saw it from outside, and could write a calming letter to Munch the week before the artist entered the clinic: "Dear Friend, How is it that you feel so frightened? I am certain that there is no one here who wants to hurt you. Everyone that I know and meet, speaks with great sympathy and warmth about you, even those whom you abuse." And about Krohg, whom Munch considered his main enemy, Thiis says: "He's a grown man now, and he certainly won't go and do something foolish just because of a few excited postcards."

But Munch is nevertheless physically afraid to go home: *I don't dare tell him* (a German author who wanted to go to Aasgaardstrand to write about Munch) *that in Norway, I would be happy if I were allowed only to sit out on one of the small skerries – and perhaps even there my life and limbs would not be safe.*

During all these years, Munch seems to be living up to Schiefler's characterization of him: "Unworried by time, place and outer conditions Munch has committed himself to a tempo furioso" – it lasted until 1908.

In every way possible he tries to break out of the vicious circle. In

Museum Director,
Jens Thiis, oil 1909
OKK 390.

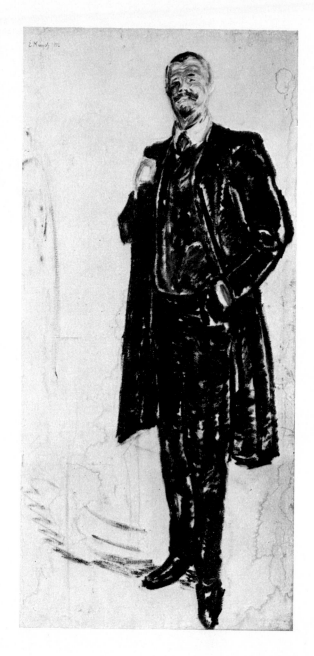

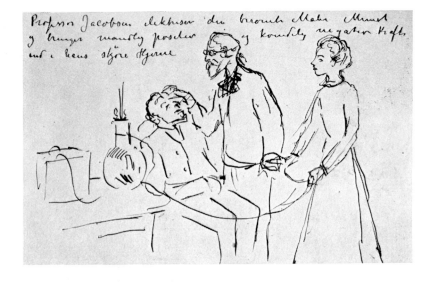

the year of crisis, during a raw cold winter in Hamburg, he writes to Thiel who has sent him money for a trip to Paris. *I have almost nothing to do with anyone, for all social life stresses me. It is very difficult for a man like me who is used to having friends and going on sprees now and then, to completely cut himself off from all this, but it's absolutely necessary.*

After going on a three-day spree with a Norwegian author in Copenhagen, Munch finds it necessary in the autumn of 1908 to enter Daniel Jacobson's clinic, and 7–8 months later he returned home to Norway to remain there for the rest of his life – recovered and renewed, both as a person and as an artist. It is obvious that he has committed all his will – and all his unbelievable energy – to getting well again. With his increasing continental fame he has in all seriousness discovered his own value and wants to preserve himself. He wants to live for his work. *It was in quite a brutal way that I finally made the decision to restore myself . . . let us hope that this is the beginning of a new era for my art.* And he sees his stay in the clinic *as the conclusion of a period in my life.*

214

Opposite: Caricature "Professor Jacobson electrifies the famous painter, Munch, and brings masculine positive and feminine negative forces into his fragile brain", drg. 1908–09 OKK 1976.

This page: The insane, lith 1908 OKK 281.

The strange thing is that all during this time he retained that noble trait of self irony, and in a way writes more amusing letters than either before or afterwards: *I've joined the Order 'Don't Indulge' – cigars without nicotine – drinks without alcohol – women without sex – so you'll probably find me to be quite a boring fellow.* In letters to Jappe Nilssen we can see again this new ascetic, who – rather regretfully – says farewell to his past: *Yes, it's a part of the past now, that mixture of pain and happiness that alcohol can give – a strange world is closed to me ... I shall also leave woman in her heaven – as did the old Italian artists – the thorns of the rose are too sharp.* And in these letters we can trace his shifting mood, we hear that he is being *electrolized and massaged and I'm enjoying myself here surrounded by obliging nuns and a very clever doctor.* When he returned home after his victory over certain outward aspects of his personality, he continues to be an abstainer, his only indulgence being *that foaming nectar of the gods, unfermented malt beer.* He lives in *loneliness, wary of people, but this is my nature. I no longer have the grape vine to support me – but then, it never was a very trustworthy support.* The new Edvard Munch has established himself.

215

THE TIME OF ILLNESS BECOMES A TIME FOR WORK

At Jacobson's clinic Munch gets over his restlessness, and this period of illness becomes also a period of work. His own situation doesn't interest him very much as an artist; but it is reflected in the dreary atmosphere of the lithograph "The Insane", this picture of a woman who lives with her own shadow. We see it too in the disguised representation of himself as "The Rag and Bone Man" (or "The Wanderer', this heavy figure, that dominates the sad city street through which he aimlessly wanders, bearing with him the heavy burden of is many failures. It adds to our picture when we find that during this time he takes up again the motif of his lost oil painting, "The Lonely Ones". Above all, it seems to be outward things that interest his painter's eye: his nurses are portrayed in sensitive etchings, we see them at their work "washing", and the friends that visited him play an even greater role. Helge Rode is done in a life-size portrait, a revealing characteri-

The Rag and Bone Man, etch. 1908–09 OKK 131.

Opposite: The Danish Author, Helge Rode, oil 1908–09 National Museum, Stockholm. Professor Daniel Jacobson, oil 1909 OKK 359 A.

zation, particularly in the posture itself, of the sensitive, intellectual Jew. We also have a lithograph, done ten years earlier, that shows again Munch's deep understanding of this model, who was for his own part deeply interested in Munch. At the time, Rode was writing his play "The Escape", and Munch was his model for the main role, an airplane designer who turns down an easy and conventional career to go his own way, and succeeds. This character has a "will that reaches out to heaven," and the play ends with his being received by the King – this was written during the year that Munch received the Order of St. Olav from the Norwegian King!

Other friends visited him too, and had their portraits painted. Among

217

others, he painted a charming picture of Pernille, the daughter of one of his friends. But his greatest accomplishment is the colourful portrait of Daniel Jacobson, painted as it is with a bit of amusing spitefulness. To the patient in the next room Munch explained that he had painted the Doctor exactly as vain and conceited as he really was." But at the same time Munch has managed to give him authority, strength, and self-confidence. To Karsten, who came to visit Munch, the Doctor said: "Frankly, I am rather worried about him. Here you can see a painting he has done of me. It's a crazy thing." But when Karsten saw the picture, he got down on his knees and clapped his hands together shouting: "My God – it's a work of genius!"

Both the natural resentment of a patient, and a happy feeling of well-being seems to lie behind this portrait. The figure, sharply defined, moves towards us – yet at the same time we experience a rare blending of space and shape. When Munch later told of the picture's creation, he said"I put him into the picture, large, with legs astride, in the middle of flames with all the colours of hell. And then he began to plead for himself, and became as tame as a dove."

This was truly a period of work for Munch, and it included two spe-

Opposite: Mandrill, lith. 1909 OKK 286.
The Nurse, etch. 1908–09 OKK 128.

This page: Caricature of his "FRIENDS", Heiberg and Boedtker, lith. 1903
OKK 252.

cial phases in Munch's artistic production. As he as recovering, he
made some trips to the zoo, where he made revealing studies, perhaps
we could call them characterizations of the animals. It was the soul of
the animals, the demonic qualities of his new models, that he was
trying to find, and he became so involved in this, that later he some-
times took up these animal motifs again.

The other special phase is his showdown with the "gang" at home in
the poetic fable, "Alpha and Omega". Munch began early to draw
caricatures, but during these years there were more of them. Already
in 1903, he wrote, in a letter to Christian Gierloeff, about "the con-
spiracy" and that he was *sending some etchings garnished with a few
small, monumental caricatures.* Well, perhaps the word "monumental"
is debatable. These caricatures dealt with "animals and people." For
example, Heiberg becomes the "poet-hyena", and Boedtker the "critic-

Poison Flower, that introduces the Alpha and Omega series, lith. 1908 OKK 304.

poodle." This very same Gierloeff can tell us that Dr. Linde had advised Munch to "put his experiences on the foreign coasts of love into a series of drawings. It will help you to regain your health." And Munch followed this advice. "Alpha and Omega" – the fable – represents a malicious and naive philosophy of woman, with its introduction consisting of the three-headed "poison flower", that is a derrogatory abstract of "Woman at Three Stages" (p. 155). This fable tells *in jest and in earnest, the eternally repeated story, that ridiculously enough, man seems to go through again and again, this man who through all time is deceived by a faceless woman,* says Munch and puts his "lovers" on a deserted island. After having awakened Alpha and had intercourse with him, Omega then is false to him first with the flowers and then, one after the other, with all the animals. The situation becomes intolerable among the fighting animals, who suffer from all the pangs of jealousy, and Omega escapes, riding on the hart, leaving Alpha behind with all the animal babies. When she returns, the angry

Alpha murders her and buries her in the sand. – In this way Munch retold his "experiences on the foreign coasts of love", quite simply and naively. That Dr. Linde's suggested cure really was successful, we have evidence for in Munch's own words: *A strange peace came over me while I worked on this series of cartoons. It was as though all malice left me.*

There is very little relationship between the self-searching self-portraits from the unhappy wandering years, and this Munch who painted himself in Dr. Jacobson's clinic. He uses the same long powerful strokes as in "Death of Marat", forceful red and blue-violet strokes. A strong will and an out-going attitude seems stamped on the expression of the people he sees. This man knows that his crisis will soon be a thing of the past. He feels as sure of himself as when he painted the self-portrait with the cigarette in Paris fourteen years ago – now he lets the chalk portray a conquering Munch surrounded by the curling smoke of his cigarette.

HOME TO NORWAY

And now he was successful even in Norway. This time of mental illness was also the pont at which he achieved recognition in his own country. Already in 1907 there was a change in the tune of the critics and the opinion of the public when he exhibited in Oslo. But when Jappe Nilssen and Jens Thiis in 1909 arranged a gigantic exhibition with a hundred paintings and two hundred graphic works, his victory was complete – apart from the intrigues and the newspaper discussion concerning the National Gallery's purchase of five major works. However, with perfect self-assurance Jens Thiis concluded the discussion with: "It's still too early to judge whether this purchase will be crowned with honour, or dishonoured." The first result of this bold purchase was, by the way, that a private individual made a donation to the Gallery of sixty Norwegian works of art, among them several Munch pictures.

In the eyes of the "bourgeoisie", this recognition was now quite easy, because Munch the previous autumn had been made a knight of the

Order of St. Olav. Rightly enough he himself felt a little ashamed of such a bourgeois honour, and in his rather awkward way he writes: *The St. Olav Order attracted quite a bit of attention at the clinic – the nurses thought it was a lovely brooch.* But in a letter to Thiel he tells about his sincere happiness: *I am not terribly fond of that kind of decoration; but after all it is a sign of appreciation from my country.* And he did appreciate it, he who had been rejected and banished. He felt it to be a public reinstatement after years of struggle and malicious persecution. During the exhibition the patient in Copenhagen received a cheery letter from Jappe Nilssen about his success: "No previous exhibition has attracted so many people or sold so much. There seem to be, God help me, tags with the word "SOLD" on them hanging on over half the pictures there. The place is black with people." Munch knew what friendship and mutual appreciation was. When his friends eventually could wire him the financial details of his success (50,000 N.crowns) the happy patient in Copenhagen invited them to have "a regular fizzer of a spree" in a private room at the Grand Hotel in Oslo. The three friends had a telephone on the table with an all-night connection to the bedside of the celebrated patient in Copenhagen!

On the boat home, a friend who accompanied him encouraged Munch to participate in the competition for the murals that would grace the University Festival Hall in Oslo. There was to be a centenniel jubilee in 1911. And safely home in Norway, he found the place that was to provide the inspiration for his monumental major work. *This is where I want to stay!* he exclaimed when he saw the white houses of the little shipping center, Krageroe, and the same day he found the mansion which was to be his home and place of work. He had found the place he had dreamt of at the clinic. With the thought of the new life that was now to begin he wrote to Sigurd Hoest: *I'm looking for a house. I want the open sea, I'm not going to die along with all the half-dead fish in that stinking Christianiafjord.* (Oslofjord) It was here that he was to settle down in peace during rich and creative years, perhaps the most harmonious years of his life. Without committing himself, he learned to know the small town and its people, and as recently as in 1942 he was to write to Gierloeff, who lived there, about how he appreciated this *white pearl among the coas-*

Self-Portrait, oil 1909 RMS Bergen.

tal towns ... I will always have a high regard for that consideration that was shown me when I happened to be cast ashore there. It was the evidence of an old culture, and the respect for art – even though my own art, no doubt, was incomprehensible to them. The next year, he talks of a speech, which in his happiness he would like to make to his friends from a mountain height – it was not a long speech: *I am like Jonas who was cast ashore from the belly of the whale and seeing that the land was good, settled there.*

It was here that he invited those friends who had not deserted him, Germans like Kollmann, Schiefler, and Curt Glaser, as well as Nor-

wegians. Here, in peace and quiet, he could develop the kind of friendships he had such a gift for, he could sit with his nectar of the gods, unfermented malt beer, while old Boerre, who later became the inspiration or the painting "History", went to town to fetch wine for the guests. One by one, he painted those of his friends who had not been portrayed before, to complete the *bodyguard of his art.* Jappe Nilssen and the others took their turn according to the monumental scheme Munch had already started on in the 1880's.

"THE BODYGUARD OF MY ART" AND OTHER PORTRAITS

The portrait painter Munch has, as a matter of course, been touched upon in all of the previous chapters – both in illustrations and text. The young artist, naturally, found it necessary to paint "cheap" models, himself, and his closest relatives, but soon the circle of those

Self-Portrait, lith. 1908
OKK 277.

Opposite: Winter in
Krageroe, oil 1912
OKK 392.

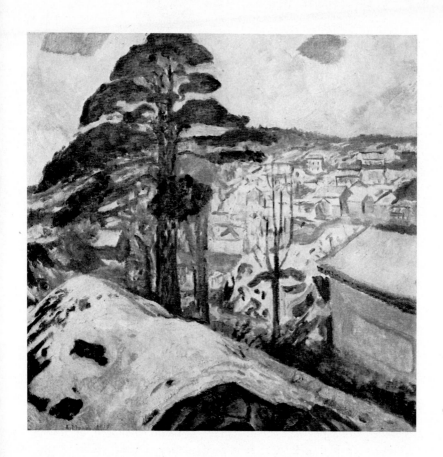

portrayed widens to include the friends of bohemia and the Berlin and Paris group. At an early point, the design itself of many of these portraits seems to be a forerunner of the life-sized portraits that were to come in the beginning of the new century. When he develops the line further, from the painting of his sister Inger in her confirmation dress, to paint Przybyszewska in Berlin in 1893 (pp. 53 and 96), we notice that he was driven to work on a monumental scale.

A good example of it can be seen in this directly frontal portrait of Dagny with her hands behind her back. The figure is sharply defined in contrast to the more diffuse strokes of the background, and the for-

mat, almost a yard and a half in length and a yard wide, tells of the monumental effect he was trying to achieve. That he was developing a strong urge to work on a large scale may be seen already in 1885 when he painted the "scandalous" portrait of Jensen-Hjell (p. 55). As I have mentioned, the format and pattern of this work is representative of the plan he had for the great portraits that were to come, some done on commission and some done on his own. Seven years laer, he followed up by painting his twenty-four-year-old "Sister Inger". There she stands, turned slightly to the right, with her shadow suggested against the blue-white wall, so sharply contrasted with the red floor. There is something quite formal, almost hierarchical about this young lady, an effect that we find again in many of his large, representative portraits.

The portraits were among the first of Munch's works to be more or less accepted by the public and the critics, although they were considered caricatures. Munch himself understood his strange ability to bring out some inner truth about his models: *I can see the person behind the mask,* he wrote and when he felt that he knew them and was satisfied with his work he could exclaim: *I'm shooting at a target and when I hit it, I hit the bullseye.* To what degree he could expose the weak points of his models, is evident in the painting of a well-known Oslo barrister, a Munch admirer and a socialist. Munch had been ironical towards this sophisticated socialist, and painted him with a top hat and a cane against a fiery red background. The barrister had refused to accept a painting he had commissioned of his four children, he was not satisfied with it, but he was sentenced to pay for the painting. In a joking way, the newspaper *Intelligenssedlerne* wrote: "It is seldom we have the opportunity to see such a good painting of children. If it resembles its subjects we cannot say, but one thing is certain – the children resemble Barrister Meyer!"

How was it that he got "behind the mask"? It seems to have been through the use of the shy person's old method – continual nervous talk. When Mrs. Förster-Nietzche asked him why he talked so much he was said to have answered that he was building up a wall of words between himself and the model in order to paint in peace behind it. Concerning a stubborn model he wrote, *he works on a short-wave length and won't let himself be anesthetised by my long-wave*

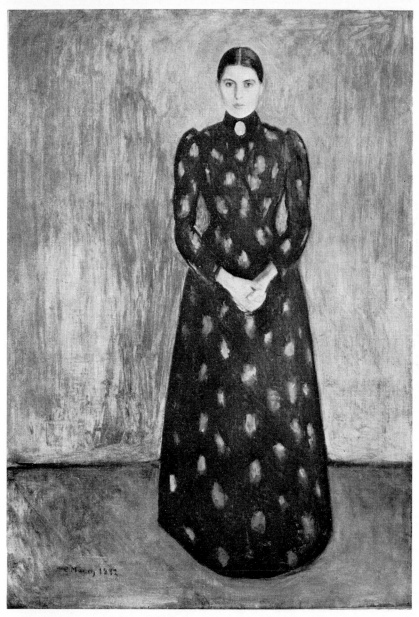

The Artist's Sister, Inger, oil 1892 NG.

talk. I must have people anesthetised if I am going to paint them and my foolish talk is restful to me. And another of his methods was to produce a bottle of wine to soften up his models.

The first decade of our century was devoted to these great portraits, and his pattern is the same as the one he worked out for the great portrait of "sister Inger" almost ten years earlier. He keeps the pale background, often with a suggestion of a door, a rug or something like that. As in his other paintings, he emphasizes the front view to accentuate the person. This is quite evident in the double portrait of the Noerregaard's, painted in the last years of the old century. It is the strong personality of his important friend, Aase, that interests him the most. She looks straight at us, while her husband is in profile. We see her in the same way in other portraits, and it is she who leaves the group and comes directly towards us in "Ladies on the Quay" from 1903. In the double portrait of the two Parisian friends a few years earlier, it is the painter, the red-headed Paul Hermann with his triangular face who interested Munch, and not the other, the dark one, the so-called Assyrian.

In the same way we have front views of the self-confident friend Schlittgen (p. 101) and the relaxed, thoughtful Swiss-French author, Achinard. Munch's desire to show individual character traits fits well with his equally strong desire towards monumentality. The keen characterization and the monumentality make paintings like these typical – in the real meaning of the word. It is more than a coincidence that these two pictures were called by Munch himself "the German" and "the Frenchman".

He departed from the frontal view in the great portrait, as monumental as it is humorous, of the gay and spirited Consul Sandberg, a friend of artists and an understanding sympathiser when the world seemed against them. As he worked on this portrait, the imposing corpus of the model seemed too big for the canvas, and the first time it was exhibited, the canvas had to be folded up at the floor line – later a piece was added to make room for the left foot. A frontal view would not have said as much about the bodily abundance of the model, standing there in front of the white door. The severe composition is

Consul Christen Sandberg,
oil 1901 OKK 3.

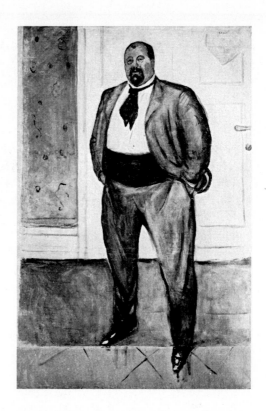

tied into a whole through the colours. The yellow-green colour of the
wallpaper is repeated in changing shades, both in the figure and in the
floor.

The commissioned portraits have the same character as the portraits
done of friends, and it is an interesting thing that the friends are por-
trayed in the same representative way as those who commissioned their
portraits. In all of these pictures, the monumental is united with a deep
individualism – whether he is characterising the thinker and industrial
magnate who later entered politics: Walther Rathenau, or the art-
critic and friend from his summers in Aasgaardstrand: Jappe Nils-
sen, painted as an aware, though relaxed spectator: whether he is
characterising the self-confident Jens Thiis, in his study for a large

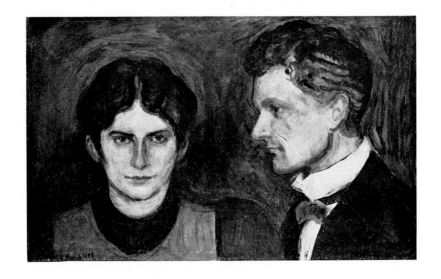

portrait, or his elegant colleague, the gallery director, Harry Graf
Kessler, whom we also find in a head and shoulders portrait. Into his
portrait gallery he also puts the painter Karsten in his white suit, al-
ready in 1905, and that same year he portrays himself with palette
and brush. The latter picture is quite different from the self-searching
paintings, for example: "With a Bandaged Hand" from that same year
or "With a Bottle of Wine" the year after (page 193). Like the other
paintings in the same series, this is a representative painting of himself
with the tools of his trade.

It was after coming home, that Munch again took up the tradition
from 1901 and painted portraits of his friends without any particular
thought of selling them. Even if, however, the portrait of Gierloeff,
which had a landscape in the background, was sold to the museum in
Gothenberg. Most of the other portraits, nevertheless, remained in
Munch's possession. Perhaps he was thinking of making a hall of honour,
hung with portraits of those who hadn't failed him, in the museum of
which he was already dreaming.

By 1912 this special series was pratically finished, although he con-
tinued to paint portraits. In that year he painted "Christian Gierloeff

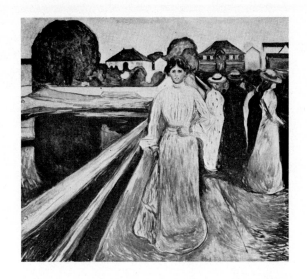

Opposite: Harald
og Aase Noerregaard,
oil 1899 NG.

This page: Ladies
on the Quay, with
Aase Noerregaard in
the foreground,
oil 1903 Bergen
Billedgalleri.

with his Wife" using even richer colours in the background. Gierloeff
is portrayed, powerful and self-confident, sitting on a stool; and his
wife stands – apart from him – almost like a pillar between her hus-
band and the wall. This picture too, remained in the artist's possession
and he used it many years later as the basis of an illustration for Ib-
sen's "The Pretenders". – There is always a continuity in Munch's
art.

This series of portraits, his patrons and his friends, could of course
be enlarged by adding a number of his more ordinary portraits, such
as the charming painting of the actress Ingse Vibe Müller with the
white hat. Quite apart from what he produced in these years, and in a
class by itself, is the great Nietzsche portrait. It was a commission
from the Nietzsche admirer Ernest Thiel. It was Thiel who brought
Munch to Thüringen and Weimar, where he stayed for a long time at
the resorts, finding out as much as he could about the poet-philosopher
who had died five years before he was commissioned to do this work
(1905). He was not accustomed to this type of work although earlier
he occasionally had also used photographs in connection with com-
missions for portraits. But now he studied the works of the poet and

231

his milieu – one of the studies for the portraits shows, for example, Nietzsche at a table in front of a window through which one sees a mountain landscape. But he concluded by painting this great philosopher of his – and of his period – out of doors, leaning against a railing surrounded by what Munch himself called: *a melancholy landscape*. Munch thought himself closely related to this thinker, who having poor health himself had said "there can be no deeper knowledge without illness, and the peak of health is reached through purifying illness."

While working on this commission Munch wrote to Thiel: *I have chosen to paint him (N.) in a monumental and decorative way. I don't think it would be right for me to paint him in a sensuous way – as I have never seen him with my own eyes . . . I have painted him stand-*

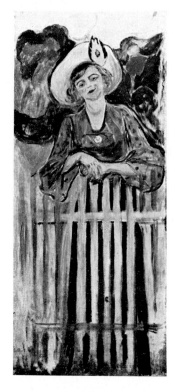

The Actress, Ingse Vibe Müller, oil 1903 OKK 272.

Opposite: The Frenchman, oil 1901 NG. Aase Noerregaard, oil 1903 OKK 709. Harry Graf Kessler, oil 1906 National-galerie, Berlin.

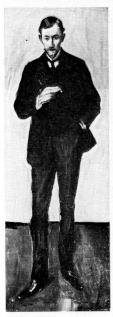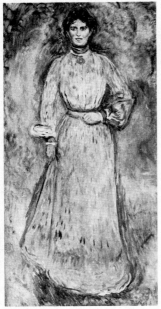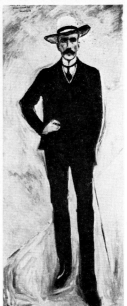

ing on his veranda and looking down into a deep valley, with a glori-
ous sun rising over it. The sun has disappeared in the two final pain-
tings; but its light floods through the sparkling colour of these pictures,
you see it shining in the red and yellow behind the blue figure of
Nietzsche. Goesta Svenaeus has seen this picture as part of a greater
whole and gone into the historical and environmental background in
a way that is beyond the scope of this book.

We recognize the composition from earlier paintings, the long rai-
ling on the veranda outside of "Zarathustra's Cave", slanting inward
so that it gives dynamic power to the composition. This movement is
only stopped by Nietzsche's powerful figure outlined against the soft
swinging curves of the valley and the mountains. The painting was a
great success in those circles that had the opportunity of seeing it, and
Munch suspected there might be great possibilities of improving his
still quite poor financial situation. Two years later, therefore, he pro-
posed painting both Ibsen and Bjoernsen, as well as Strindberg and

233

Friedrich Nietzsche,
oil 1905–06 OKK 724.

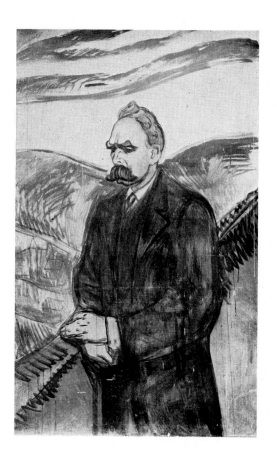

Drachmann *in the same decorative way as Nietzsche, that is to say
not like photographs the way most painters produce portraits ... I must
try to get a regular income, if I want to live and paint in peace.* Un-
fortunately, nothing ever came of this series, whether it was because
neither Thiel or anyone else commissioned it – or because of the
nervous breakdown three months later.

The Last Munch Battle -
The University Murals

The last great Munch scandal was of quite another character than the earlier ones. Munch had to face opposition from the University faculty, who built up a wall of antagonism and disapproval towards genius and unconventional talent, in the same way in which other University authorities, in other parts of the world, at other times, have done. There were many intrigues, and in these limited circles Munch was met both with malicious cruelty, as well as generous understanding. As the quarrel developed, however, Munch won the favour of both the public and the newspapers (with the exception of *Aftenposten*).

The first competition in 1910, limited to five participants, was a failure; but when Munch the next year competed with the sculptor Gustav Vigeland's brother Emmanuel, who was best known for his church decorations, the decision should have been clear. The jury unanimously refused Vigeland's study, while two of the jury members with a few small reservations, were in favour of what Munch had submitted. The third jury member, an old professor of art history, who was representing the University, had tried to withdraw from the jury, pointing out that he had "weak eyesight". "This makes it impossible for me to perceive a decorative colour effect, which is so overwhelming, that classic conceptions of correct design and completed composition just collapse. For this reason I suspend my judgement." – He was obviously under pressure.

All the same, the University said no. It was first in 1914 that a new faculty accepted the decision of the jury, thanks to the efforts of Jens Thiis, who was a member of the jury. But the final acceptance was perhaps even more due to Munch's own efforts – and also to the fact that now again he was successful abroad.

Already in 1910, Munch exhibited 6 studies for the decoration as well as two other sketches. Despite a lot of difficulty, the next year he was able to use the auditorium itself to show some of the studies.

235

This exhibition included all of thirty pieces, and now one could see "History" full-size (18" x 46½") in three different versions, as well as another version, half-size. On the same scale was the main painting for the opposite wall, "the Researchers", as well as "The Sun", done in coloured chalk. There were studies to fit all the areas to be decorated. In 1912 a collection was started to pay for, at any rate, "History", which was even exhibited in the place it was designed to fill.

That same year Munch and Picasso were the only living artists to have their own room of honour at Sonderbund's great international exhibition in Cologne. It was very evident that Munch had become one of the classics of modern art. During these years he also exhibited in ten capitals and big cities, among them New York, and in particular he was praised for the University Festival Hall murals. During the autumn of 1913 he participated, by invitation, in the Berlin Secession with twelve of the University paintings in quarter size, and it was even suggested that these could be purchased for the Jena University, if they were not used in Oslo.

Even a casual reader of newspapers must by now have discovered that Edvard Munch had become world famous and that it might be a good idea to re-evaluate his art. Thus, when Munch had exhibited these paintings in the final version in 1914, even the University had to capitulate, and in 1916 the University Festival Hall paintings were finished. Langaard and Revold perceived what had happened in this way: "After seven years of adversity and untiring effort Munch had succeeded in completing this work. A beautiful and spirited decorative hall had been created, the first in Europe to show that an artist did not have to be a single 'stylist' in order to realize his artistic vision as a mural. Quite the opposite – it was possible to make the greatest use of his own artistic effects, the modern effects that belonged to his own period."

We have said earlier that there is always a continuity in Munch's art, and no one understood that so well as he himself: *the "Life Frieze" should also be studied in connection with the University Festival Hall murals – because in several respects it has been a forerunner for them and without the 'Life Frieze' these University murals could not have been done. It was the Frieze that developed my decorative*

236

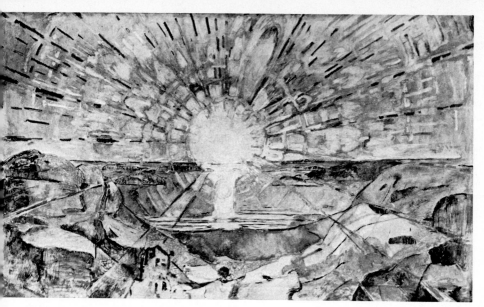

The Sun, main mural in the Festival Hall, Oslo University.

sense. And the concepts they represent should also be seen together. The "Life Frieze" presents the sorrows and joys of the individual seen at close hand – the University murals present the larger eternal forces.

The "Life Frieze" dealt with "love and death", individual experiences that were universalized. At the age of fifty, Munch now has the desire to free himself from himself and his own experiences, and to meet the world as it is. Mystical philosophising is replaced by the realities of life; but these too become classic and universal, in the same way as his personal experiences. We have already met this new attitude in the cheerful paintings of the bathers from Warnemünde, with their new use of colour. And equally interesting, we see that these paintings are related to what was created elsewhere on the continent: the period just before the first world war was the great era of vitalism in a world that was still optimistic. In Scandinavia it was the time the Danish artist, Willumsen, had his breakthrough. But in the University murals, Munch, the vitalist with his bathing men, has obediently followed the lines of the classic architecture, and we see him as never before, or after, as a classic. Yes, that is what he felt himself to be, while he was working with the University murals. In

237

connection with the Cologne exhibition, he wrote a letter saying how happy he was that he had been given the largest room at the exhibition, and goes on to say: *Here* (in this exhibition) *the most radical paintings from all of Europe have been brought together. I, myself, am a faded classicist beside them. The Cologne cathedral must be shaking on its foundations ...*

The decorative areas in the University Festival Hall were planned by the architects, and concerning his use of them, Munch writes in 1911: *While the three main paintings, "The Sun", "The Researchers", and "History", should have a heavy and imposing effect, as bouquets in this hall, and the other (eight) works should have a lighter, less dominating effect as a transition to the style of the room, providing a framework for the major works.*

His original lack of success with the University murals during that previous year seems mainly due to the study for "The Human Mountain". In this sketch we can see the same mystique we know from the "Life Frieze"; and the motif itself was nothing new. We have already seen it in "Marche Funèbre" from 1897 (p. 161), and other artists too were interested in the motif of "The Human Mountain". It is to be found for example in the many studies Gustav Vigeland made, working towards his "Monolith" in the famous sculpture park. In this study for the "Human Mountain" the mood from Nietzsche's "Zarathrustra" lives again under Munch's own melancholy moon from his works of the '90's. But the fact that this moon has become a sun and that the mountain of struggling human beings has changed its title and is called "Towards the Light" in this new version, is evidence of Munch's development and struggle with himself during these years. Munch continued to work further with this motif until the end of the 1920's; but fortunately he was able to develop his "Sun" already in 1911. It is fascinating to follow the development of this concept and see the life-giving and stimulating sun becoming more and more powerful. In the end the depiction of the sun grew so large that the groups of sun-worshipping men had to be moved over to the side-panels, displacing what was originally planned for them. "The Sun" itself dominates the central panel, dominates in fact the whole room, as it rises

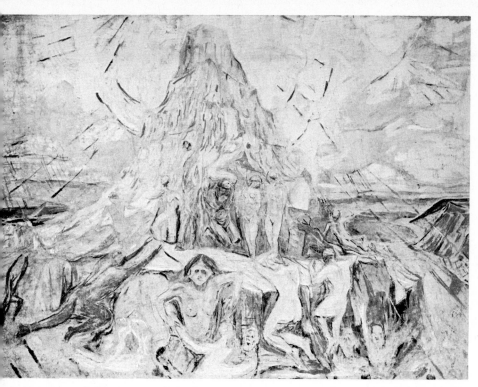

The Human Mountain, study for the main mural in the Festival Hall, Oslo University OKK 978.

over an accurate section (proven by photographs) of the scenery which surrounded him in Krageroe. Accurately reproduced yes, but monumentally simplified. This white-hot sun spreads its rays, in all the colours of the spectrum, over the whole auditorium – tying together all the murals. We understand what the "stripe method", developed before and during his time in the hospital, has meant for him when we see it in this grand composition.

From the time of the first competition in 1910, the study that was to become the side wall "History" was obviously a winning entry. (It was originally planned for the central panel behind the stage.) Munch himself was never satisfied with these studies. Already the following year, as we have mentioned, he submitted all of four large studies, accompanied by these simple words: *"History" shows in a distant, almost historic landscape, an old man from the fjords, who has truggled*

History, the main panel on the left wall, Festival Hall, Oslo University.

through the ages, now surrounded by a wealth of memories that he can impart to a fascinated little boy. The canvas, almost 36 feet long, contains only this great gnarled oak tree, an old man, a little boy, and a primeval Norwegian landscape.

The historian P. A. Munch's nephew has created a symbol of history as clear and simple as the composition itself: the oral tradition that linked generation to generation. The motif is taken from everyday life, the grandfather who tells a story; but yet the work is monumental and full of dignity. The peaceful dignity sings in the harmony of the colours, in the many-changing shades as the greys change to blue. The old man sits under the oak tree as though he had been sitting there forever, and the colours of his patched clothing find their reflection in the roots and branches of the great oak. This happens to be a particular oak tree, which with Munch's strange sense for detail, is reproduced even down to the scars made by the ropes of a child's swing. You can see them in the large branch that ties the whole composition together. The oak is as faithfully reproduced as the storyteller, who was Munch's handyman, old Boerre, who had sailed on all the oceans, and was full of stories.

Munch had to look for another type of scenery when he started to work on the opposite wall, "Alma Mater", which was to symbolize both fertility and the University. He had bought some property on the east side of the Oslo fjord – yes, and even rented still another piece of property – and there he found what he needed. As in Krageroe, he built several large open-air studios. His financial problems were over; but it sometimes happened that he felt his peace and quiet threatened.

240

Alma Mater, Festival Hall, the main panel on the right wall.

In a letter to a friend, he defends his right to have a private beach, breaking out with: "what is more important, I ask, that your children have a place to bathe or that Alma Mater's children bathe?" In its colours, this fertile fjord landscape has little in common with "History". But in its composition there are similarities. Instead of the mighty oak tree, we have a group of trees on the right; in both paintings the composition is concluded by trees on the one side, but open towards the powerful "Sun" on the back wall. On the one panel we are led over low rocky cliffs towards the sea, and on the other, we have the open arm of the fjord beneath the blue mountain ridges. On that open landscape, the scene is dominated by a realistic Alma Mater with a child at her breast.

The Researchers, designed for the main panel on the right wall of the Festival Hall OKK 962 (sometimes called: The Explorers).

16 – Munch.

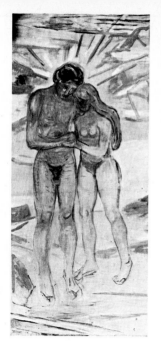

But Munch was not satisfied, and this panel worried him well into the 1930's. At that time he was even considering moving Alma Mater into an inland landscape. This doubt of his, about the painting, went all the way back to "The Researchers" which he had exhibited full-size in 1911. In this painting too "Alma Mater" dominates the landscape, a landscape which contrasts with that in "History", reflecting as it does another side of Norwegian nature and spirit, summer and fertility, the drive to explore new fields, win new knowledge, and perform heroic deeds.

The symbolism in "The Researchers" is simple. Almost hierarchical, but at the same time vigorous and earthy, "Alma Mater" rules over her servants, the research workers or, "children", who explore the nature around her with never-ending curiosity. When the University, in 1946, was going to mount the canvases again after they had been stored during the war, there was doubt about which of the two paintings should be hung, the same doubt that Munch had had throughout his life. "Alma Mater" was chosen mostly because it was in better condition. "The Researchers" has been hung in the Munch Museum.

Opposite: New Rays,
Harvesting Women,
Chemistry.

This page:
Women Turning towards
the Sun.
Men Turning towards
the Sun.

Munch's plans changed while the work was in progress, and after he had decided not to use "The Human Mountain" Munch thought of placing "The Source" in the panel that was later given to "The Sun". When you go into the Festival Hall today, you find "The Source" in the first panel on the "Alma Mater" wall. In a straight vertical, the falls pour down from the source of wisdom (or perhaps life), and two people stand out against this background, drinking the life-giving water. The frame of the panel literally restrains this decoration from flowing out towards us. But on the other side, the landscape composition continues towards "The Sun" and we are reminded of Munch's statement that the shoreline was to wind itself through the "Life Frieze" giving the pictures continuity. Against the background of fjord and blue mountain ridges, two women stretch out their hands to pick the apples, the symbols of the rich harvest in this land of Alma Mater. The women picking apples is a motif we recognize again, both from the "Linde Frieze" and other works.

It is particularly "The Human Mountain" that tells us how the ideas from the '90's continued to interest Munch. To the exhibition in

1914 he submitted "Man and Woman" giving it the new title of "Metabolism" (p. 126). This painting he regarded to be the "buckle" in the belt of the "Life Frieze". He makes this quite clear: *both the "Life Frieze" and the University murals are represented in the "Life Frieze"'s large picture "Man and Woman in the Forest with the Golden City in the Background".*

Even if this painting from the turn of the century was not part of the university murals, related pictures showing man and woman frame "History" – whether they are *illuminated by new rays, heart to heart,* or *poring expectantly over glowing flasks, both pictures containing the spirit of the future.In the first painting the colourful rays of the* sunrise point to the new day that is dawning, and in the other painting, children, in the smoke of the chemist's flasks and test tubes, give witness of the coming generations in the age of research. This is the only panel where Munch has used more imaginary symbols to tell of research and life.

In spite of the Festival Hall's classic character, the motifs Munch used were not borrowed, either from the classical period or any other period. Like everything else that Edvard Munch has created, all these paintings are part of himself, part of the nature that he knew. Here again he has used the painting methods that were particularly his own during these years. In solving this very special commission he did not turn classicist, but became classic himself. As in the "Life Frieze" paintings, he has universalized his own experience, and made it timeless – that is something that is quite rare in great contemporary decorations, whether we find them in Oslo or in other parts of the world.

The Importance of the University Murals
New Monumentality

Edvard Munch himself gives an explanation of the final remark in he last chapter, when he says: *Great mural art must be whole-hearted, soulfull, or else it becomes mere decoration.* Whatever the task he has set himself, it is his whole-hearted involvement that makes his work great. This is especially true with regard to his major work in the University Festival Hall (or: Aula.)

As a deeply involved artist, his own being was central to him throughout his life. He wanted to know himself, the source of his work, and therefore he made himself a subject for research in the many self-portraits, *these self-examinations during difficult years.* His own complex personality becomes so important that he also identified himself with his symbolic figures and often presents himself as "a substitute" – to use Paal Hougen's expression. In more or less universal and symbolic representations we find his own features, and when he in the middle of the 1920's again takes up "The Human Mountain", even the bi-sexual sphinx in the foreground bears the traits of the artist. There were so many symbolic thoughts in that time, the productive nineties, and it is more than a coincidence that Przybyszewski published at that time a book with the title, *Androgyne.* Whether we find him in the pure self-portraits, or as a "substitute" in other representations, he reveals himself completely. He studies himself in exactly that imaginary or real situation he happens to be in. Thus we see him in "The Blossom of Pain" and in "Death Dance" (pp. 50 and 286) and he identifies himself with both Osvald and Peer Gynt.

He was unusually handsome and attractive; but everyone also mentioned his aristocratic reserve. All the same, he sees himself as an interesting subject for research and exhaustive examination. The purpose of this research is to get "behind the mask", whether he sees himself as naked "in hell" (p. 160), as the victim of illness in "The Spanish Flu" or "Inner Tension". When he develops an optical

illness in 1930, he realistically studies his own eyes and the hallu-
cinations he suffers. As an artist he exploits this reserved personality
almost shamelessly. As an old man he writes to Jens Thiis jokingly:
*I haven't been out among people since the last time I was at your place.
My hair has grown down to my shoulders and my beard to my chest.
As as result I have a fascinating free model every morning when I
can paint myself naked and skinny in front of the mirror – this can
be all the Bible paintings repeated: Lazarus, Job, Methuselah, etc...*

But as we have repeatedly noticed, it is his interest in the out-
side world, and other people, that steadily increases in this self-exa-
miner. He was an eager, but irregular newspaper reader; interested in
politics, even though he complained about the time it took to read the

Munch and his friends go for a drive, Damstredet, Oslo 1910–15. Beside the
driver, Christian Gierloeff, behind him, Albert Kollmann. In the back seat Munch
himself. He invited both German and Norwegian friends to visit him during the
Krageroe period.

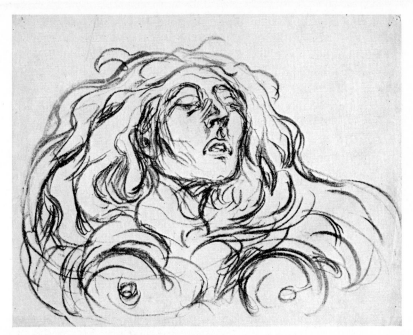

The Sphinx, drg. 1909 OKK 2453 (see The Human Mountain p. 239).

newspapers. His friends tell us that he could make the most surprising statements concerning, for example, political conditions in Mexico. In the middle of painting the University Festival Hall murals, the First World War broke out and one of the university motifs, called "The Apple Pickers", became a poster for a Norwegian exhibition in Copenhagen with the ironic title "Neutralia". The two Nordic sisters are seen harvesting the fruits of war, while the seaman who created this wealth, sinks with his ship. The life-giving spring of Wisdom becomes "The Blood Falls". The World War also inspired a lithographic series "Europe Rising from the Ashes", and as we might expect, he takes up again the motif of "Metabolism", rotting old life giving birth to new.

Apart from a powerful political involvement when Norway broke away from Sweden in 1905, an involvement he shared with most all Norwegians, we don't really find that Munch had serious political in-

terests. But way back from the "Seamstress" period in the bohemian milieu, the east-side doctor's son was interested in the little people in the community. During the time just before the First World War, he discovered workers near by and their role in society. When he painted his first workers in Warnemünde, the black mechanic and the white mason were probably mostly an aesthetic experience. But now he sees a new class emerging, and he understands that they are the ones he must reach through his art and his motifs.

He puts this literally into a larger picture. Munch feels that the time of small paintings is past, they were intended to decorate the rich man's home: *during the French Revolution the middle class was, fighting for their human rights, in our time it is the workers, and it is only right.* In another note he asks: *Perhaps art once again will become the property of everyone as it was in the olden days – it will appear in public buildings and even on the streets? Frescoes?*

The University Festival Hall murals made him a painter on a mo-

 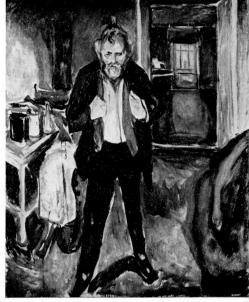

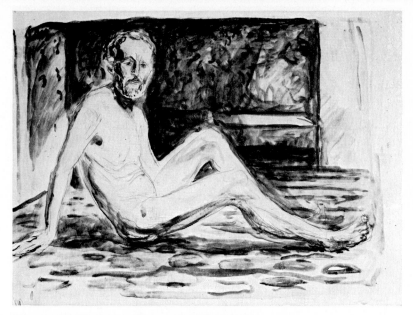

Opposite: Self-Portrait in Bergen, oil 1916 OKK 263.
Inner Tension, Self-Portrait, oil 1919 OKK 76.

This page: Self-Portrait, 1933/34 water colour OKK 2462.

numental scale, and it is certainly with the thought of new decorative commissions that Edvard Munch now begins to paint large canvases with subject matter from working life, the kind of subjects the new generation of Norwegian artists, several years later, were to present as murals.

In 1928 the architects of Oslo's City Hall, which was still in the planning stage, asked Munch to make suggestions for decorations. They knew that he had been working with motifs from working life and they turned to him, independently of the arranged competition, as Norway's greatest and most recognized artist. The previous year, the two greatest exhibitions that have ever been held of Munch's work had reenforced his position. Ludwig Justi had emptied the Kronprinzenpalais in Berlin for an exhibition of 223 Munch paintings, and in Oslo the National Gallery had also been emptied in order to house an even

249

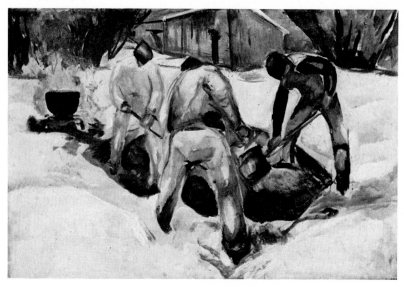

Workmen Digging, oil 1920 PC Oslo.

Opposite: Workmen in the Snow, oil 1912 OKK 371.

larger exhibition with 289 paintings in addition to water colours, draw-
ings, and graphic work.

 These exhibitions are surely part of the reason for the City Hall
architect's request to Munch. The next year he had his suggestion
ready in one of his open-air studios, glued and patched together and
with bits of painted canvas or paper as his habit was. It was a large
work, both in its composition and its format, with a width of over
seventeen feet. As so often before, he used bold motifs in a new com-
pound composition, in this case three older paintings. "Workmen in the
Snow" is both in its content and form amazingly related to the "Bath-
ing Men" from Warnemünde. In that same *en face* way the confident
leader of the team of workers comes towards us, a direct piece of real
life. He and his companions are outlined against the white snow, and
the three main figures are connected by the line of the hill behind
them. The contrast between the sweaty black snow-shovelers and the

250

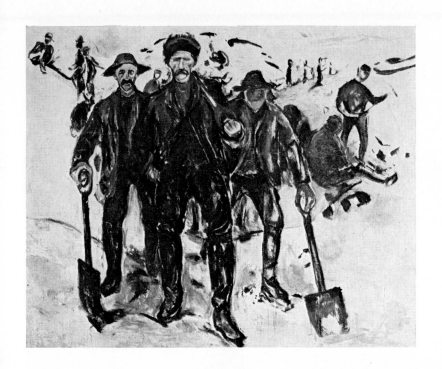

white snow makes the picture almost three-dimensional, and it is no coincidence that we find two of these figures again in one of the few sculptures we have from Edvard Munch's hand. In the large study, the hill itself is more defined and bold. Munch outlines a concentric arch that ties together the whole composition, and includes two other older paintings. Like the monumental "Workmen in the Snow", the "Snow-shovellers" on the right of the large study were first created during the beginning of the competition for the auditorium decorations. Both of these paintings are based on his observation of men at work on a snowy day in Krageroe. We can participate in these observations ourselves when we study "Workmen Digging", this group of men working near a cauldron over an open fire.

The City Hall was not started before 1933, when Munch was already seventy years old, and the eye trouble that he suffered from during those last three years can also have been one of the reasons that his

251

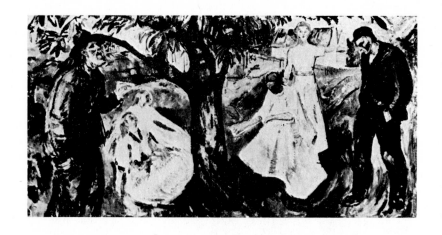

plans for City Hall decorations were never realised. But due to Hitler's "clearance sale" of Munch paintings from German museums, one of Munch's major paintings has all the same been hung in the City Hall. This is "Life", that today enhances the room used for civil weddings.

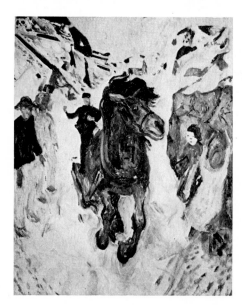

Above: Life, oil 1910 Oslo City Hall.

Galloping Horse, oil 1912 OKK 541.

The Woodcutter, (also
called: The Lumber-
jack) oil 1913
OKK 385.

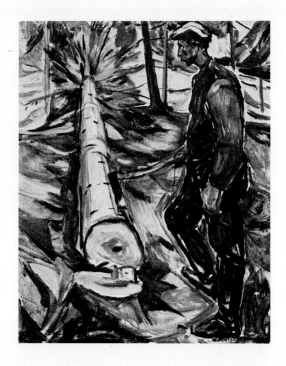

This painting from 1910 fits into the changing ranks of preliminary
studies for the University paintings. The symbolism and the compo-
sition is as simple as possible, with the figures of the old man and the
young man framing a scene of fair women under the tree of life.

One of Munch's worker paintings differs from the others, it gives us
something more than a picture of people at work. Munch may have
sensed something of the irresistible power of a social class on the
march, when he in 1915 painted "Workmen Going Home". Has he been
listening to "Millions on the March"? We can not avoid them as they
march directly towards us. Boldly forshortened as the figures in the
foreground are, the whole group takes on dynamic power, and the
long compelling perspective lines seem to draw the spectator right into
the painting. You could call it a picture of solidarity; but there is no
propaganda in it, just the impression of an unusually sensitive man,
one of the fathers of expressionism.

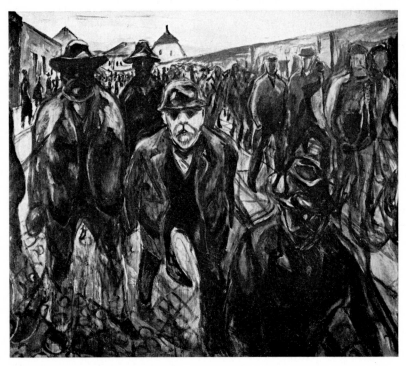

Workmen on their Way Home, oil 1915 OKK 365.

While new movements in Europe were turning away from perspective as a means of expression, Edvard Munch continued undisturbed to develop his own line. From the time he painted "Rue Lafayette" (p. 23) he deliberately used perspective in his art. When he painted "The Woodcutter" the whole picture sparkles with colour and the free, broad brush strokes of pure delight. The composition is tied together by the fallen pine log, that lies directly inward into the picture, so that the perspective carries straight through to the decorative treetop.

If even a dead log can be dynamic – then what about a "Galloping Horse"? The sight of the horse that has started to gallop in the middle of the steep and narrow road must have moved Munch. Fascinated by the sight, he had gone home to put this dynamic picture of power onto his drawing pad. A cautious grown-up and frightened children quickly

give way, while the driver, securely planted on the sled, obviously has full control over the situation. The perspective is emphasized by the horse's broad chest and the powerful wild head with the flying mane, that shows up dark and threatening against the white snow.

During the work with the University decorations, Munch had above all experienced the close connection between simplification and monumentality. "The Woodcutter" is in its simplification a monumental painting, the same as "Workmen in the Snow". "The Man in the Cabbage Field" is in himself a monument, there he wades stolidly towards us with the harvest in his arms. Also here Munch achieves the monumental by using lines of perspective to give the man bearing and to move him forward over the juicy cabbage leaves with their many shades of fertile green.

For each additional year, Edvard Munch seems now to become more and more a painter and to give himself to the joy of painting. His colours increase in strength and become steadily bolder, the brush strokes freer, and the composition simplified.

Ekely

"The Man in the Cabbage Field" was painted in 1916, the first year that Edvard Munch lived on his new large property, Ekely. It was near Oslo but still a part of the open farm land. Perhaps the one who was closest to him at this time, Christian Gierloeff, thinks that the Krageroe period was he happiest in Munch's life, and that the purchase of Ekely was a mistake: "He had come too near his beloved home town, too close to his painful memories, and had too many surprising new troubles." His troubles were particularly due to his increasing fame; it brought him letters asking for money, demanding art dealers, journalists, and people who wanted to buy. He had to suffer the curiosity of his neighbours – and of their children – he even experienced having one of his dogs shot through the fence. On top of everything else he was continually quarrelling with hard-hearted tax authorities.

Lonely in his self-chosen isolation – and famous. Fame is a burden for lonely people. This disturbing interest on the part of perfect strangers for his life and his art gives rise to a flock of anecdotes, that we shall not take up here. A note from a telephone conversation tells us something about his tribulations: *People imagine they can come out here and buy paintings, that I have somewhat of a country store such as you find in Hamsun's books – that I can pull down paintings like soap or smelling salts from the shelves. But I shall not sell my own paintings any more.* He was reluctant to sell paintings even to close friends. He could send Ingse Vibe Müller and her husband piles of lithographs and be extremely friendly with them, even carrying on long telephone conversations with them during certain periods. But when Mr. Müller, in what was apparently a weak moment, offered Munch 50,000 crowns for the painting of Ingse (p. 232), Munch answered abruptly: *I must have some of my friends on the walls.* He lived together with paintings, not people.

Opposite: The Man in the Cabbage Field, oil. 1916 NG

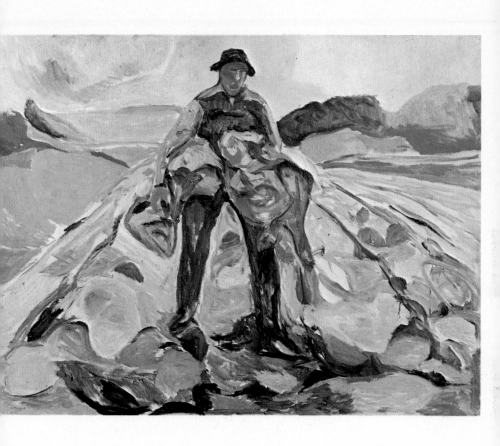

The tax authorities were not able to understand that these works were material to be the basis of new works, and were not accrued capital. His lawyer can produce the most curious letters about the authorities who regularly tried to evaluate his unsold works. Munch sweated over his income tax returns, he worked on them with care and accuracy for days – even for weeks. Yes, at times he even left *that disgusting hole, Ekely* in order to work on his papers in peace and quiet, and he considered changing his home address because of the taxation problem. He suspected *malicious forces behind this persecution.* By talking about "accrued capital", they gave Munch the idea that he had to pay in order to keep his own work: *I think I should be supported rather than suffocated. I have invested my gold, not that dirty gold that can be exchanged, but the gold of the spirit, I have invested it, made the most of my talents in order to further my art for the good of the country and the people.* He tried to explain to some of them something about the *lithographic works that were lying around in piles on the second floor.* He (the tax authority) *could find out anywhere that it isn't the number of prints that increases the value. If that were the case, you could print your own bank notes . . .*

Munch had to keep to the way of life he had chosen in order to follow his own call. I believe Professor Schreiner, his doctor, was the last close friend Munch made, and to him the old man has said: *The last half of my life has been a struggle to keep going. My past has led me along a cliff edge, a bottomless depth. I've had to jump from stone to stone. And now and then I've gotten off the path, and thrown myself into the rush of ordinary life. But I have always had to come back to the path, and follow it along the cliff edge.* So he consciously isolated himself more and more in his own world, the world of his art, protected by his dogs behind the high board wall. Apart from the long telephone conversations, his most important communication with the outside world was by taxi – whether he let himself be driven away from the fog in the Oslo basin, up to a lonely walk in the hills, or had himself taken to an art exhibition before it was officially opened, or simply used his regular taxi driver to send a letter when he wanted to contact friends. He could drive down to the East Railway Station in order to see people around him, people moving, travelling. Or he

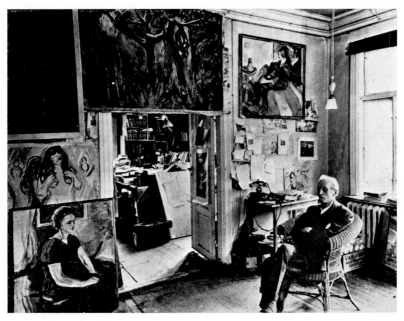
The old artist at Ekely.

would go to the cinema, always with a newspaper in his pocket in order to have something to hide himself behind, during one of the many pauses that were so common in those old films. In sleepless periods he could simply take a night train to Stockholm, because he knew he slept so well on the train. Most of the time he had a house-keeper who was allowed into two of the rooms. But he also had periods when he was completely alone and managed his own housekeeping, in a very simple way. He might buy a codfish, cut off the tail and boil that and throw the rest away. Apart from the room he ate and slept in, all the other rooms were work-rooms, with easels standing around so that he could go from room to room and continue working on paintings he always felt were unfinished and could be improved. The floors were awash with prints, he treated them in the same neglectful way as the paintings.

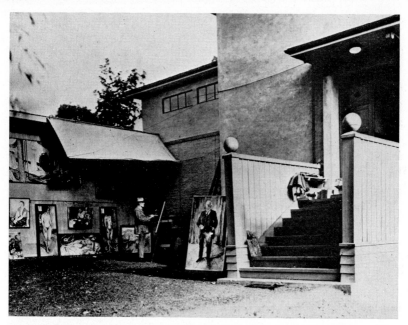

Munch at work in one of his open-air studios at Ekely. On the right the winter studio that was built in 1929.

And as on his other properties, the open-air studios grew, where he stretched out large new canvasses or mounted old paintings together, with a thought of creating new monumental compositions. The paintings were exposed to wind and rain and snow – yes, he hung the new oil paintings up to dry on the branches of his apple trees. He had a kind of a feeling that "his children", the paintings, should live their own life, should get the patina and scratches that life could give them. A *good painting with ten holes in it is better than ten bad ones without a single hole* he said. With the thought of continuing work on the "Life Frieze", and the possible decoration of the Oslo City Hall, he built in 1929 a large and roomy winter studio – which today has become a sort of communal studio and workshop and occasional gallery for all of the artists, who today live and work in the artist colony, Ekely. But the old wooden mansion where Munch lived has been torn down.

Two years after the University Festival Hall murals were finished and had been acclaimed by all and sundry, Edvard Munch made his last great public effort on behalf of his "Life Frieze". In 1918, fifty-five years old, he held that strange exhibition of the "Life Frieze", paintings, and in the catalogue he told about their history, defended them, corrected the critics, yes, even printed again Edouard Gerard's article from 1897 (p. 134..

Now I exhibit my Frieze again, in the first place because I think it is too good to be forgotten, and in the second place because throughout all these years it has meant so much to me in an artistic way, that I, myself, want to see it collected together again. The realization of the Frieze had always lived in Munch's mind: *You have to think of the creation of these paintings during 30 years – one in an attic room in Nice – a couple of them in a dark room in Paris, one in Berlin – some in Norway, always travelling around under difficult conditions, always getting derogatory reviews – without the least encouragement.*

As we have heard earlier, he had hoped that during the Norwegian centennial jubilee someone would propose a national monument, which might contain both his "Life Frieze" and sculptures by Gustav Vigeland, who was beginning to attract public attention. This was before he complained about his tax money going to further Vigeland's gigantic plans.

As in his earlier days of poverty, exhibitions were still the only way he could experience his own work hung collectively, and he continued to exhibit his "Life Frieze" paintings and to remind people about the Frieze in print. He has his own opinion of what a frieze is and what it should be: *A frieze, I believe, can have the effect of a symphony, it can lift itself up into the light and sink down agan to the depths... Even now at Blomquist's (the Oslo art dealer's exhibition in 1918) the "Life Frieze" has the effect of a symphony, of rhythm.* Munch still feels that the frieze does not have to consist of large panels; but his continuing work with it during the years that followed showed that he has paid attention to the critics. He talks about different rooms for the different themes, mentioning in one place, a death room. In one of his studios, for example, he hangs up paintings with a fear and a death motif to make a "Gate of Hell". It was obviously his intention to put the

260

Self-Portrait with
Brushes,
oil, 1905 OKK 751.

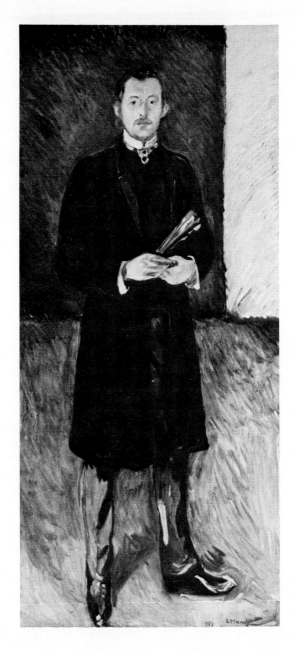

subjects together into a whole, the way he did with the three pictures for the City Hall study. Photographs from the open air studios show, among other things, a row of new "Life Frieze" paintings in the same large format, paintings that today may be found in the Munch Museum. The building that was to be a frame around the "Life Frieze" continued to be, as Munch himself said, a castle in the air. But the Freia chocolate company in Oslo gave him, at any rate, a room to decorate. In the canteen there, the sixty-year-old artist obediently subjected himself to the desire of the room's users, to their dreams of holidays, sunshine, summer, happy people, and fertility. The old dream of letting the shoreline from Aasgaardstrand curve through the whole, continued to live; but it has lost its atmosphere of doom.

TRAVELS AND EXHIBITIONS

Eventually the "Life Frieze" reached *a kind of harbour out in Skoeyen,* where he collected the complete works at Ekely. Thus Munch had all his working material around him, and the open-air studios in which to work on the new tasks that he assigned himself. During long periods of time, he also worked in the studios on his other properties.

Munch continued to hold exhibitions both at home and abroad, and some of them were a high-water mark both for himself and for his position in European art and his influence. It can almost seem as though, during the years after 1902, he was consciously working on and providing a basis for his increasing fame, but nevertheless, coincidence plays a large part. During the time at Ekely, he continues for the most part to travel with his exhibitions, the way he did in the years of struggle. It should be mentioned that he was not fond of attending openings, but preferred to pop up some ordinary exhibition day. Sometimes he was recognized, sometimes not.

As his fame increased, he was necessarily made more aware of the role of the art dealer. Already in 1904 he gave Bruno Cassirer sole rights of sale to his graphic works in Germany, a difficult agreement that was later to give him many troubles. That same year he arranged

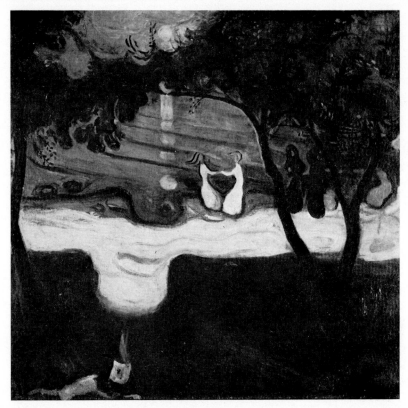

Dance on the Shore, oil 1900 Narodni Galerie, Prague.

for most of his paintings to be sold through Commeter in Hamburg, who also organized several of his exhibitions during the next few years. Eventually he had broken into what the experts call a "sellers market", and in his self-ironic way he wrote to his friend Jappe: *Besides this, I have the cold joy of power in knowing that Germany has been conquered for my art, and that has at any rate increased the interest in it.*

Here it is obvious that this restless round of exhibitions, that on the continent was only interrupted by the First World War, must have been of some importance for youthful art in Europe. It was something

of a sensation when he, during the "art dealer's year", 1904, exhibited in Vienna, and we can observe the influence of Munch in the works of Gerstl and others. That same year, he exhibited six rather poorly hung paintings in Prague; but all the same they were discovered: The art group, Manes, invited him to their new and modern exhibition pavilion in 1905. German friends warned him against the exhibition and told him not to go there. Kollmann wrote, "the Czechs are so sanguine that it's easy to become nervous in Prague." But the exhibition and his short stay there belong to the big events during that troubled and often deeply depressing period of his life. He was later to write to Thiis: *I have just come from Prague, and it has been an ointment to my heart, so wounded by my own beloved city – I stayed there as a guest of the artist union Manes, treated like a Lord ... I was even allowed to use the mayor's carriage ...* After his exhibition in Hamburg he summed up his impressions in this way: *In Prague there was a lot of honour, but not much gold – here in Hamburg the gold seems to be more important.* But Munch had sold in Prague five prints and two paintings – one of them was that strange purely romantic mood painting "Dance on the Beach".

Even when he withdrew from the world, the closed gates of Ekely would always open for Czechoslovakians. Munch never forgot the unique understanding he found in Czechoslovakia. Even though the artists that he had made such a strong impression upon, were soon to find their way to Paris, to be captured by the aesthetic French tradition, all the same it was Munch who had freed them from the barren academic Prague style. The painter Emil Filla describes "how the young artists at the Academy were met only by the worst kind of indifference", and that "they were surrounded by carelessness, and no one helped us – and just then Edvard Munch came. His art was like an explosion." Filla's colleague, Vaclav Spala expands the picture by telling us of the spiritual support Munch gave the young artists, of the debates that followed the exhibition and how Munch had split the Czech artists into two camps: "the Modernists who rushed the barricades, and the wise men of the Academy." But the strangest thing that was written during that year, came from the great Czechoslovakian art

264

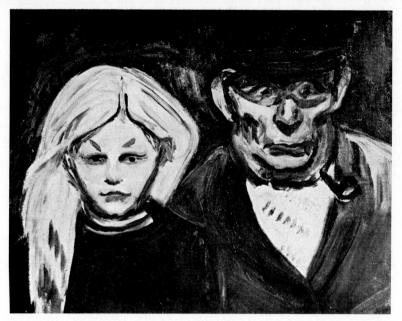

The Fisherman and his Daughter, oil c. 1902 Städelsches Kunstinstitut, Frankfurt.

critic Franticek X. Salda, who, in addition to the article "The Violent Dreamer", also attacked the "so-called Czechoslovakian art critic's" treatment of Munch. He knew Nordic art and culture, and says that Munch in the beginning seemed to him more like a "gangster than an artist", but "Munch is a violent dreamer. How artists like this can be fitted into the pattern of artistic development, and how their works will change in value, has always been a mystery and an important problem. Lonely artists have always moved freely and proudly above the main stream, a stream they cannot follow. But often they determine the direction of the stream of art for tomorrow."

Salda had also discovered something essential about these great lonely artists, and he warns Munch admirers: "Only those who are guided by something deep inside themselves should try to follow Munch; and they must remember that his past is a past full of drama and doom." Perhaps partly for this reason Edvard Munch, though he

265

has been falsely copied, had scarcely any direct imitators, even among the lesser artists. He hasn't had pupils either, though he did open many eyes for new artistic values, inspired them to tread new paths.

At the time of the First World War, the concept of expressionism was used as the name of a new direction in art. Of course an expressionist art has always existed, an art that even by use of exaggeration tried to express the feelings an artist had in experiencing his motif. According to this definition, the very talented late-impressionistic artist, Edvard Munch, was really an early expressionist. One may dare to say that even today the painting "The Shriek" from 1893, "der gebalte Schrei des Expressionismus", as it has been called, is one of the most expressionistic painting that has ever been painted in modern times.

The "Life Frieze" paintings, and all the graphic works that were connected with them and their motif cycle, are in their deepest meaning expressionistic. The essential and the important is brought out, accentuated, details and unnecessary decorations disappear, the expression

Primordial Man, wdct. 1905 OKK 618.

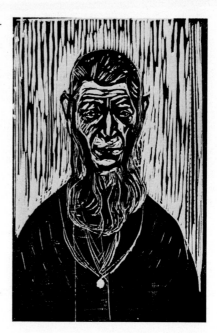

is emphasized, and the motif simplified as much as possible. It was not only the "unfinished quality" of the painting and appearance of splotchiness of them that so shocked and excited the critics and the public, it was more the colours, themselves, that did not correspond to the nature they thought they knew.

Even regarding such a late work as "History", Munch's most classic work, the so-called experts reacted towards the colours. From his own studies and experiences, Munch himself put it in this way, in one of his notes: *A blue stone! That, I can assure you, doesn't exist, he said* (the critic). *I have seen many blue stones – but besides, a horse in a different lighting can be red – yellow – white and blue. Concerning* the feet of the old man in "History", the feet that were "too big", this classic "expressionist" says: *That was done for a reason – it is the big feet and the heavy legs that give the man his height and authority.*

In his definitively expressive paintings Munch turns away from naturalism, and makes use of colours to create the right mood, or simply

because he needs a certain colour in the composition. Also in a purely formal way, Munch is a forerunner of the expressionists to come. In 1903 he painted, for example "The Fisherman and His Daughter" that accompanied his exhibition among other places, to Prague. The use of strong contour lines, the modelling of the fisherman's face right down to the expression on it – not to mention the simplified conception and characterization of the daughter – all this makes us immediately think of painters like Nolde and Kirchner. In a formal way, perhaps the graphic works are equally important when we are talking of those who were to be influenced by his art. In the year of the Prague exhibition, 1905, he was to cut "Primordial Man", and it was just during this year that the circle of artists was formed in Dresden, that circle of artists who, more than any others, were called "expressionist", the famous group "Die Brücke". When this group gave their first graphic exhibition the next year, in Dresden, Munch exhibited his paintings there. On the whole, we can conclude that practically the whole younger generation of German artists, and some of the older too, during these years had the opportunity to experience the controversial Munch exhibitions. If we study for example, the newly "rediscovered" German early expressionist, Wilhelm Laage, whose graphic works have also been catalogued by Schiefler (until 1912), we discover that this five-year-younger artist stayed and exhibited in the same places as Munch. While Laage himself belonged to the pioneers, and started his innovative career in woodcuts at the same time that Munch did, being a younger artist, his situation was different. These younger artists were not always willing to recognize possible influence of another artist; we have proof that some of them deliberately gave their pictures a date previous to when they were actually done.

There is a general feeling that Munch was probably mostly a liberator for those who followed him. He did away with the accepted taboos concerning what could be accepted, both by artists and by the public. In short, he cleared the way for a number of highly independent talented artists. After a while each of them was to go his own way, but we may suspect Munch's "Puberty" and "The Fisherman's Daughter" to lie behind Kirchner's "Marcella" and the influence of Munch's "Bodyguard" may be seen in his life-sized portrait of Heckel.

268

This artist seems to have been one of those who followed Munch closely for a time.

It was a time of revolution and fermentation, when groups were being formed and the developing art policy played an important role. Nolde had some time ago broken out of "Die Brücke" when he in 1909 turned to Munch and asked him to join him in a new group of artists that he planned to start. As Munch, however, had said no to joining "Die Brücke", he again refused this time, using their mutual friend Schiefler to tell Nolde that he was ill. Nolde joined the artists from "Brücke" in a revolt against the leaders of the Berlin Secession, and at Munch's death, Nolde, who was forbidden to paint by Hitler, wrote that Munch died "in honour" and made the following entry in his diary: "Munch's art led to the forming of the Berlin Secession, my art split it, and aided its demise."

Munch was dismayed in Cologne in 1912 to see the works of the new French artists and their younger German colleagues. While the other Norwegian participants had a room for themselves, Munch's room of honour was placed in the middle of the German section – he had really meant something for these Germans! With fresh impressions from the exhibition, Jens Thiis wrote: "One thing is sure: that at this exhibition Van Gogh seems to be a distilled classicist, Gauguin a slightly faded romanticist, and Master Cézanne's art seems mild and smooth as milk and honey, compared to the strongly spiced dishes of art that are here set before a hungry modernist. Yes, whether you believe me or not, the large separate exhibition of 35 of Edvard Munch's works, in addition to the Van Gogh collection, were the Germanic high point of the exhibition. These paintings seemed calming to the nerves, clear, peaceful, and almost like the work of an old master, after the shock that the eyesight had suffered before reaching this section."

Martin Urban thought that the young expressionist's admiration for Munch was not returned and he quotes Schiefler, who already in 1907 had shown Munch a print by Schmidt-Rottluff. Munch shook his head and cried out: "God protect us, hard times must be coming!"

Munch, however, was to experience a lot of this new art on his many trips. When there was a large German exhibition in Oslo in 1936, he recommended to a friend of his that he visit the exhibition and

look: *particularly for a Paul Klee, study him carefully, he is a marvellous artist*, and Munch continued to remark that he knew a lot of the exhibitiors, and *they are excellent painters, all of them.*

These German friends, on the other hand, were also able to study Munch's paintings in the many exhibitions held in Germany, also after the First World War. These exhibitions reached a high point in Zurich, and other Swiss cities, in 1922, when Munch exhibited seventy-three paintings and close to four hundred graphic works. In this land of art dealers, his international position – and along with it, his prices – were established. The way was clear for the gigantic exhibition in the galleries of Berlin and Oslo in 1927. Some of Munch's old German friends reacted against his art and that of his imitators. In his memoirs von Schlittgen complains about these portraits, particularly the one of himself called "The German" and goes on to say: "And then there are the colours, what a misfortune they have been, for he is one of the fathers of that kind of synthesis that today has become poster painting. Everything is pure colour, the heads are pale cadmium, the contours blue, the background emerald green, they explode, they cut down everything that is placed beside them . . ."

East of the Rhine, however, Munch's victory was complete, and concerning his influence here, it has even been clamed that Munch has played the same role for German art as Cézanne for French, a statement that makes a telling comment about the distance between French and German art. Munch's tireless propagandist, J.P. Hodin, was one of the Czechoslovakians that Munch welcomed to his home as recently as in 1938, and he gives us a pathetic picture of his meeting with this old master. Hodin says quite correctly that until the middle of our own century, Munch was practically unknown in the U.S.A., England, and France. One of the few Englishmen who suspected his importance was Herbert Read who wrote that there is "no doubt that he has been one of the most important influences of the last fify years." Munch was not yet discovered by the critics and art dealers of the West. Hodin gives Munch great importance when he says that he created: "what we may call a spiritual climate. No other artist, not even van Gogh, can be compared to him in this respect. Munch is the only artist who can be named along with Dostoevski, Nietzsche, and Ibsen as having

formed a whole generation's attitude to life." The Frenchman Jean Cassou adds the name of Strindberg to this list, when he talks about the strange role "le genie scandinave" played in the Europe of that time.

In France many years earlier, Munch had during the symbolist period such a strong position that he, then still a young Norwegian painter, had been invited to exhibit his "Life Frieze" paintings in the Salon des Indépendants in 1897. He also exhibited later in Paris; but in this art capital, new signals were soon to be raised. *L'art pour l'art* point of view took over, and pure aesthetic criteria became decisive. In this light a Munch seemed barbaric, Germanic, and literary – not suitable for this new milieu.

The exhibition that Munch, almost against his will, held in London in 1936, was no real break-through in the English art world. Private buyers did appear, but no public institution or gallery. To the question of sale Munch answered dryly that he was no shopkeeper.

This English reserve towards both Munch and the expressionists probably is, as several have mentioned, connected to the traditional puritain attitude, the English "understatement", and a fear of emotion that made art of this type seem exhibitionistic.

This in spite of the fact that one would think that both van Gogh and Kokoschka, who later was to acclaim Munch as one of his artistic fathers, should have softened the English prejudices.

WORKING YEARS

The only real danger for me, is to be unable to work, said Munch, and the first fifteen years at Ekely were one long working day for this more and more lonely man, a working day only interrupted by trips both within Norway and abroad. In spite of all his innovation and renewal, Edvard Munch remained loyal to his old motifs, always looking for continuity both in his own life and in his art. For years he continued to paint on old works, he printed up again his graphic works, worked on them further, tried new colours in his woodcuts, using dif-

ferent techniques both on them and the lithographs. The old subjects could suffer change, become even more expressionistic in their concept, their form and colour – or, after his experiences with the University Festival Hall murals, be even more monumentally simplified.

Since we have just emphasized Munch's relationship to expressionism, it can be very illuminating to see how he already in 1913, the same year that he painted "The Woodcutter" and in the midst of his work with the University murals, he again takes up his old motif of jealousy. But the painting is another, the woman is another, and the arrangement; but the men are related to those of the older days. With complete freedom and superb control, he uses colour in any way he likes, a multitude of changes – green, yellow and blue. When he takes up again the picture he himself saw as a key to understanding his own development, his respect for this great work is too strong for him to change it. In 1927, he painted again "The Sick Child" for the last time, *as I must have it to complete that "Life Frieze" which is always being stripped of its components*. The composition is the same but he clothes it with his new strong colours. On the other hand, the large canvases for the "new" 'Life Frieze' show not only a new colour scale but a more massive, decorative style of composition.

Norwegians don't often use very descriptive word "nostalgia". But it fits very well to describe the lonely Munch at Ekely, longing back to what had been, to the life he had led and the people he had met. In the middle of the 1920's he was to paint both the bohemian's wedding and his death. The latter picture was probably based upon Hans Jaeger's last days fifteen years earlier (1910). Poor, ill, and miserable – the aged bohemian had, in the end, lost his taste for everything, except champagne. Munch worked with these motifs in drawing, graphic art, and oils. We find, for example, the artist himself in the large painted sketch "Alone at the Table", or together with the other wedding guests, and in one of the finished paintings, he participates again with his face turned to one side, as in the paintings from the '90's. Munch can recollect all the details, a half empty glass, the sadness, a lack of closeness between the people, the disinterested "bride", the bent neck of the groom, and the old lover who leaves the party.

272

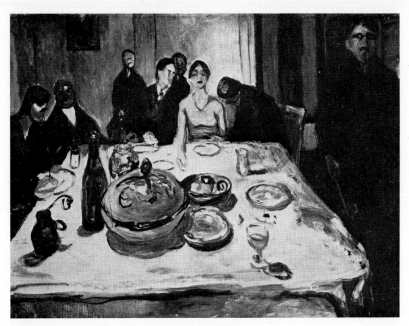

The Bohemian's Wedding Feast, oil 1925 OKK 6.

A wedding in which eroticism was dead – and death itself. Even when he was in the midst of his work with the auditorium paintings, his memories of the death chambers lived on, in a grandiose conception of the atmosphere from his own paintings on this subject. The large size (56½" x 73") of "At the Death Bed" indicates that he considered it as part of the new "Life Frieze". Another clue is the fact that he retained a later version. Almost down to the smallest details, this painting is based on the lithograp, "Fever" (p. 34) with the hallucination demons on the wall, done in 1896. In "At the Death Bed", however, the demons are gone. As in the paintings from his youth, the drama is shown in the faces of the spectators, in the figure of the father, and the pale face of the young man, but this time the woman portrayed in the foreground is different.

18 – Munch.

273

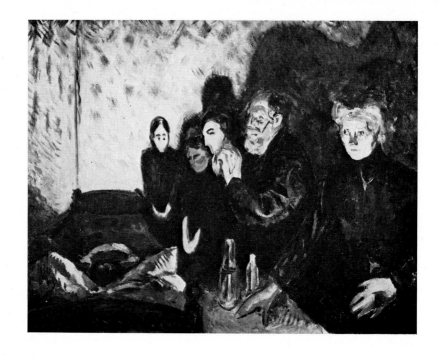

With loneliness it is natural that the time devoted to self-examination increases. This merciless interest for the person, Edvard Munch, seems to increase with age, and in the end it becomes his major subject. During "the Spanish influenza" in 1919 he produced a cold-blooded study of the patient, himself. Later, he asked his helpful friend, the great collector of Munch, Rolf Stenersen, who has written an amusing and respectful book about Munch: "Does it make you ill?" "What do you mean?" – "Don't you notice the smell?" – "The smell?" – "Don't you see, I'm practically rotting away!' Yes, there is decay about him – and the room – there he sits in that brown dressing gown with the green blanket around him, lean and flabby under his clothing, dirty and unshaven. But the expression in his face and the look he gives us is sharp and aware – but perhaps that still vital defiance in his look is not for us, but for death itself. He is, at any rate, not a beaten man but ready to defy "Influenza' and carry on his work.

274

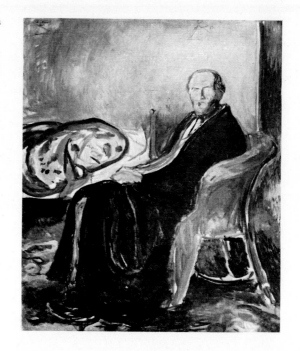

Later, he lets us see him again in all his loneliness, in "Inner Ten-sion". The open door, and the long perspective line into the empty room, with the unused grand piano tells us something of the loneliness behind his deep emotion. The effect is increased by the high perspec-tive, that gives the figure weight and causes it to lean towards us. This painting is contemporary with the self-portrait that was a study for "The Bohemian Wedding Feast", but whereas in that painting he made himself thoughtful, weak, and absent-minded, in this one, we see an active and creative sixty-three-year-old, wide awake, and obser-vant, as he stares into the strong sunlight, the sunlight that makes hard yellow and green colours sparkle around him.

This is a vital man of sixty-three we see, and just in these years he is able to give us essential pleasure with his nudes, they seem to be done by a straightforward painter, without those bothersome convolu-tions of inner meaning. Even more than before, there seems to be "a

layer of air between", and he can, for example, choose to let the model symbolize four times of the day, from "morning" to "night". Here the study of the model is more important than his own mood, and in the simplified interior he lets the colours play freely around the woman's body. It seems a far cry from such nudes to "Madonna", and we have the feeling that he is painting for the sake of the painting itself, and the pleasure in the many phases of the female body. However, he has always been able to make a fascinating and sensual nude painting such as "Girl at the Window" from 1906 (p. 207), not to mention all the nudes painted in those distant years in Paris, when the model was cheap for a poor young artist. This attitude of pictorial qualities being the most important thing, is shown again in "Nude by the Wicker Chair". Light plays over the colourful lap-rug lying on the chair, and in softer, lighter tones casts light and shade, cold and warmth, on the full busomed body. The model herself is characterized by the modesty of her bowed head that in spite of all the glory of her body

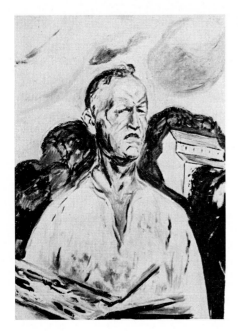

Self-Portrait from Ekely,
oil 1926 PC Oslo.

Opposite:
The so-called "Krotkaja",
oil 1927 OKK 752.
Nude by the Wicker Chair,
oil 1929 OKK 499.

276

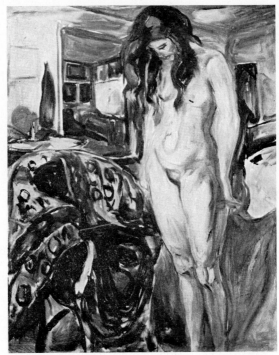

makes her shy and isolated in the room that is open, towards the next
room, a blue rectangle against the yellow wall.

This painting from the end of the 1920's in spite of all its lushness,
is in atmosphere related to the painting of the lean so-called "Krotkaja"
painted at the beginning of the decade. The name is taken from a
story of Dostoevski; she was christened by a friend of Munch's who,
like Munch himself, admired the great Russian author. The woman
really belongs among the mound of figures in the "Human Mountain",
but Munch's friend happened to be reminded of Krotkaja" just before
she thows herself out of the window and at that moment smiles pro-
bably for the first and only time in her life." This long narrow picture,
rather thinly painted in shades of blue, hung over Munch's bed in his
last years, and when he died, Dostoevski's book "The Devils" was
lying on his night table.

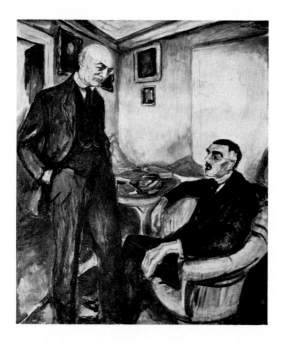

The painter's eye can be gripped by a situation that he keeps in his head and later puts into a tight composition. That's what happened in "The Model on the Sofa" that in its composition is built upon the diagonal within her body lying across the diagonal of the sofa. Against all the perpendicular lines in the background, Munch puts the model into the strict design of the composition, soft, feminine, natural, and relaxed.

This was, as we have said, a time in which his fame had spread and the commissions for portraits were many, but Munch accepted very few of them, and even those with a lot of quibbling. It is interesting, too, to note the master of Ekely often moved his model out into the open air as in the portrait of "Else Mustad" in the shimmering sunshine. He was perhaps most successful when the model was someone who was close to him, and he felt more as though he had commissioned the portrait himself. In connection with the portrait commissioned by Doctor Dedichen, he painted a large double portrait of his friend

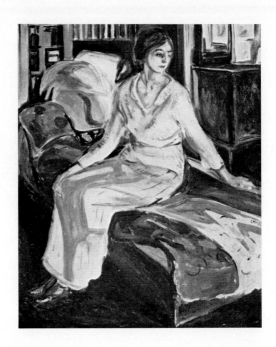

The Model on the Sofa,
oil 1924–28 OKK 429.

the doctor, and Jappe Nilssen, one of the paintings he kept himself – *some of my friends I must have on the wall,* as he had told Ingse Vibe's husband, that time he refused to sell him her portrait. The characterization is outstanding – the confident placid doctor, and the shop-worn ageing bohemian in the chair. The curving chair back at the same time determines and compliments the tired, relaxed posture of the figure.

It is very natural that the broad, peaceful east Norway landscape around Ekely would play a role in Munch's art. The fertility he found there, we have seen already in the painting called "The Man in the Cabbage Field" done the year he moved there, and it was from the same fields that he painted several pictures of horses pulling the plough through the damp spring earth. He loved his horses, and some of this last thoughts concerned the old white horse he had used as a model for many years. As Munch himself made clear, the same horse could have the most varying colours according to the play of light,

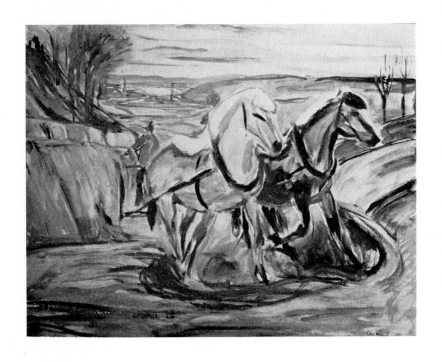

something proven by those two horses pulling the plough, yellow and blue as they are.

You get a feeling that the open landscape of east Norway made Munch conceive space itself in a new way. We have already noted the tendency to arrange the painted surfaces in planes earlier. But in the two, quite similar, monumental "poems" called "Starry Night", it is as though he captures the whole landscape at a glance, standing there on his veranda. His point of view is marked by the perspective of the staairs, and the close mysterious shadows. We follow one curved line over the other, inwards into the picture – over the blue-white snow with its tint of rose, further over the domes of the trees, with the lighted house behind the crown of the tree against the strip of city lights. Their line is broken by the perpendicular group of trees on another plane, only to end in the calm mountain ridge under the sparkling starry sky. This landscape, without people, is all the same a drama in itself. You

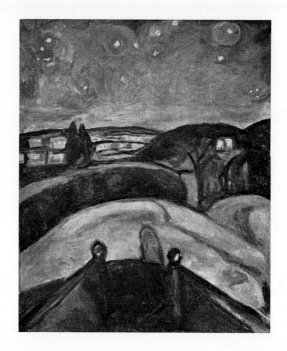

can feel the crackling cold of the night. Munch himself once said, that Ibsen's "John Gabriel Borkman" is the best winter landscape in Norwegian art, and we can certainly believe that it was on a night like this that the lonely Borkman met his death – and the title of that play has also been used for this painting. We know that in the years before this monumental winter landscape was painted, Munch had worked with illustrations for the drama.

When Munch during these years continues to work with the "Life Frieze" we naturally find that the once so fateful shoreline lives on. But when he now again experiences the meeting between the sea and the beach, it is the painter's experience that he brings us. In "Waves against the Beach" the trees that bow to the gusts of wind tell us that there is a storm in the air but the waves striking the beach are almost arranged in an ornamental way, the long parallel foaming lines of the surf.

OLD AND NEW IN THE PRINTS

Both as a person and an artist, Munch was fascinated by Ibsen throug-
out his whole life – from the time he first made theatre programmes
during the '90's in Paris. It was for "John Gabriel Borkman" that he
drew his Ibsen with the lighthouse in the background, and many years
later he worked on drawings for the drama. Using that "Starry Night"
just described, he produced a magnificent lithograph, where he for
the most part follows Ibsen's own stage directions, and places the dying
Borkman on the bench in the foreground.

His intense concern with "Ghosts" for Reinhardt in 1906, his iden-
tification with the painter Osvald, continued to live in his mind, and
around 1920 he took up this material again. In 1906 he had designed
his interiors from a recollection of his home. Now these recollections
become stronger, and he even puts his own father into his painting
of Fru Alving's sitting room. He always seems to turn back to his own
life, when he concerns himself with an Ibsen play. While he was work-
ing on the auditorium decorations, he made playful drawings of "Peer
Gynt", turning literally to himself – and giving Peer his own features,
something he did again at a later date. Paal Hougen has shown how
Munch takes up again his old work in these studies for illustrations.
He places, for example, a Consul Sandberg at the Ibsen's party of para-
sites on the Morrocan coast.

There are many who have been surprised that Munch was so inter-
ested in Ibsen's last saga drama, "The Pretenders". We have a draw-
ing, probably dating from 1912, and a dozen woodcuts that for the
most part are from the 1920's. Probably Munch's interest here, too, is
a part of his intense identification, in this case with the complicated
doubting and uncertain duke, Skule. Interestingly enough, this seems
to have been Ibsen's portrait of himself in his relationship to Bjoernson.
(King Haakon).

We are still waiting for the new Schiefler in order to have a complete
survey of Edvard Munch's graphic works. But when it comes to the
etchings, the task has been done for us by Sigurd Willoch, though the
catalogue has not been translated from the original Norwegian.

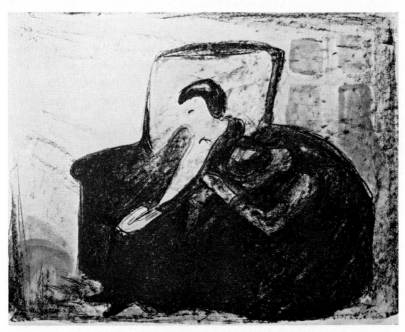

From Ibsen's Ghosts, (Mrs. Alving and Osvald) lith. OKK 421.

The year of break-through, 1902, is one of Munch's most productive
years, as an etcher, with all of thirty-eight works; but the year he
moved into Ekely, 1916, he deserted his copper plates, although he
occasionally worked on some of the etchings later. The print with the
woman and "The Big Codfish" (Gunnar Heiberg) done in that year
seems almost to predict the lithographic series about Alpha and Ome-
ga, that we have treated earlier. He works with caricatures during
these years, and can, for example, exaggerate the features of old girl
friends in "Burlesque Dance". The old and the new change place
during this whole period – he can take up the "Life Frieze" subjects
at the same time as he works on a variation of one of his major works,
like "Girls on the Quay" both in new oil painting and in an
etching. Later he was also to take up the subject in one of his finest
woodcuts, and we have reason to believe that the spiritual etching of
"Man and Woman" is a preliminary study for his deeply emotional

woodcut of "Man and Woman Kissing Each Other" from the same year. On the other hand, a very central, older painting such as "Ashes" can suddenly achieve a more realistic formulation, when he lets the woman leave the man and the bed, and lift herself up from him in a related position with her hands behind her head. That dramatic atmosphere of doom is gone, and the experience has become just an episode at any rate for the man.

The models seem to play a larger role for Munch himself, whether he is making portraits of them or letting the fifty-year old Munch play the role of the "Seducer" both in the oil painting and in the etching. Also, when he etches a lying half-nude, which has been called "Ecstasy", this earlier "naturaliste par excellence of the life of the soul", seems to be more interested in what the model looks like, rather than the way he feels. There is, as we stated about the nudes done in oils, a layer of air between him and the model. There is a big difference between "Ecstasy" and "Madonna" in that moment when life

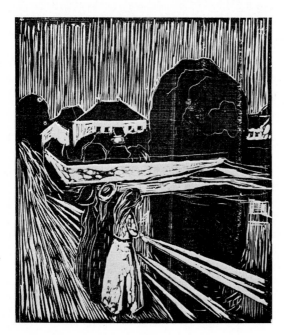

Girls on the Quay,
wdct. and coloured lith.
1920 OKK 647, (see
ptg. p. 181).

Opposite:
The Big Codfish,
etch. 1902 OKK 75.

284

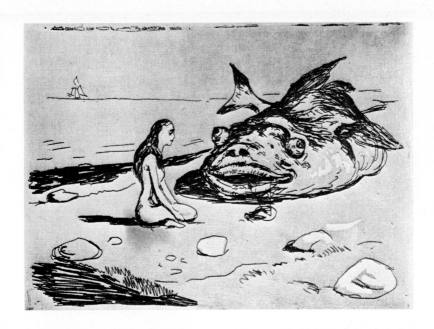

and death touch hands. Something similar happens with an old and very central subject, "Metabolism": Adam and Eve under the tree have become a genre painting of the meeting between the seaman and his Eve under the apple tree.

During his last year as an active etcher, in 1916, Munch sat at Ekely thinking of the Krageroe period. He repeats again both the paintings "Ship in the Scrapyard" and the major work "Galloping Horse" on the copper plates. Yes, Aasgaardstrand too, and the dramatic conflicts there, more than ten years earlier, become so alive for him, that one day he lets the etching needle tell about his fight with his painter friend Karsten.

While his technique can change according to the subject in the etchings, we really can't talk about any thorough change of style. But in the lithographs, and, above all, in the woodcuts, something new happens. We might ask whether it wasn't that Munch deserted etching because this technique didn't suit his new attitude as a graphic artist. We have earlier suggested how his oil paintings became freer, more sketch-

like, and "arty", around 1906–7. At the same time the woodcuts and lithographs become more strict, planes and masses more important, and it appears as though the graphic works represent the artist's final presentation. In a completely new way the woodcuts and the lithographs become a goal in themselves, the way we already experience it in the lithograph "Attraction" from 1896, this melting together of two older paintings into a new composition. (p. 148).

Most of the lithographs, after his period of illness in Copenhagen, were done during the years 1912–20. During that decade he reworked his old stone and wood plates, experimenting with new colour combinations or simply colouring older prints by hand. Naturally he took up motifs from his paintings, impressions from the daily life in Kragerø like "The Snow-Shovellers" for example. His intense work on the

Dans Macabre, lith. 1915 OKK 381.

Birgitte, wdct. 1930 OKK 703.

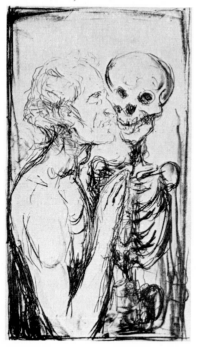

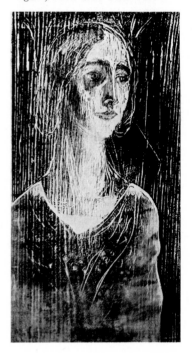

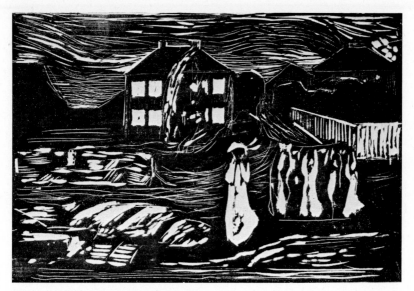

Stormy Night, wdct. 1908–09 OKK 622.

auditorium decorations have also left their traces in the lithographs – we can find "History" and "Alma Mater", both of which he was still changing and colouring as late as in the 1930's. In an exhibition poster he uses his "Apple Pickers", and for another of his own exhibitions he uses the magnificent "Towards the Light". We can follow the man's figure in it, from the bathing scene at the pool in Warnemünde, through the University Festival Hall, and over to this poster.

In spite of everything, his choice of motifs is not new, although the fear motif for example, can be given a new formulation in the lithographs; we can note that though the thought of death lies under so much of what he created, it does get a new deeply personal formulation in "Dans Macabre" from 1915. Now he knows that the victory is his. He knows that his major work, the auditorium pictures, have been given their place, and he is able to meet that strange, cheerfully smiling skeleton, calmly.

It seems that his own fear of death has been overcome. But the fear of death itself, universal as it is, lives on in his woodcuts. There is good reason to believe that the first World War was a contributing

factor towards the enlargement of this theme, changing it from a personal fear to a collective one. Approaching the age of fifty, Munch seems to have been able to rise above his own problems.

Ekely was increasingly to become a house of memories. We have already mentioned how Edvard Munch in the middle of the 1920's took up again his recollections from the bohemian days, and developed them both in oils and lithographs. And the wandering years, that were so often brought to mind when he travelled, as well as the many contacts he had in Germany, make him – almost mechanically – repeat that profound self-revelation "With a Bottle of Wine".

In 1930, Munch the lithographer reached the end of this very creative period in his life. It closed on a note of grandeur with the portrait of his friend and doctor, Professor Schreiner. The monumentality and the rather large size seemed to indicate that it was not the artist's intention to produce a painted portrait from it later. The lithograph was intended to be even larger, for the anatomist originally held a skull between his hands. In other words he stood in that same position as in the lithograph that Munch had made after visiting the professor's institute. In this lithograph he presents himself on the dissecting table – it reminds us again of "The Death of Marat".

Going for a Walk, (also called Fear) wdct. 1916 OKK 645.

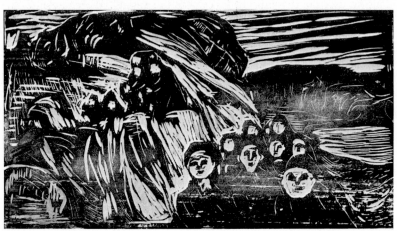

288

Opposite: Women on the Beach, oil 1930's.

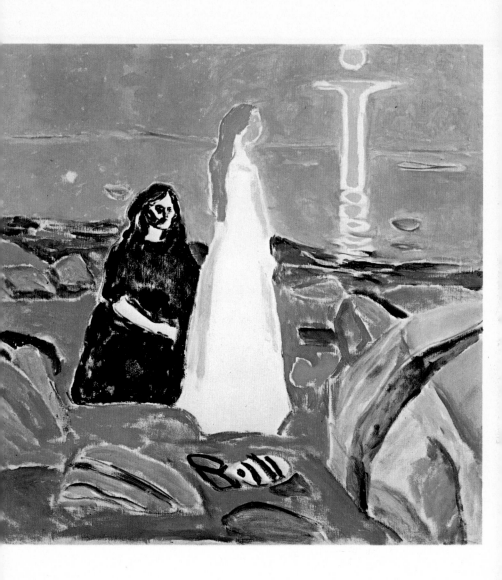

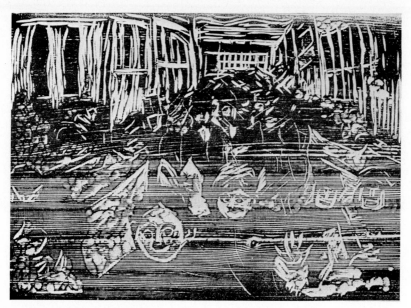

Panic Fear, wdct. 1920 OKK 648.

It would seem as though the eye disease that affected him during that year put an end to his work on lithographs, and during the 1930's Munch limits himself to re-working or colouring old prints.

It is, above all, in the woodcuts that Munch creates something new during these years and achieves results that were to give guidance to others as well. But during the thirties it seems as though he only made a few sketchy efforts on the wooden blocks, after his accomplishment with "Birgitte" or "The Gothic Girl" in 1931.

During the year he was ill, 1908–09, Munch made a woodcut in a new style. "Stormy Night" is based on the theme he has used before, the woman who detaches herself from the group, but it is a completely independent work compared to his earlier use of the theme. The black and white effect is exploited to the utmost, with the lighted windows in the closed house, the white fence, and the use of white on the women and in the landscape. The expressive quality is emphasized by the use of the grain of the wood. It is a night of anguish in which man feels himself small; it is carved by a man suffering inner pressures. Perhaps

The Sacrament, wdct. 1919–20 OKK 672.

it is no accident that he printed it again in 1918, the last year of the World War. There is fear in every line, the same way in which the fear motif continued to live in Munch's mind, yes, it could even find expression in a splintered landscape. It lives, too, in the title: "Fear", where featureless people come towards us, are almost pressed towards us, through a small and narrow "Lane" – a lane with high banks on each side. The collective fear of that time – and also of Edvard Munch – was given powerful expressive representation in "Panic Fear" from 1920. The spontaneous and slightly nervous way he used the cutting iron makes the walls of the houses buckle, as though there were an earthquake. The people in the foreground have become masks flying towards us, and the masses behind, black and powerful, surge forward with an inevitable force.

We have been able to follow Munch's expressionistic woodcuts, from the time before the turn of the century when he carved "The Skipper", through the "Primordial Man" from 1905, down to the examples that are mentioned here. "Panic Fear" from 1920 leads us to suspect that Munch on his trips had seen his German followers.

His own personal experiences, scenes from the death chamber, are taken up again in a new objective way, for example in that strange descriptive cut of the minister coming with the "Sacrament". The figures create space in a masterly way, and their fears are echoed by the unquieting and nervous treatment of the walls flickering in white and black. But the past is not completely gone – the brother leaves the room here, as he did in "Death in the Sick-Room".

This woodcut is closely related to another woodcut from the same period, "The Last Hour", where Munch in a unique way has managed to isolate the lonely rejected person marked for death. The closed black group of people behind her add to her isolation; she has already lost identity. Uneasiness lives in the two moving figures behind her head, and in the restless reproduction of the flagstones of the great square against the strict gothic arches. These arches, that might have been taken from the modern prison in the gothic style in Berlin, turn our thoughts to the illustration for "The Pretenders". "Carrying the

The Last Hour, wdct. 1920 **OKK** 650.

Iron" is the most interesting print of this series; it too portrays a lonely woman, the king's mother Inga. Through the group of curious, slightly caricaturised warriors she wanders, as unaffected by them, as by the glowing irons she has carried in her hands. The gothic church portal behind her gives the figure grandeur and contributes towards making this mother of a king one among the many. The model for Inga can be found in other spiritual portraits, such as "The Gothic Girl".

We have often considered how loyal Munch was to himself and his work. When he around 1920 re-works "Girls n the Quay" as a woodcut, we find that in spite of the fact that he was in the midst of his experimentation with expressionism, he remained loyal towards one of the subjects he had worked the most with since the end of the '90's. The woodcut is perhaps even more monumental than the 12 oil paintings with related motifs. This is particularly due to the way in which Munch used the structure of the wood, his even greater simplification of that famous tree top and the perspective drive he puts into the pier and the road. The simplification in the woodcut gives the white wall that we recognize from so many works a new strength in relation to the dark water. The woodcut is a reverse of the painting, so he has closely kept to the original followed his older works; but the material itself has made the result something brand new.

The Last Years

The eye trouble that was such a catastrophe for Edvard Munch in 1930 was to continue to bother him, and it put him in the situation where he couldn't work, or at any rate his ability to work was greatly decreased. This was the man who had said: *The only real danger for me is to be unable to work!* But no one could take away from him his past, and what he had created. Events were to bring the past even closer during the 12 years left to him.

In connection with his seventieth birthday in 1933, two personal friends prepared biographies, descriptions of his life and his work: Jens Thiis, who had been his friend from the days of his youth, and who more than any other Norwegian, worked for the success of his art; and the younger Pola Gauguin, the son of the great Paul, who had meant so much to the symbolists and probably to Munch as well. As he was very close to both of these men, he followed the progress of their work and we have a large and important amount of correspondence from this period. Going through this material, however, it is not completely clear how afraid Munch really was that certain indiscretions might appear in these works, particularly in the material presented by Thiis, who had known him for such a long time. It is for this reason that Thiis' biography of Edvard Munch is written in such a reserved, almost restrained way. Every week Munch arrived in a taxi to collect the manuscript and go through it as Thiis was writing it. That is why the milieu and background material dominates the book to such an extent. In this connection a joking comment from the seventy-year-old Munch tells us that he hadn't lost his sense of humour: *Have you read,* said Munch to a mutual friend, *Jens Thiis' autobiography about me?*

This cooperation with these two biographers, and direct questions from them about certain matters of historical value, lead to Munch's going through again his many and often rather unusual notes. And now he had not only that suitcase with papers that his sister Inger tells

us he always carried with him on his travels, but everything that he had collected throughout his long life – even down to unopened letters. *I have never used a wastepaper basket,* as he himself once said. He had also, as we mentioned before, thought of writing about the decisive years in his difficult life; but now it was more as a painter that he relived, for example, his fight with Ludwig Karsten in 1905 – and other episodes as well. To Jens Thiis he wrote on New Year's Day 1933: *I am now trying to paint the drunken fight and dramas of those times.*

During these moments of recollection, he turned again to his old subjects. Now he has freed himself from the past, and creates new works, new both in colour and design. In the oil paintings of these later years we notice how he has kept up to date with the art movements of the times, and we find traces both of Matisse and the cubists. We find him using an array of colour related to "Les Fauves" when he paints the two women on the beach, a painting that goes all he way back to the monumental "Mother and Daughter" from 1897; but yet this is a new piece of work. He keeps the basic mood; but it is the painter and only the painter who brushes his colours onto this almost square painting. The curving shoreline from that magnificent coloured woodcut is not used, and the composition of the painting is based on the horizontal lines of the beach parallel to the skyline and the vertical line of the quite unromantic pillar of moonlight, and that erect white figure of a girl with the red hair against the heavy, black, seated old woman. In all truth Munch saw not only "blue stones", but stones of all colours and shades!

He painted several colourful pictures of this type, pictures we have difficulty in dating, pictures in which he had quite freed himself from what he had created before – among them, a new representation of "Ladies on the Quay". The simple composition is solidly built, and the horizontal lines of the row of houses and the beach are contrasted with the broad irresistible perspective of the pier. The strongly decorative character of the painting is emphasized by the group of women, so tightly constructed of large blue-white surfaces to give an almost cubistic effect. The use of these powerful colours in such paintings may be related to his weakened eyesight. But regarding this disregard both

The Fight, oil 1933 OKK 554.

for nature, and for the motif as he had previously designed it, there is good reason to let Munch himself explain: *I can only complete my work when I am out of sight of it, so that I can collect my impressions. Nature itself confuses me, when I have it directly in front of me.*

Munch was to return to his large portraits already in 1932, when he painted Mrs. Thomas Olsen full-size. This long narrow portrait is on such a large scale that it seems almost as though he was trying to convince both himself and others that he still had both his sight and his power. A number of commissioned portraits, of more or less important people, were also done during these years, and we almost have the feeling that he is painting them because he would like to avoid selling all his other "children", that he had collected around him at Ekely.

The Night Wanderer,
oil 1925 (?) OKK 589.

He is more and more interested in the model who already had gone through self-examination. It has been said that it is just these artists who are so involved in their own times and the people of their time, who are particularly given to self-study. Without knowing yourself you cannot know others. These self-portraits, many of which we have already studied, are again Munch's major efforts during these years. They are witnesses of an inimitable power, an intense ability of observation; at the same time they reveal the artist in his melancholy moments and difficult situations. His sense of self-irony and his genuine humour live on too, we see it in the dissecting of a big codfish head or in the comic mixture of bartender and "Alchemist".

His self-biographical interest never failed. We have told how he studied the effects of the disease on his eyes, and how after a fight he painted himself "with a bandaged hand". In the same way, he does

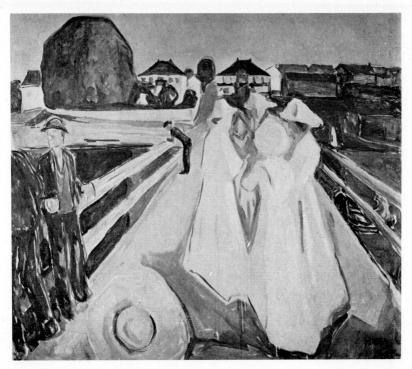

Ladies on the Quay, oil 1930's OKK 30.

a yard-high drawing in black chalk, and it is precisely this diseased eye that claims our attention.

How he was still inclined to work on impulse, for example, to make a hectograph print on the spur of the moment, can be seen in the self-portrait he sent to Thiis, together with the yearly box of apples at Christmas time. The long inscription starts like this: *I enclose an old Greek philosopher, drawn in the Japan of the previous century, yet drawn expressly for you today ...* He wanted Thiis to know what he looked like just then.

We have previously met the old Munch "in inner tension", and we find him again at "two o'clock" one night as the victim of insomnia, the pale "night wanderer" in an empty house. Throughout his life, Munch thought in simple symbols, as a rule with a quite realistic start-

ing point, based on his own experience. There is a simple symbolism in the pathetic picture of the old man "Between the Clock and the Bed". He manages to give a certain majesty to that shrunken body, in those clothes that are now too big for him, standing between the clock ticking away his measured amount of time, and the bed where he is to die. An unknown source of light makes a play of colour in the room. He comes from the life he has lived, tragic and rich as it was, something that "Krotkaja" reminds us of – the painting that actually hung over his bed. In the same way as when death moved him that far away night in St. Cloud, there is a cross marked on the floor. That time it was the moon that outlined the shadow of the window's crossbars on the floor in a double cross, now it is the sun that guilds a cross from the windows at his feet. Here he had already performed his "Death Dance" with a peaceful mind, and is ready to meet death after a long and complex life. In spite of all the strange turns of fate, his life was to end in harmonious loneliness, in that self-protective way of life he had built for himself at Ekely.

Psychologists have, of course, already made their first analyses of Edvard Munch's personality. There will probably be many of them, particularly as his personal notes become more easily available than they are today. Regardless of the importance of the notes, we must never loose sight of the fact that he had a strange ability to use his creative art to master both inner and outer difficulties. It was as an artist that he solved his problems, and it is through this art that we get the true picture of this remarkable human being.

A very special personality like this, who meant so much in the history of art, and who lived and created for such a long period of time would necessarily become the subject of anecdotes and legends. The making of his legend was already begun before the death of this lonely genius, and it has continued through his friends and others who have concerned themselves with him, in speech and writing. In spite of the legend, in spite of the analyses, everyone who is seriously concerned with Edvard Munch must discover how undivided, how whole his personality is. This is particularly demonstrated by the continuity in his art, from the close of the 1880's until his death on a cold day in January, 1944.

298

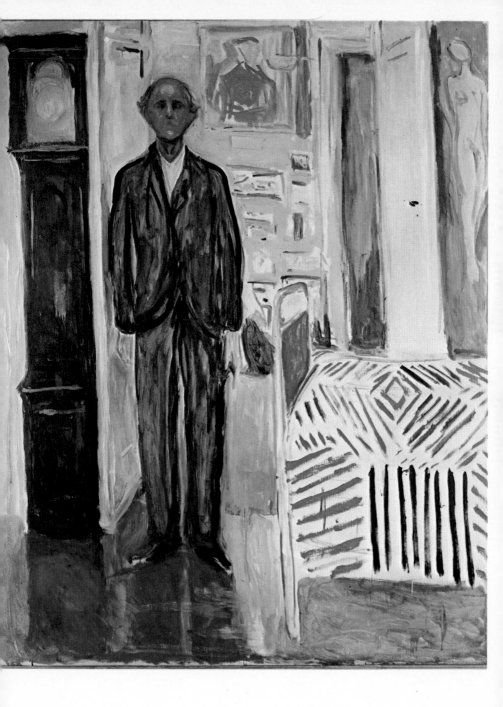

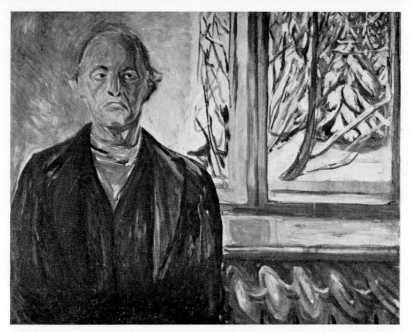

Self-Portrait at the Window, oil 1940–42 OKK 446.

In 1935 Edvard Munch shared the honour of being exhibited in the "Entartete" (depraved) exhibition in Hitler's new palace of art in Munich, together with the best modern painters of Europe. Two years later, eighty-two of his paintings were removed from German museums, and later sold in order to acquire sorely needed hard cash for the Third Reich. Numbers of prints were sold at auctions, some of them in Oslo. Now this art of his had achieved market value even on an intergovernmental level! It is strange to read what he many years earlier had written to a friend: *My paintings will never be of market value, but must be forced on people by all possible means.* At another point he said, slightly resigned: *So many of my prints have been sold, that it is not possible to sell many more.* As he stood in the midst of an ocean of excess graphic prints, at one point he even played with the thought of burning them all!

It is surprising that Munch accepted so calmly his betrayal by that

Germany to which he owed so much. But it is hardly a coincidence that he developed at that time a hectic round of exhibitions outside of Germany, that he helped German artists, and even gave money so that one of them could come to Norway. The same year that his paintings in German public ownership were confiscated as "depraved", the Czech art group, Manes, made an evaluation of his art. In that threatened Czechoslovakia, they invited Munch to the fifty-year jubilee of that group, the same place where he had held his famous exhibition in 1905.

When Norway was occupied in April 1940, Munch refused to admit both German painters in uniform, and Norwegian and German Nazis. He was to experience the occupation personally – the Germans confiscated his large property along the Oslo fjord, and two representatives of the Reichskommissariat, warned him that he must leave Ekely within a fortnight. Fortunately it turned out that this move was not necessary. From the beginning of the occupation, it had been necessary for him to consider evacuating. German tanks were parked on the

Self-Portrait as a Greek Philosopher, the hectograph Munch sent Jens Thiis 1933 OKK 732.

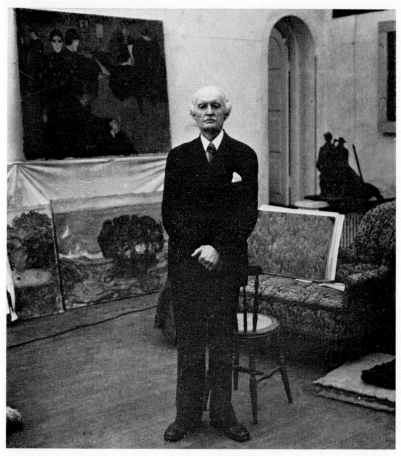

Munch 75 years old, 1938. In the background, The Workmen, one of his few sculptures, a version of Death in the Sick-Room, and two paintings from the Linde Frieze.

neighbouring farm, and on a nearby height were placed the most important German anti-aircraft batteries in the Oslo area. Apart from the winter studio, most of his life work was collected in the old wooden house, and not to mention the thousands of letters and notes he had collected during all of 60 years – this man who never used a waste-paper basket.

Already when his paintings were removed from German museums,

Munch discovered that he shared the fate of many. Even though throughout his life he had felt himself to be lonely and isolated, still this feeling of sharing his fate with others became stronger in the new situation. His personal problems became less important, as was the case with many Norwegians. When Pola Gauguin visited him in 1940, he expressed his surprise over this calm that seemed to have come over Munch: "He pointed towards the sky where three large Junker planes were flying low over the house, and said – *now you understand that all the old ghosts have crawled down into the mouse holes in fear of the one big ghost.*" – It was in captive Norway that he felt a freedom he perhaps had never felt before, freedom from himself.

This possibility of evacuation bothered him, and from one of his letters to Gierloeff it is evident how he even goes through the cellars and tries to roughly order his countless papers in boxes and drawers. Once again he relives the past, and writes that he is sitting *deeply buried in a thousand old letters... yes in these old letterst he past is still alive and the dead leave their graves. It is a stirring thing, often moving and painful.*

The thought of his 80th birthday, the 12th of December 1943, was very stimulating. He had had a fine spurt of work, and took a very sincere pleasure in receiving flowers, telegrams, and all the homage that was shown him. But only a week later Ekely was shaken when an ammunition depot exploded; windows were blown out, and Munch caught that bronchitis which put an end to his hope of surviving the war. It was this hope that had kept him going. A self-portrait from the time of occupation tells eloquently of his stubborn will and deep-felt protest. Dressed in the blue suit he wore at home, the old man stands, tense and wide awake, with his face flushed in front of the warm reddish-yellow wall. But the conquered country-side, seen through the window, is barren and icy cold.

Edvard Munch worked, as was his habit, until the very end. Professor Schreiner was not very satisfied with the old lithograph of Hans Jæger, and wanted him to make a new one. Munch accepted this challenge, perhaps not so unwillingly, for he was more or less forced to live on in memories. He had always felt himself to be in debt to the

bohemians, who had made the young son of a doctor wake up, had given him ideas that he kept throughout his life, had freed him from the narrow-minded, bourgeois Christiania.

As his life and life's work finished on this note – this last tribute to his once so admired teacher, it is fitting that we conclude with the title of a book by the greatest Norwegian author of that generation. Knut Hamsun, and say in truth that Munch had come: FULL CIRCLE.

Hans Jaeger, lith. 1943–44 OKK 548.

Some Important Dates

1863 Born at Loeten, Hedmark.

1864 His parents move to Oslo (then called: Christiania).

1868 Death of his mother.

1877 Death of his sister, Sophie, 15 years old.

1880 Gives up engineering studies to become an artist.

1881 Enters Royal School of Design, Christiania.

1882 Rents a studio in Stortings plass together with six fellow artists. Their work is supervised by Christian Krohg.

1885 Three-week study trip to Paris.

1886 First versions of paintings: The Sick Child, Puberty, and The Morning After.

1889 First one-man show, in the Student's Association. Death of his father. In the autumn, again in Paris, studying at Léon Bonnat's Studio.

1890 Living in St. Cloud, outside of Paris, with the Danish poet, Emanuel Goldstein. Home to Norway in the summer.

1891 To Paris and Nice. Granted State Scholarship for the third time.

1892 Exhibition in Verein Berliner Künstler, Germany. The exhibition is closed.

1893 Living in Berlin. Exhibits the series "Ein Menschen-Leben". Frequents the circle of authors, critics etc. associated with the periodical, *Pan.*

1894 The first etchings and lithographs produced in Berlin. The book, "Das Werk des Edvard Munch" by Przybyszewski et. al. is published.

1895 His circle of friends includes the many Scandinavians in Berlin, among others Gustav Vigeland who makes a bust of him. (destroyed). To Paris. Meier-Graefe publishes a Munch folio. His younger brother, Andreas, dies.

1896 The first coloured lithographs, coloured etching, and woodcuts.

1897 Purchases a house in Aasgaardstrand.

1899 In Italy, Paris, Norway.

1902 Albert Kollmann introduces him to Dr. Max Lide in Lübeck, who publishes the book "Edvard Munch und die Kunst der Zukunft". He does the Linde Folio. Gustav Schiefler begins cataloguing his graphic work. Exhibits 22 Life Frieze paintings in Berlin.

1903 Several visits to the Lindes in Lübeck. He paints the family and begins working on a frieze for Dr. Linde's house.

1904 The Linde Frieze is refused. A number of exhibitions, among others in Vienna and Oslo.

1905 Important exhibition in Prague.

1906 Does decorations for Henrik Ibsens *Ghosts,* produced by Max Reinhardt.

1907 Frieze with Life Frieze motifs for the foyer in Max Reinhardt's Kammerspielhaus.

1908 Nervous breakdown in Copenhagen. Enters Professor Daniel Jacobson's clinic. Is made a Knight of the Royal Norwegian Order of St. Olav.

1910 Buys the property "Ramme" in Hvitsten. Working on the decorations for the University Festival Hall.

1911 Wins the contest to decorate the University Festival Hall.

1912 Accorded "place of honour" at an exhibition in Cologne – the only living artist so honoured (except Picasso).

1916 The Festival Hall decorations mounted at the University after bitter quarreling.

1919 Suffers from Spanish influenza. Working on Life Frieze motifs.

1922 Paints decorations for the employees dining-room at the Freia Chocolate Factory, Oslo. Large exhibition in Zürich, Bern, and Basel.

1927 Important exhibitions in Berlin and in Oslo.

1928 Working on a study for decorations for the Oslo City Hall.

1929 Builds the "winter studio" at Ekely.

1930 Trouble with his eyes keeps him from working for several years.

1933 Receives numerous tributes on his seventieth birthday – among others, Grand Cross of the Order of St. Olav. Biographies written by Jens Thiis and Pola Gauguin.

1936 Continues working on City Hall decorations, but turns down the commission.

1937 82 works of Munch in German public galleries confiscated as "decadent".

1940 Writes a will leaving all works in his posession to the City of Oslo.

1943 Receives many tributes on 80th birthday. Catches cold.

1944 Dies on January 23rd at Ekely.

1963 The Munch Museum is opened.